PROENZASCHOULER.COM

ROBERTA'S
CLASSY RESTAURANT

 ~~PIZZA!~~ *pussy!*

FOR EVERYONE!

February 1, 2013

BUSHWICK, BROOKLYN

Dear Roberta's,

First offly I was gonna go into this whole list of all the things we are sorry for like we talked about in the meeting when you suggested we write this letter. Henceforth instead of a big list, here are said apologies numbered in a consecutive fashion:

1. Sorry for stealing that shipment the other day. We thought it would be a routine heist of your wine cellar, but it turned out to be reams and reams of this fancy letterhead. Do you want it back?

2. Sorry we keep peeing in the sink, it looks like a urinal sometimes.

3. Sorry about getting the President super high at that party last fall. He approached us asking for weed and I had some new Kushwick Haze that we were trying out. Dude inhales now!

4. Sorry about all the pizza shaped burnouts! Those were awesome.

5. Apologies for setting the backyard on fire during the 2009 Deth Rally. It was entirely unavoidable however as there was still gasoline left after the races.

6. We are sorry about that cartoon we did for the New Yorker that depicted Roberta's customers as various breeds of dogs, though ▬▬▬▬▬ is totally a pug right??

7. We are sorry for letting the eternal campfire go out, but you know you can always re-light that shit with a little gasoline right?

8. Sorry for texting like a crazy person the other night, we were all at Pumps together for the first time in weeks and it felt like you should be there.

We appreciate your consideration in this matter of this letter, Please confirm acceptance or denial of this apology in writing on attached letterhead. As always, all corresponance is purely confidential and should not be published elsewhere.

Thank you for being Inspiring,
Good Black History Month to you,
Your Pals in the Community,

Buddy Johnny

Vice Dictator of Letters.
DETH KILLERS OF BUSHWICK MOTORCYCLE CLUB.

P.S. You now have your apology in writing as requested, can we please be allowed back in the restaurant?
P.P.S. Can I have my VHS copy of "Nail Gun Massacre" back please?

JT:gm

261 MOORE STREET, BROOKLYN, NY 11206

YOKO Ono Fashions for Men 1969—2012 opening Ceremony

Contents

APOLOGY

Editor-in-Chief / Art Director: Jesse Pearson
Design Director: Stacy Wakefield-Forte
Seller of Ads: Laris Kreslins
Web Development: animalstyle.biz

Copy Editors: Sam Frank and Jodie Young
Occasional Illustrations of Flowers: Tara Sinn
Spot Illustrations: Sammy Harkham

Insight, advice, and camaraderie were gratefully received
from Paul Maliszewski, Sam McPheeters, and Tara Sinn.

Cover photograph made by Roe Ethridge for *Apology* while we
listened to the Neil Young albums *Time Fades Away*, *Tonight's the
Night*, and *On the Beach*.

ISBN 978-0-9859326-0-2

Printed in Canada by The Prolific Group on FSC certified paper
with soy based inks. All papers used are acid free. The interior
paper contains FSC certified, 100% post-consumer fiber.

Distributed throughout North America, the United Kingdom, and
Europe by D.A.P. / Artbook.com

We invite submissions but cannot promise replies or the return
of materials. Find our electronic and physical addresses at:
www.apologymagazine.com

No animals were harmed in the making of this magazine.

I am not afraid of storms,
　　for I am learning to sail my ship.
　　　　　　　—Aeschylus

Welcome to the first issue of *Apology*!

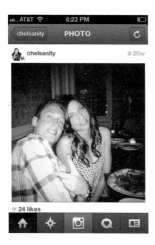

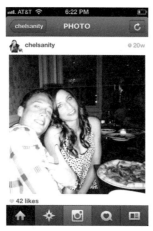

Where are we... a ristorante in Italia? No, we're in Chicago, yet that is the luxuriant foreign feel of this filter.

Black-and-white photo filter = legitimacy and staying power. This could go in a future biography.

This is so tiny it's hard to say what the lighting conveys but one thing is clear: The girl has nice hair.

CHELSEA

Chelsea Peretti really likes Chet Haze.

"Wait," you ask, "do you mean Chelsea Peretti, the comedian who has been on *Louis* and *The Sarah Silverman Program* and lots of other stuff, and who used to write for *Parks and Recreation*, and who is one of the funniest stand-ups working today, and who has the most infectious laugh in the history of comedy? That Chelsea Peretti?"

To which we say, "Yes. That Chelsea Peretti."

And then you go, "Okay. But who the hell is Chet Haze?"

Chet Haze is the stage name of Chester Marlon Hanks, the 22-year-old son of Tom Hanks (*Bosom Buddies*, *Splash*) and Rita Wilson (whom you'll remember as Dr. Peterson from the "Mary Nightingale" episode of *227*). Chet Haze is a rapper. He's also a student at Northwestern University (theater major, natch) and a member of the Pi Kappa Alpha fraternity. So, basically, he's living not just one dream, but three dreams all at once.

He raps about the usual shit: smoking weed, macking (is it still called that?), and stabbing people in their eyes with his ski poles.

So now you're going to say, "Is

INTERVIEW (AND CAPTIONS) BY CHELSEA PERETTI

Chet's Cali tan is really popping in this pic. He's glowing, as is the window behind us. Looks like a cool place to be with a pair of dynamic, creative American artists.

This looks like a still from a movie about two passionate pizza makers who both got shot and the detective wants to solve the case before he retires. He stares at this snapshot and tries to think if there are any possible details he has overlooked. Unlike the movies, though, he never does figure it out.

This goldish filter is a great one for Chet's watch (already substantially highlighted by the framing of the photo but really shining with this warm, yellowy filter).

♥'S CHET

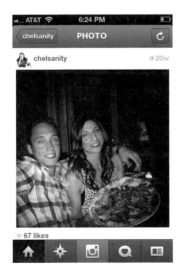

Hey, what's that green shit all over the pizza? Don't worry about it.

Chelsea Peretti kidding about this?" The answer is no.

This past summer she conducted an in-depth interview with Chet via direct messaging on Twitter, and then she emailed us screen shots of it. And then she went out for pizza with Chet and posted a photo of them together to her Instagram (or, rather, she posted the exact same photo six times, using a different filter for each one).

We asked Chelsea what she sees in Chet, and she told us, "I like his tenacity and his baby-blue eyes."

What follows is the interview in its entirety. →

.ıl. Verizon 3G 5:23 PM 29% 🔋

◀ Messages **@CHETHAZE** ↗

6/6/12 7:12 PM

As long as I can keep the answers short, sure!

6/6/12 7:29 PM

Ok I'll try to do a lot of yes/no questions

6/6/12 7:31 PM

Are you friends w Ryan Gosling?

6/7/12 8:26 AM

Tom ford

6/7/12 11:14 AM

What perfume do u like on a lady?

6/6/12 7:38 PM

Naw but Drive was dope

6/7/12 1:41 PM

Hermes?

6/6/12 7:42 PM

So dope is still cool to say? I always wonder about that. If I go to say it I feel uncertain sometimes

6/10/12 1:34 AM

Who are the big butted females u are in pics w on instagram?

6/6/12 7:48 PM

Sorry lemme phrase as a question: Is dope still cool to say yes/no? Also do u do your own laundry?

6/10/12 11:03 AM

The girls in my upcoming music video for 'Do It Better'

6/6/12 9:17 PM

Lol wtf?

6/10/12 11:05 AM

Oh shit! How did you find them

6/7/12 1:26 AM

What are your favorite snacks?

6/10/12 11:15 AM

I stood on a balcony with a bull horn in NYC and yelled, 'COME TO ME BOOTYLICIOUS VIDEO GIRLS!!!! ITS CHET HAZE BABYYYYY!!!!!'

6/7/12 2:54 AM

Jolly ranchers, Arizona ice t, and Reese's cups

6/10/12 2:25 PM

Do you consider yourself to be a vixen?

6/7/12 3:10 AM

What cologne do you wear?

6/10/12 4:34 PM

How many more questions are you goin to ask me?

6/10/12 4:58 PM

500

White Petals Surround Your Yellow Heart

Hilton Als
Bernadette Corporation
Genesis Breyer P-Orridge
Dexter Sinister
Leif Elggren
Anne-Mie van Kerckhoven
Irena Knezevic
Inez van Lamsweerde &
Vinoodh Matadin
Erin Leland
Zoe Leonard
Wardell Milan

John Miller &
Aura Rosenberg
Paulina Olowska
Seth Price
Rammellzee
Nick Relph
Carissa Rodriguez
Nader Sadek
Frances Stark
Catherine Sullivan
Scott Treleaven
Amy Yao
and more

February 6 –
July 28, 2013

Institute of Contemporary Art
University of Pennsylvania
118 S. 36th St. Philadelphia, PA 19104
(215) 898–5911 www.icaphila.org

ICA is grateful for generous support of this exhibition from the Nancy E. & Leonard M. Amoroso Exhibition Endowment Fund; the Steven & Cheri Friedman Fund; the Amanda & Andrew Megibow Fund; the John & Lori Reinsberg Exhibition Fund; the Horace W. Goldsmith Foundation; the Dietrich Foundation, Inc.; the Overseers Board for the Institute of Contemporary Art; friends and members of ICA; and the University of Pennsylvania. Free admission to ICA for the public is sponsored by the Amanda (C95) & Glenn (W87/WG88) Fuhrman Fund. General operating support provided, in part, by the Philadelphia Cultural Fund and the Barra Foundation. ICA receives state arts funding support through a grant from the Pennsylvania Council on the Arts, a state agency funded by the Commonwealth of Pennsylvania and the National Endowment for the Arts, a federal agency. ICA thanks La Colombe for providing complimentary coffee at public events. ICA acknowledges Le Méridien Philadelphia as our official Unlock Art™ Partner.

WHAT IS 80s?

By Lesley Arfin

THIS GAME that I made up, which is called the 80s game, is about naming random things that feel so much like the 1980s that you can't stand it. It can be a little bit impressionistic, but when you really nail one, you'll know. Your gut will go, "Oh my God. That's so 80s." It's about a feeling, and it's also about hazy memories. Have you read the poet Joe Brainard's memoir *I Remember*? You should. This game, to me, is like that book.

I started the 80s game with a tweet I wrote last year: "The 80s game should never be obvious. Reach into your personal feelings bank." And then I let loose a still-continuing stream of my personal 80s vibe-makers.

But now that I think about it, I've broken the Rule of Nonobviousness myself (like when I wrote, "Hurricane Gloria: 80s"). So maybe there really are no rules to the game. Maybe it's not even a game at all. In fact, I started the first draft of this "essay" off with that thought because pretty soon this will no longer be an "essay," but rather a list. Of tweets. Which is very 2013.

Anyway, it's obvious that Hurricane Gloria is 80s because it literally happened in the 80s. 1985, to be exact. My dad took me outside when the eye of the storm was passing over us on Long Island. The sky was blue, and I didn't understand what the big deal was. Maybe the tweet should have been, "Not understanding hurricanes: 80s."

I get a lot of people tweeting at me, saying, "Atari is so 80s," or, "*Goonies*: 80s." Those examples are boring because they're too easy. The game (okay, fine, let's just call it a game) isn't about flexing your commercialized nostalgia skills. That's cool that you know what Atari is and you were born in 1999. But I don't care and neither does Atari, just like nobody cared when I decided that *Welcome Back, Kotter* was a good thing for me to get into when I was 13.

So what follows is a small part of a long list I've compiled throughout the past year. It describes what the 80s were to me. Hopefully some of it will evoke a feeling of authentic nostalgia and warm, snuggly-buggly memories in you. If not, then go buy a butterfly net and catch your own memories!

PS: Using the word "commercialized" is super 90s.

PPS: Using a PS is kind of 80s. 🦋

PEANUTS

HANUKKAH

URUGUAY AND PARAGUAY

DYSLEXIA

HELEN KELLER

KARATE

LARYNGITIS

SLOW MOTION

ACID RAIN

WRITING YOUR NAME ON A FOGGED-UP MIRROR

WHITE PEOPLE EATING HÄAGEN-DAZS IN THE SUMMER AFTER DINNER

THE UNIVERSITY OF MICHIGAN

CLAPPING WHEN YOUR PLANE LANDS

CHILD ABUSE AND 1-800-CHILD ABUSE

CHEESE DANISH

MURDER

JUPITER

OTHER PEOPLE'S DADS (ALSO ON MY "SCARIEST THINGS OF ALL TIME" LIST)

HAVING BLOND HAIR

SLEEPWALKING

HALF-BIRTHDAYS

THREATENING TO SUE

TENNIS

SIGN LANGUAGE

QUICKSAND

AMNESIA

WATERBEDS

THE WORD "TOMBSTONE"

TWISTING YOUR ANKLE

MIDNIGHT SNACKS

BREAKFAST IN BED

HAVING OR WANTING A PHOTOGRAPHIC MEMORY

EARTH

WANTING TO TRY TURKISH DELIGHT

GETTING STUNG BY A JELLYFISH

THE NAME "DAVE"

WANTING TO RIDE IN / GET ENGAGED IN A HOT-AIR BALLOON

PARIS

SATURDAY NIGHT

KIDNAPPED
by
JOHNNY RYAN

When my dad left us I didn't really care much. We never got along anyway. It was 1985 and I was about 15 years old. I was into reading comic books, watching "Doctor Who" and playing with Star Wars dolls. He was into buying Duran Duran albums, getting perms, playing soccer, drinking himself into oblivion and beating the shit out of us kids with a belt. So we didn't have all that much in common. I definitely couldn't relate to all those Afterschool Specials where the parents get a divorce and the kids are emotionally devastated. My only feeling about it at the time was: "Cool. Something interesting is finally happening around here."

After my father left my mother went on a few dates with different men. I remember one that my sister and I called ~~them~~ "The Priest" because he looked like a priest. There was also a Filipino ballerina named Marcel. He ate hot dogs smothered in peanut butter. My mom also went on a date with that actor that played the wheelchair dude in "The Deer hunter". These were all brief things. But then came this guy named Tom.

Tom looked exactly like Kenny Rogers — so much so that total strangers would come up to him in the street and start singing "The Gambler". He was the first long relationship my mother had post-divorce. She would even spend several nights a week at his house. I didn't really have a problem with Tom. I thought he was an okay guy. He wasn't punching me in the back or calling me a faggot, so that seemed like a step up.

My mother and Tom had been going out for ~~some~~ a while when she noticed that some money was missing from off the top of her dresser. First she blamed my sister and me (especially me since I had been known to have sticky fingers in the past). But we denied it — honestly. She then tried to put the blame on one of my friends that had come over to play ColecoVision. We eventually convinced her that that wasn't the case either. There was only one other possible suspect. That night she asked Tom about the money, and he admitted that he took it. He claimed he'd been planning on paying it back. They broke up that night.

But that didn't last very long. Tom returned the money, and with a bunch of apologies he was able to worm his way into our lives again. My mother took him back on a trial basis, with the stipulation that he was no longer allowed in our house. After a couple weeks it became clear that only meant that my mother would have to spend more time at his place. So eventually she caved in and that one condition was discarded. Tom was back, all the way.

They dated for a few more months. I wasn't really privy to the inner workings of their relationship, but you could tell that things were cooling off between them. My mother started spending less and less time with him. And that's when Tom started to get really weird.

One Fall afternoon, my sister and I got off the school bus and rushed home. I wanted to watch "Voltron" and she wanted to watch "Inspector Gadget". Our differing tastes in TV blossomed into a full-blown fistfight on the living room floor — and yet somehow through all the commotion and the yelling we heard something

moving upstairs. We stopped fighting and ran up to investigate. There was nobody there. The only strange thing we noticed was that the doorknob lock that had been on the bathroom door in the hallway was now on my mother's bedroom door. We started up a riff about it. "How did that get there?" "Who did that?" "It was probably that fucking asshole Tom!" "That stupid Kenny Rogers piece of shit!" "Dumb Fuck!"

We said a lot of hurtful things about Tom, not realizing that he was hiding in our mother's bedroom closet ~~the~~ three feet away from us. While we'd been at school and my mother had been at work, he broke into the house, switched the locks on the doors and was now crouching behind a pile of my mom's clothes in her closet. Of course, we didn't know all this until later, and he ended up ~~staying~~ hiding in the closet for a few more hours until my mother came home.

After watching "Inspector Gadget", I went up to my room to do some homework. I think I must have fallen asleep for a while. I remember waking up and hearing my mother and Tom talking in the bedroom. I thought, "I must've really conked out because I didn't hear Tom come in at all." A little later my mother came into my room and said she was taking Tom home. I said okay. No big deal. Happens all the time.

The next morning I woke up and got ready for school. I was watching a Woody Woodpecker cartoon when my mother came down the stairs with Tom. I thought that was weird but whatever ... My mother said again that she was giving Tom a ride back home. She put her finger to her head and made a couple small circles. They left and I went back to watching cartoons.

I only ~~found~~ found out what had happened to my mother from what she told me later. Turns out that Tom had kidnapped her. He used a flaregun to force her to drive him all over Boston's North Shore to collect money from friends and other bullshit errands. She chauffered him around

for most of the day. He finally let her go later
that afternoon.

When my sister and I got home from school that day
there were police cars all around our house. We
were told the situation. It was exciting. The cops
were planning a sting operation to catch Tom.
~~They~~ They had my mother call him and arrange to
meet him at some bar. He totally fell for it, and
the cops arrested him.

Next came the trial. Our lawyer wanted to get Tom
for breaking and entering, but he was claiming that I
had left the door unlocked and he just walked in. He
had been in our house plenty of times, he was dating my
mother, what's the big deal? So I had to take the stand.
Tom's lawyer was a really sleazy looking dude with a
three-piece suit, a crazy head of Larry Fine hair and
a pink carnation in his lapel. He tried to trick me
into admitting that I had left the front door unlock-
ed. He said I must have been really excited to get to
school, to get on the bus, to see my friends. So
excited that I probably left the door unlocked,
right? I didn't fall for that shit. I said, "Yeah, but
I definitely locked the front door."

Honestly, though, I couldn't say with 100 percent
certainty that I locked it. There had been times
when I had left it unlocked before by accident.
But I was so determined to see Tom found
guilty and sent to jail that I didn't really care.
Maybe I committed perjury. LOL!

I don't remember the exact verdict. He did at least
a few months in jail. We never saw him again,
but a year or so later my mother told us that
he had been arrested for raping a woman. That
was the last I ever heard about Tom.

My sister and I were forbidden to talk about
this event with anyone at school. It was a
private family matter, our mother said. Of
course, we told everyone. I finally had some-
thing interesting to talk about. ❧

ROOM 666

By Sam McPheeters
YMCA *by Rick Froberg*

W HEN NEW YORK'S Sloane House YMCA opened in the first year of the Great Depression, the word "transient" wasn't yet a slur. Looming over 34th Street, one lot inland from 9th Avenue, the fourteen-story, quarter-million-square-foot building housed thousands of servicemen before and after World War II. Rooms cost $1.30 a day. It was a cheap way to share a street with the glamour of Macy's Herald Square and the Empire State Building. →

This glamour evaporated in direct proportion to New York's long slide under mayors Lindsay, Beame, and Koch. A fire in 1972 killed four residents. In 1978, the Village People transformed YMCA residency into a sleazy punch line. By the 1980s, Sloane House was a place ripe for intrusion, its residents easy targets for assault, theft, rape, and suicide. Its closed central courtyard—known to residents as "the pit"—was filled with years' worth of trash and smashed furniture, turning the building into a colossal garbage can. By its closing in 1993, only 20 percent of Sloane House's 1,400 rooms were occupied, and six of its 14 floors had been abandoned.

I can't remember if I'd set foot in Sloane House before the day I moved in, in late 1989, but I do know I was well aware of the building's existence. The eerie geometry of midtown made 34th Street a canyon of perfectly straight lines; even on the far East Side, the building's red neon fin shimmered like a beacon. The farther away you were, the more mysterious it seemed.

As I waited for an elevator to ferry me and all my possessions up to my new home, the lobby looked quaintly and uniquely New York to me, like a Times Square novelty shop or a stage set from *The Wiz*. Across a vast expanse of checkerboard linoleum, velvet ropes and stanchions cordoned off the front desk, perhaps knowingly mocking the reputation the place had acquired as a glorified flop house. Nearby, several hardened street scum murmured to themselves. My dad stood next to me, holding a box. He turned to me slowly, with a diplomatic half-smile, and said, "Are you sure you want to do this?"

I was. I'd fallen for a classmate. Naomi (not her real name) and I were undergrads at Eugene Lang College. We met through the Amnesty International group she'd set up. I had joined, but—despite my excellent intentions—never wrote a single letter on a prisoner's behalf (I kept this detail to myself: Naomi told me she admired my commitment to human rights). She already lived at the Y, having been housed there by our school. The month before I moved in, she'd won a room lottery and upgraded to a palatial seven-by-ten-foot suite on the corner of the sixth floor.

I inherited her old room. Although the building had no 13th floor, it did have a Room 666, which became my home for the next eight months. It measured six by ten, barely enough space for the YMCA-provided bed, desk, and dresser. Also, I'd lugged a full-size file cabinet with me. Why did I have a file cabinet as a 20-year-old? Probably for the same unfathomable reason I filled my dresser with boxes and boxes of tatty fanzines.

Bathrooms were communal, with only a sheet of opaque plastic separating the shower stalls. Ventilation slats in every room's door made full privacy impossible. The hallways were lit 24/7 by severe fluorescents, and all of the walls had long since been painted an off-white that could be fairly called "smoked peach" or "flesh-colored" (if the flesh in question belonged to one of the permanent residents on the piss-stinking fifth floor).

It's amazing how much one can willfully overlook when in love. The month before I'd moved in, an upper floor resident had leaped out her window, casting herself down into the pit. The week before I moved in, the chief of security had been stabbed in the head, neck, and stomach in the basement, in front of the L-shaped, cul-de-sac laundry room. I knew these things, but somehow felt okay with my weekly, solo trips to do wash. I cheerfully dismissed the menacing transients in the lobby as colorful quirks of the Big Apple.

Naomi's and my relationship, however, was itself transient. When she inevitably dropped the hammer—ending "things"

before much of anything had really transpired—the blow came far from Sloane House, in Washington Square Park. I was good about not making a scene (in a city full of sidewalk drama, a college-boy meltdown wouldn't have been worth the effort). But after we parted ways, it occurred to me that we'd both be returning to the same place. That night, crossing the Sloane House lobby, I finally gained an awareness of the situation I'd put myself in. Lured to the Y by love, I'd found myself trapped in the physical embodiment of loneliness. I'd fallen for an emotional bait-and-switch.

The timing was bad. I'd moved from a two-room apartment on Houston Street that I'd shared with four other people, most of whom I no longer had any connection to. A year earlier, I'd started a band with some friends; after a few concerts that summer, the rhythm section defected. I'd been good friends with the bass player, but it seemed that fall that we were going our separate ways. So the band was, at best, on hold. I didn't know anyone in midtown and didn't seem equipped to make new friends.

After an aborted mugging by two hostile bums on 8th and 33rd, I confined my day trips to going to class and back. My nightly outings were no longer into the city, but down to the lobby for snacks from the vending machines. In a very short period of time, I'd lost what Joan Didion once called "the sense, so peculiar

to New York, that something extraordinary would happen any minute, any day, any month." Moving to Manhattan had been an emergence into a much larger world. Life in the Y was a withdrawal. More and more of my free time involved solitude, listening to shortwave radio, receiving news through a filter of static.

The fanzines that crammed my dresser reflected years of laborious correspondence. As my other relationships atrophied, this link to the outside world took on an outsize importance. A brief letter from the Dead Kennedys' Jello Biafra made me far happier than it should have. I read a lot of bad, all-capitals Henry Rollins poetry, and thus wrote a lot of bad, all-capitals Henry Rollins poetry:

IN ROOM 666
AGAIN
TRAPPED IN MY MIND
AGAIN

Besides myself and a few fellow undergrads—Naomi's pals—the sixth floor was a zone of solitary graduate students, monklike and spectral in their coming and goings. I shared a workspace with one of them, but if I ever met this person, they certainly made no impression on me. We also used the room for storage, but I didn't trust the mysterious other party enough to stow my filing cabinet there.

Sleeping on the internment-camp bed was difficult. And I was unprepared for the level of demoralization that came from trying to brush my teeth next to someone using a urinal. As it got colder, the radiator forced me to keep my window open all day. My room was close to the floor's old wooden phone booth, so I was often the person who answered, placed the receiver aside, and went roaming the halls looking for the recipient. One neighbor's father told me he was calling from Vancouver. Something about that word—the sad pronunciation, the

remoteness—made me burst into tears.

Twenty years later, a study in the *Journal of Personality and Social Psychology* concluded that loneliness itself can act as a contagion, infecting those who come into contact with the forlorn. By the time a relationship has severed or withered away, the damage has already been done. Urbanites have long known the obvious—that it's easy to feel lonely when surrounded by people—without, perhaps, understanding the complexity with which feelings of isolation can be transmitted.

In Manhattan's latest incarnation as a safe metropolis, it is easy to forget what a wretchedly lonesome place it was just a generation ago. Crime amplified New York City's capacity to inflict loneliness, and every resident who locked themselves in at night created their own isolation chamber. The Sloane House YMCA of the late 80s was the essence of urban seclusion, a desolation reinforced by lack of data. For example, the suicide and the attack on the guard: Were they real? Could I be sure? In the pre-internet era, such stories just sat there—unverifiable facts, possibly apocryphal tidbits.

Looking at Facebook's "Sloane House: 1980s" page gives me a palpable feeling of disconnectedness—a weird echo of the loneliness of living there. The School of Visual Arts housed its students a few floors above us, and (like Lang, Parsons, and every other college in the shadow of NYU) fed its students a timeless excuse for the lack of facilities: "New York City is your campus." Now I see that the SVA students living at Sloane House took this command seriously. They conducted expeditions, not just into the city but into the building. They explored the 25-foot cathedral ceilings and ocean-liner boilers of the basement and subbasements. They made frequent excursions to the roof. The tone of their camaraderie on Facebook is jolting. Even their shared horror stories (like the student whose pit-facing AC unit was pooped on from above) are told for chuckles, not pity.

Scrolling through these pages, I'm disturbed less by the visions of the building's evolution—not surprisingly, Sloane House has been converted into spacious condos with hardwood floors—than by the details from my own era that I must have taken great pains to miss. One floor below the pit, there was apparently a large ballroom and/or gymnasium. And I'd been completely unaware of the second-floor lounge, with its old-timey ice-cream-parlor decor and promise of interpersonal communication. I just had my room. The lonelier I got, apparently, the less suitable I became for actual human interaction.

Sometime in early 1990, I was returning to Sloane House when I ran into a high school classmate on the street. Jeff (also not a real name) and I had never been pals, but our graduating class was tiny enough that we knew each other well. "New York did me in," he said, as if to apologize for still being there. I nodded, unsure how much I should say. Two years earlier, Jeff had been living at the Vanderbilt YMCA, on 47th Street, when a stranger came to his door with a gun. They'd tussled, and Jeff wound up stabbing the man to death with a pocket knife. I'd heard this story through mutual friends and—unlike other tales of Y violence—I'd been able to verify it in the newspaper (although the *Times* listed the assailant as a roommate).

We didn't have much more than small talk to share, and when we said good-bye it was with that pre-internet certainty that we would never encounter each other again. I tried to figure out what emotion the exchange had raised in me.

A block away, I realized it was annoyance. New York had far worse pits than mine, and this fleeting glimpse into real human torment put my own droopy self-pity into perspective. I couldn't even feel sorry for myself now. 🐾

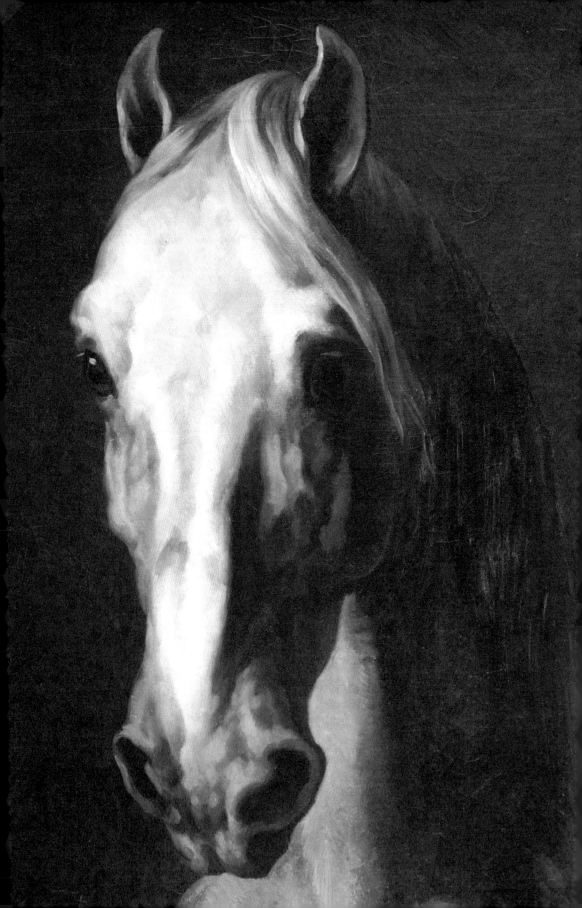

MIND READING WITH MALICIOUS INTENT FOR CASH AND PRIZES

By Gus Visco

Head of a White Horse *by Théodore Géricault*

Wear your darkest thoughts on your sleeve...

B REAKFAST WAS a bowl of cereal— Horseshoes, intended for children. The colors are a great way to start the day. After breakfast, John was compelled to vomit, and he did so in the sink of his kitchenette. Too many colors, John decided. He left the faucet running to flush out the sink and went to the roof for a cigarette. The roof provided a commanding view of Propensity Lake, an industrial wasteland of crumbling brick and defunct smokestacks, home to an aging population of retired factory workers and a cancer-incidence rate well above the national average. Propensity Lake the town overlooked Propensity Lake the lake—known regionally for the legend of the Propensity Lake Monster, a water serpent with the face of a beautiful woman and the antlers of a mighty elk—and from the roof John could see the far bank and the wilderness beyond. A black stallion was charging with its head down, a powerful mass of muscle, back and forth, bucking and rearing, trying to throw an invisible rider from his back. With no other horses in sight, a chill crept up John's spine.

"Is this display for my benefit?" John dropped his cigarette and backed away from the edge.

Sundown passed before John returned to the roof for another cigarette. The far bank was visible in the moonlight and John could see a clan of horses moving down the bank and into the forest. The black stallion was not among them. Elsewhere in the forest John could see figures around bonfires, but no black stallion. He had finished his cigarette when he noticed a horse standing by the dumpsters behind his building, an older mare, tan coat with a white tail and mane. John watched her as she wandered away from the lights of the parking lot and out of sight.

By the following day, John had forgotten about the horse. He was carrying a box of garbage to the dumpsters when he saw her again. "Good day," said John. The horse was startled and turned the corner in a swift gallop. John heard a metal door slam, and when he reached the turn the horse was gone.

Until now, John had been the only resident of the Lakeside Shopping Plaza, a two-story commercial strip mall with ten storefronts on the ground floor and office space above. John occupied a small

unit in the back of the second floor. The rest of the plaza was just boards over windows, but the signs remained from businesses past. There had been a discount shoe store and a nail spa and a mattress showroom and a deli named Skinny's Steak Sandwiches and a pet store named Puppies in the Ruff and a jeweler named Royal Duchess Cash 4 Gold. There had also been a sports bar, Molly Curly's, but now there was a new sign over the door where the Molly Curly's sign had been: in neon, a cormorant with its wings spread. The windows remained boarded and the sign had no words, but the glow of the neon meant they were open for business.

The following evening John watched from the roof. When the horse appeared by the dumpsters, he ran down the side stairwell, trash in hand, and circled the building by way of the front, putting himself between the horse and the door she had used to escape him the night before. As he approached the dumpsters, their eyes met. She was spooked, but she did not run.

"I didn't mean to startle you," said John. "I'm just taking out the trash." John held up the bag of trash and then tossed it into a dumpster. The horse remained silent. "I live right there." He pointed to his window on the second floor. "Are you new here?"

"Yes," said the horse.

"Welcome. My name is John."

"Fast-Busy," said the horse.

"Fast-Busy," John repeated. "I just love horse names. They're always so original."

Fast-Busy said nothing.

"I noticed your sign. A cormorant. Very interesting."

Fast-Busy remained silent.

"What is your business here?" said John, and then came a noise from beyond the lake, the splintering of wood and a distant thud, and Fast-Busy turned her back to John and trotted several steps toward the lake, quickly and in a

manner that made John fearfully aware of her size. Her ears were up and forward, and her gaze was into the darkness. "I didn't mean to offend you," said John.

Fast-Busy's ears dropped as she returned to John. "You did not offend me, Mr. John," she said.

"I'm happy to finally have a neighbor," said John. "I've lived here going on three years as the only renter in the strip. How many are you?"

"We are many, Mr. John," said Fast-Busy, "but too few for concern." She walked past him without a glance.

"Where are you going?" said John, and he cringed because he imagined that he must sound desperately lonely.

"I must return now, Mr. John," said Fast-Busy. "Perhaps we'll meet again." And the following night they did meet again. John found Fast-Busy standing by the dumpsters, staring across the lake and into the night.

"The wild is calling you?" said John.

"Perhaps it calls to me, Mr. John," said Fast-Busy.

"It's just John, if you please," said John, but Fast-Busy continued to call him Mr. John as she shared with him a story from her youth on *l'île de Sable*.

News had come of a mare from her village, murdered for sport near Pickton by a gang of drunken seal hunters. Fast-Busy and another filly made a secret joke of the murder, challenging each other to make the trip to Pickton to avenge the mare by murdering a random seaman,

but in time their young minds were over-powered by the rhetoric of their own humor and they found themselves on a bluff overlooking Pickton, searching for a victim. They spied a bearded man tending a campfire farther down the slope, and seeing the man the other filly floundered in her resolve. She cried and begged Fast-Busy to spare him, but Fast-Busy ignored her pleas and loosed a boulder that rolled over the man, reducing him to what Fast-Busy described as rubble and gore.

"Something calls to me," Fast-Busy said to John. "Perhaps it is the wild, or something worse. But I know myself, and I suspect you and I were cut from the same hide."

John nodded and stared into the night and considered which horrible secret to share with Fast-Busy but decided to tell her nothing incriminating. "I moved here from Corpus Christi three years ago," said John. "I work for the casino."

"What do you do for the casino?"

"I design and program custom video slot machines," said John, to which Fast-Busy had no reply. "It's not a bad job, but I work in isolation." John paused and rubbed his eyes. "Last week I set fire to an abandoned warehouse on the other end of town. I just wanted to watch something burn. It's a great mystery, fire. For me fire is the greatest mystery."

Fast-Busy nodded and John believed that she understood, and they spoke no more of arson. John produced a package of chicken livers he had purchased earlier at market, and together they fed the feral cats that frequented the dumpsters. They said good night and John retreated to his couch and television and paged through the *Penny Bazaar* mailer. When he reached the back pages that list adult services he noticed one ad with the image of a cormorant with spread wings identical to the one hanging over the entrance to Fast-Busy's establishment. It read, "Equine Modeling Studio," and included direc-tions and a small map of the Lakeside Shopping Plaza and available parking, and John pressed down on the map at the location of his office and imagined a giant finger from above shattering his roof and crushing him.

Claim secret knowledge of God's creation...

"AT HIGHER DIMENSIONS," said John, "all points in space and time intersect." Those at the bar who were listening were already confused, and it showed on their faces.

"Higher dimensions like outer space?" said Duffy.

"It's not important," said Fast-Busy. "Listen first and then ask your foolish question."

John continued. "I possess esoteric knowledge of an unknown higher dimension that is unimaginably small, many trillion times smaller in circumference than that of even the smallest known dimensions, and curved in ways that prevent the passage of all known force carrier particles, but not the passage of certain unknown force carrier particles, of which I also possess esoteric knowledge.

"These unknown force carrier particles convey unknowable forces, forces such as mystery and paradox, and operate at distances so small they approach the limits of comprehension. But if I imagine myself comprehending these incomprehensibly small distances, and I imagine two unknown-waveforms-conveyed-by-an-unknowable-force moving sufficiently close enough to each other so that they fall into this dimension and into each other until they touch in a way that two known-waveforms-conveyed-by-a-known-force cannot touch, and I imagine that one of these unknown waveforms is a thought that I'm thinking, such as the thought of myself possessing undue extrinsic

knowledge of your thoughts, and I imagine that the other unknown waveform is a thought that you're thinking, such as a thought related to a number you just wrote down on a napkin, it is likely if not certain that I will know that number."

"We horses speak of the same truth," said Fast-Busy, "but we require far fewer words to describe it. We say that the surest way to know a thing is to know nothing else."

"It still don't make no sense to me," said Big Dave the Jew. "That don't explain how you knew what number I wrote down."

John and Fast-Busy were regulars at the Pierogi Tavern, a dilapidated roadhouse with an extra-large NO COLORS POLICY sign out front. The Pierogi Tavern was also John's preferred location for perpetrating his scam that begins with Fast-Busy bragging about John's ability to read minds. Sooner or later, usually sooner, some local tosspot would step forward and challenge John to read his mind, and John would propose a bet: "You write down a number from 1 to 99 and if I can guess it you pay our bar tab, else we pay yours." The mark would agree and go searching for a pen, but never find one so John would hand him a pen from his jacket—a seemingly innocuous plastic pen that was in fact a pen that John had constructed himself, at great expense, containing sophisticated hardware and software that processed pressure and motion on its tip into synthesized speech transmitted to a device in John's ear. And if the mark hesitated to pay out, John offered up a wordy explanation on the mechanics of telepathy with references to particle physics or higher dimensions or holograms or symmetries, and spoke of parallels between thoughts and quantum fields, lofty words that made a powerful impression intended to corner the mark into silent compliance lest he appear too stupid.

"John Southpaw thinks himself smarter than me," Big Dave the Jew said to Duffy.

John and Fast-Busy had plenty of money to pay for their own drinks, and Big Dave the Jew and Duffy had very little money, but it was trickery for the sake of trickery. Also, Fast-Busy had judged them to be dimwitted, which was incentive enough for John to scam them.

"John Southpaw keeps company with a horse," Duffy said to Big Dave the Jew.

"Her name is Fast-Busy," said John. The Pierogi Tavern was the only drinking establishment on the road from Propensity Lake to the casino that allowed Fast-Busy to enter.

"A horse and a prostitute for hire, I hear tell," Big Dave the Jew said to Duffy. Then John wrapped his arms around the big neck of Big Dave the Jew and began to squeeze but was quickly overpowered because Big Dave the Jew and Duffy spent their days lifting concrete blocks in a cement factory and John spent his days in front of a computer terminal. But John suffered only a few blows before Fast-Busy tossed Big Dave the Jew over the bar and ripped a chunk of hair from Duffy's scalp. Then Angie the bartender was on the bar screaming that John and Fast-Busy and the trouble that follows them were no longer welcome in the Pierogi Tavern, and they left without paying their substantial bar tab, which included 37 lagers and 19 shots of the more expensive scotch and a plate of pierogies and two bowls of hard pretzels and two bowls of oat cakes and a bowl of pickled eggs.

John and Fast-Busy crossed the street and stood in the tree line looking back at the Pierogi Tavern. John produced two cigarettes and a vial of tan liquid from his shirt pocket and dipped one of the cigarettes into the liquid and placed the cigarette in Fast-Busy's mouth and lit it. Then he dipped the other cigarette into the liquid and lit it for himself. They stood in silence for a short while before Fast-Busy said, "Why did you attack Big Dave?"

John shook his head. "I don't know why I did it."

"You fooled them real good, John. They would have paid up for a certainty."

"Most likely, but it doesn't matter."

Fast-Busy finished her cigarette and swallowed the filter. "I suspect you're right."

They followed a footpath in the darkness that led them downhill to the lake bank from where they walked in silence for a long while along the edge of the lake through thickets and thorns. John watched a star that shined in colors abnormal for a star until the star buzzed past his ear and landed in his hair. He fell backward onto his arm, and pain cut through his back and shoulder, and with the pain John had a moment of clarity and saw himself from outside and above his being. He saw a sickly little man covered in sweat and tiny cuts from thorns slashing at his face and forearms, and his clarity opened into an epiphany and he laughed aloud and said, "I understand now that I can read minds for real and true," but when he turned around Fast-Busy was not behind him, and it occurred to him that she had most likely not been behind him for a long while and that he had been running through thickets and thorns that would have proved difficult or impossible for her to navigate had she been behind him.

John lay down in the dirt and wet grass and wished that he and Fast-Busy had not been separated in the confusion that follows angel dust, and he resolved to come down from the effects of the drug and find his way home to bake a key lime pie for Fast-Busy as a show of friendship.

Empty your heart...

THE DATA SHOWED that *Whore of Babylon* was John's most popular slot design, and the most popular high-profile slot installation in the history of video slot machines at the True North Casino. It featured a buxom woman dressed in red and wreathed in flames, motioning seductively at the gambler. Occasionally she transformed into a water serpent with elk antlers and swallowed whole a screaming caricature made to resemble the gambler, auto-generated from holography data collected through an array of photonic sensors hidden within the slot's decorative fixtures. Insert a coin and she would moan with pleasure. Pull the lever and she would touch herself. Cash out and she would scream threats, and if the programming detected a male gambler she would mock his lovemaking abilities and the size of his sex organ—the cocaine-addicted actress that played the whore relished these lines. The slot card symbols included a slaughtered goat, a chalice of blood, a beast with seven heads, and the whore in a white wedding gown. Gamble one coin, and three slaughtered goats on the pay line won 40 coins. Gamble three coins, and three whores in white on the pay line won 10,000 coins.

John hated *Whore of Babylon*. On the day it was installed on the gaming floor, Righowser, the sleaziest of the casino's floor managers, forced John to give him a high-five. John knew Righowser well enough to know that the high-five was in recognition of whores, either that he believed whores to be the motif of the game or simply because the word "whore" appeared in the game's title. John had in-

tended *Whore of Babylon* to be an allegory for gambling addiction, seducing and devouring her victims, but the cocaine-addicted actress that the casino had provided was too good, too whorish, and Righowser later told John that she was on the casino's payroll as a hostess, which at the True North Casino is a euphemism for house whore.

John confronted Lynne, the casino's chief operations officer, and told her that *Whore of Babylon* was a failed design and he demanded that it be removed from the gaming floor immediately, but when pressed for more information John could only cite damage to his artistic integrity. Lynne reminded him of the discussion they had during his preemployment interview regarding lawsuits filed against one of his previous employers for manufacturing a video slot machine of his design that featured sex acts between animated characters arguably identical to characters copyrighted by both Disney Media Corp. and Nintendo of Kyoto, a design that dispensed winnings in cash or cigarettes or condoms. Then she laughingly ordered John to drag any remaining shreds of his artistic integrity down to the lake and to hold them underwater until they stopped twitching.

A week later, John falsified a work order for maintenance on *Whore of Babylon,* hoping to destroy it along with its prototype and all documentation, but as maintenance workers were uninstalling the machine to wheel it into the tech room, Righowser started asking questions. John's forgery was exposed, and in front of several witnesses John threatened to murder Righowser as he punched holes in the drywall of his own office.

After that, John relinquished his office in the casino and moved to his rented space in the Lakeside Shopping Plaza in Propensity Lake, five miles north of the casino and the interstate, returning to the casino only when necessary. Lynne encouraged

him to keep his office in the casino—she assured John that everyone disliked Righowser and that no one would blame him for his outburst—but John refused, citing all of his best work as the product of isolation. This was a lie. The truth was that John wanted to get away from *Whore of Babylon.* He could no longer stand to look at it, even in passing.

"Three years now, and the success of *Whore of Babylon* has not waned," John told Fast-Busy. "A carousel of a dozen *Whore of Babylon* video slots is positioned prominently in the center of the main gaming floor."

Fast-Busy shook her head in disgust. "It's your creation, but you let it torment you." She spit. "Take control. It's your prerogative."

"But how?" said John.

"My brilliant friend is blind in some ways. Break your stallion. Clip its balls."

"Horse riddles," said John.

"Horse riddles, perhaps," said Fast-Busy. "Close your eyes, John, and look inside. See what you want, not what you have."

John closed his eyes. He saw all traces of *Whore of Babylon* destroyed by fire, and Righowser thrown from the casino's top floor to his death, and he smiled.

"Now show me this *Whore of Babylon,*" said Fast-Busy, and she and John walked the five miles to the casino, stopping first at the stables behind the racetracks attached to the casino where John asked a passing jockey whether he could borrow a saddle blanket decorated with the official

True North Casino racing logo. The jockey stank of inebriation. He eyed John and Fast-Busy with suspicion then cursed and spit and took a swing at John but missed in the extreme. Fast-Busy kicked the jockey in the head to put him down, and John and Fast-Busy took what they needed: a saddle blanket, a bridle, and the jockey's outfit which fit John, as a man of small stature, perfectly.

The casino did not allow entry to horses for gambling, but jockeys leading their thoroughbreds across the main gaming floor was a regular sight—this was unnecessary as there was no direct path through the casino to the racetrack, and was done purely for the amusement of the casino-goers. John and Fast-Busy, dressed as jockey and thoroughbred, walked directly through the crowded casino to the service elevator that connected the casino's kitchens to the hotel above. From there they went down one level to the access-restricted tech room. The tech room was a labyrinth of partially assembled video slot machines. John led Fast-Busy to the station where his designs were assembled.

"This is *Million Dollar Funeral*," said John. "Vodka tonic?" He pulled the slot lever and held a highball glass to one of its fixtures, but it only hummed and rattled and played country music. "It isn't hooked up properly."

Fast-Busy leaned over the slot for inspection. It was a confused mix of ancient Egyptian and Mayan imagery, a tomb built for ancient royalty, covered with tiny windows in which crowds of silhouetted funeral-goers hummed with conversation. The secondary video screen was a window onto an open casket surrounded by veiled mourners. The corpse in the casket was a caricature made to resemble Fast-Busy. John stepped between Fast-Busy and the slot, and the caricature in the casket changed to one that resembled John. Fast-Busy considered the slot carefully. "It confuses me," she said.

"I know, but it's super-popular," said John. "I think it plays to our weaknesses. Your average person worries that their funeral will be a lonely affair."

"Is that why you created it?" said Fast-Busy. "Do you worry that your funeral will be a lonely affair?"

"No. I couldn't care less."

"Then why? What inspired this?"

John's mouth was dry, and he swallowed. "These things just come to me, FB. I've learned to trust my intuition." Fast-Busy's stare said *continue*, so John continued. "Many people, especially the gambling types, believe death to be the end. Their relationship to God is corrupt. It's for this reason that they unconsciously seek fantasies of their immortal memory after worldly death."

Fast-Busy nodded and moved to the next slot. "What of this one?" The slot was labeled *Fu Manchu's Occult Detectives*. Fast-Busy pulled the lever with her mouth. As it spun, Fu Manchu declared, "My spies are everywhere. All your secrets are known to me." The slot cards stopped on a handgun, a bundle of dynamite, and a TV dinner. "Again, John, I'm confused," said Fast-Busy.

"This one is even more popular," said John, and he smiled.

"It has secrets?" said Fast-Busy.

"Yes," said John, and he reached into a nearby bench drawer and removed a padded box from which he removed a glass sphere. John held it up for Fast-Busy to inspect. "It's a very sensitive instrument of my own design," said John. Fast-Busy saw only integrated circuitry inside the sphere. "Each transistor requires only the smallest amount of energy to toggle, but each responds to a different and very specific frequency, and each maps to exactly one phoneme. This one contains every phoneme for all dialects of Americanized English."

"And it is ghosts that are meant to toggle these transistors?" said Fast-Busy.

John nodded.

"There is wisdom in that," said Fast-Busy, and she pulled the lever again. "Speak to me, casino ghosts. Give me my lucky numbers." The first slot card stopped on a fried egg, the second on another fried egg, but the third slot card continued to spin.

"A message from the spirit realm," said Fu Manchu, and another voice said, "Your genius friend is not but a blind fool, and you more the fool who follows him."

Fast-Busy snickered. "The ghosts of Fu Manchu think us foolish," she said. "Tell me, John, is it always this hot in here?" Then John and Fast-Busy heard the sound of the casino shifting its bones, and they turned toward the sound in time to see the ceiling on the far end of the tech room collapse under the weight of fire from above. John and Fast-Busy ran into the fire stairwell, then up and out and onto the promenade. They joined a growing crowd of gawking casino-goers being driven backward by the casino's security staff. The roof of the casino was on fire, and the fire reached up toward the top floors of the hotel above. A woman screamed and pointed, and the crowd turned and saw two bodies racing toward the ground from above. They hit the pavement in a bloodless and anti-climactic thud, and from a distance John recognized them as Righowser and the too-whorish actress who served as the Whore of Babylon.

John held a hand over his mouth to hide his gape. "My vision," he said. "But I've done nothing to cause this."

"Sometimes a vision is cause enough," said Fast-Busy.

John studied the corpses of Righowser and the actress. "Am I the blind fool?" said John.

"Blind in some ways, but never a fool," said Fast-Busy. "Do you believe everything you're told? Ghosts are only dead from living, and for all their privileged knowledge have no more wisdom in death than in life. You are less a fool than any man I've ever known."

John ignored the compliment and instead thought to collect a souvenir from Righowser's corpse. He pushed through the crowd, and in the confusion no one noticed him remove a gold chain from around Righowser's neck. He returned to Fast-Busy.

"Regrets?" said Fast-Busy.

"No regrets," said John.

Give yourself over to chaos...

ON MANY OCCASIONS John had waited by the dumpsters behind the Equine Modeling Studio for Fast-Busy's shift to end, but he never entered the studio or attempted to sneak a glimpse of the inside. Fast-Busy spoke very little about her work. The topic rarely came up casually, and John never asked. What John knew was that men, human men, would pay her to model for them, the modeling took place in the studio, and that the whole thing was a pretense for sex, a front for prostitution.

Then one evening John and Fast-Busy were drinking in the derelict graveyard at the end of Rock Quarry Road, firing a gun that John had accepted as payment in place of cash from a militiaman who had lost a wager to him in a game of nine-ball, when Fast-Busy broached the subject with complaints concerning one verbally abusive client.

"He comes in at or near the same time every quarter of a moon," said Fast-Busy. "He spooks me, John."

"I see," said John.

"I'm fixing on doing away with him, John, and I'd ask a favor of you."

"A favor?"

"I need you to rid me of the body, perhaps take it up county where no one would think to go searching."

"I see."

"Can you do that for me, John? Can you rid me of the body?"

The answer was yes. John knew without hesitation that he would do anything Fast-Busy asked of him. "Of course I will," said John. "But I too would ask a favor."

Fast-Busy nodded.

"Let me do the doing away," said John.

Fast-Busy shook her head. "This man has done you no wrong," she said.

"It has nothing to do with the man," said John, and he paused and traced his finger along the contour of his gun. "You don't understand." John met Fast-Busy's eyes. "It's about me. I want to do it."

"Very well then," said Fast-Busy. "I only require him dead."

"I would see him suffer," said John.

Fast-Busy nodded.

The following afternoon Fast-Busy let John into the Equine Modeling Studio through the back door. "This way," said Fast-Busy, but John took time to glance into every open door he passed. Each room contained a green screen and a portrait lighting stand, and each was decorated according to a different theme. One had sand and beach balls, another was centered around a pole-dancing stage, and another was a cave with skeletons chained to the walls. John passed a gray mare in the hall.

"Good day," said John, but the horse failed to acknowledge him.

"That one doesn't speak," said Fast-Busy as she led John into a room decorated to resemble the inside of a barn.

"Why doesn't she speak?" said John.

"Because she was born that way." Fast-Busy nudged John into a closet filled with cleaning supplies. "Not all of us do this work by choice. Some were bred for it, and inasmuch have lost the skill of speech."

John felt foolish for asking. He closed the door to the supply closet and after only a few minutes of waiting he heard someone enter. There was quiet at first, and then a man began to speak.

"You're a disgusting horse," said the man. "If you displease me further I'll ship you off to the glue factory, have you ground into a paste."

John cracked the door. He saw the back of the man, pants around his ankles, standing on an orange crate and thrusting into Fast-Busy from behind.

"The smell is revolting," said the man. "You're a stupid animal. I am your master, you stupid animal."

John had hoped that the image of the man abusing his friend would inspire a rage that would trigger some unknown kill instinct from the darkest reach of his shadow self. He had hoped to lock eyes with the man as he delivered the death blow. But John only felt pity and disgust. He wondered what unfortunate turn of events in the man's life could have left him sexually excited at the sight of a horse's rear end and the sound of his own hateful ranting.

"This barn is filthy, you squalid beast," said the man.

John had heard enough. He wanted it over, no suffering, just a quick and painless death for the wretched man. He felt around in the supply closet and laid hands on a short but sturdy shovel with a heavy metal scoop. He opened the door slowly, but it creaked before it was wide enough for John to exit. The man turned and locked eyes with John as John charged him. The first blow knocked the man to the floor and bloodied his face. The second and third blows ended his life.

"What of his suffering?" said Fast-Busy.

"I couldn't," said John.

"I suspected as much. There's no cruelty in you, John."

John folded the dead man into a tarp and dragged it down the hall and out the back door to a coffin-size glass pod beside the dumpsters. He lifted the

dead man, tarp and all, into the pod and closed the lid. The dead man stared back at him through blood-matted hair. There was a smile on the dead man's face that stretched from ear to ear, and John thought he saw the dead man wink at him when Fast-Busy interrupted.

"A see-through coffin?" said Fast-Busy. "If it's help you need I can think of better places for hiding bodies."

"In a moment there will be no body," said John. He pressed a button on the pod and circuitry formed within the glass walls of the pod, and the circuitry began to glow. "Every particle in this man's body is also a waveform, and in any given cycle of a given waveform there is a probability associated with every point in space-time that the corresponding particle will materialize at the given point. The probability that the particle will materialize at or near the center of the waveform is very high. Move only a short distance from the center of the waveform and that probability drops quickly and dramatically. The probability that the particle will materialize on the other side of the universe is almost and essentially zero, but not zero."

There was a flash from within the pod, and the corpse was replaced with a smoky outline of itself that quickly began to settle and lose its form.

"I have conceived of a method to invert these probabilities in a waveform for exactly one cycle."

There was another flash, and the smoky outline disappeared. The pod was empty.

"The body is gone, scattered across the infinite expanse of the universe," said John. "And unless time is also infinite, it is unlikely that any two particles of him will ever meet again."

"I think that wise," said Fast-Busy. "Some particles are best kept apart. May his soul find peace."

John and Fast-Busy bowed their heads in a moment of silence, and then came a noise from beyond the lake, the splinter-ing of wood and a distant thud, and Fast-Busy turned her back to John and trotted several steps toward the lake, her ears up and forward, her gaze into the distance.

"What do you see?" said John.

Fast-Busy returned to John. "Let us walk together this evening," said Fast-Busy.

"Do you mean to circle the lake?" said John.

Fast-Busy nodded, and without further discussion they set off south along the road that led to the casino. For each abandoned structure they passed Fast-Busy would choose a target, a high window or a dangling sign, and John would fire his gun at the target until he hit it. After a few miles they left the road and followed train tracks. The tracks crossed a trestle, and from the height of the trestle they could look down on the casino in the distance.

"I haven't been back there since the fire," said John, and he pointed the gun at the casino.

"Will you ever return?" said Fast-Busy.

"I don't know," said John as the sun disappeared behind the casino. "Looking on it from here fills me with panic. I fear I've wasted my life." He let the gun fall from his hand and from the trestle to the ravine below.

They broke from the train tracks and followed a trail down to the lake. From there they connected with another trail that ran north up the eastern shore of the lake. "I've never been on this side of the lake before," said John. In what light remained of the day he spotted a cormorant soaring overhead, and he watched as it gracelessly landed on a log in the lake. "We are at least a thousand miles from the sea," said John.

"It's good luck," said Fast-Busy.

"A seabird a thousand miles inland is good luck?"

"A cormorant is a sign of good luck always."

They walked on farther until Fast-Busy came to a stop before a moss-covered tree.

"What is it?" said John.

"Favor me with a cigarette," said Fast-Busy. John removed a cigarette from his pack and held it out for Fast-Busy. "First rub the fire end on that fellow's head." John followed Fast-Busy's eyes to the base of the tree and a patch of small mushrooms. "Rub ever so lightly." John tapped the cigarette on the cap of a mushroom. He placed the cigarette in Fast-Busy's mouth and lit it, then removed another cigarette for himself and tapped the cigarette on the cap of the mushroom.

"Powerful medicine," said Fast-Busy.

John put the cigarette in his mouth.

"Powerful medicine," said Fast-Busy again, shaking her head.

John lit the cigarette.

The path turned downhill toward the lake and opened onto a sandy clearing that ran along the lake bank and into the distance where John could see a series of distant bonfires blazing in the night.

"The inside of that cormorant is full of history," said John, and he paused and reflected on what he had said. "I think I'm messed up."

"Hold on to my mane and don't let go," said Fast-Busy. John held on to Fast-Busy's mane with both hands as they approached the first bonfire. It was surrounded by dirty teenagers, runaways, young and menacing, drinking and dancing and leaning into the fire.

"Who's that?" said one of them, and the rest stopped dancing and stared.

"It's Fast-Busy," said Fast-Busy.

"Horseshoe was here asking about you," said the runaway. "He said if we saw you to tell you to go right to him." The runaway turned his attention to John. "Who's the little faggot?" said the runaway, and the rest laughed wickedly. An empty beer can hit John in the leg. "Do you suck dick?" said another runaway to John, this one a girl, and she grabbed her crotch, and again the rest laughed and their laughter was wicked.

John held tight to Fast-Busy's mane as she led him away from the runaways and their bonfire, and when the light of the runaways' bonfire was behind them John saw that there was a glow to the plants and trees in the forest, and a glow to the things moving beneath the surface of the lake, and all around him there was color and light.

"Bioluminescence," said John.

"Be sure to hold tight to my mane," said Fast-Busy.

"I wish you could see all this beauty, FB."

"I see all the same things as you."

They came to another bonfire. It was surrounded by horses, including two foals that playfully approached Fast-Busy but then ran and hid behind their mothers when they saw John beside her.

"Be that Fast-Busy?" said one mother horse. "Horseshoe asks of you often. We think he suspects we lie for you when we say we have not seen you. Please go to him."

"You speak of Horseshoe with as much fear as the runaways," said Fast-Busy, and she and the mother horse began to argue, and as they exchanged insults John was drawn to the fire. He saw a cormorant in the flames, and as he moved closer the cormorant came into focus.

"Fire is the greatest mystery," said John to the cormorant.

"Fuck you, John Southpaw," said the cormorant. "Go the fuck home, you foolish man." The cormorant swatted at the

flames and fire splashed in John's face, then his shirt and pants were in flames. John stumbled backward and fell screaming to the ground, but on the ground he discovered that there was no fire on him and that he was not burned, and he laughed.

"Take this madman away from us," said the mother horse. John stood and took hold of Fast-Busy's mane, and Fast-Busy led John away from the horses and their bonfire, and when the light of the horses' bonfire was behind them, John saw that there was a great serpent moving beside them in the lake as they traveled.

They walked at a slow pace for a long time with the serpent in the lake beside them. They passed many bonfires in the forest that were distant enough from the lakeshore that John could only make out silhouettes moving against the flames. Silhouettes would call to them as they passed, but Fast-Busy would not respond so John too remained silent, his eyes fixed on the serpent moving beside them in the lake. Boulders on the lake shore forced them closer to the water's edge, which filled John with a sickening anxiety, and he tightened his grip on Fast-Busy's mane.

Beyond the boulders the night air was possessed. John heard the distant gallop of a lone horse and he breathed deeply of the possessed night air. He saw on the distant lakeshore the figure of an impressive stallion, and he let go of Fast-Busy's mane. The stallion ran swiftly toward them. John wiped sweat from his brow, and when he lowered his hand he saw the stallion before him, a sleek black tower of muscle. The stallion bowed submissively before Fast-Busy for a long moment, and then turned to John and breathed aggression down on him.

"Leave him be, Horseshoe," said Fast-Busy.

Horseshoe's face held rage and suspicion and rejection in combination and to a degree of expression that John had never imagined a horse's face was capable. "You would choose him over me?" said Horseshoe.

"I am only here as a friend," said John, and he placed his hand on Horseshoe's snout. Horseshoe pulled away. "Easy, boy," said John and he again placed his hand on Horseshoe's snout, and this time Horseshoe did not pull away. "Let me see your teeth." John held back Horseshoe's lips and inspected his teeth and gums. "Very nice," said John. He ran his hand down Horseshoe's mane and along the contours of his muscles to his midsection, where he found a video slot machine built into his side. John was stupefied with awe. "It's brilliant like I never imagined a thing could be brilliant," he said. The horsehairs where the slot ended and the horse began curled inward and covered the edges of the slot. John pulled the lever, and as the slot cards spun there came music from the slot, a tune that John had heard in a dream in his youth, a tune he believed he would never hear again, and he vowed to remember the tune to reproduce it later. The slot cards stopped spinning, and each showed the name of a god unfamiliar to John, and the names showed in colors new to him.

John vomited.

From the lake, a woman's voice called to him. John turned and saw a great serpent with the face of beautiful woman and the antlers of a mighty elk, and she said, "Look yonder," and she pointed to the far shore. John saw a decaying skyline that was pitiful in a way that could only have been Propensity Lake, and he saw what he believed to be the Lakeside Shopping Center and a light on in a window on its second story that he recognized as his home, and the serpent moaned with pleasure as the clouds parted and an arm reached from the sky and pressed down on the roof of his office until it collapsed. 🐎

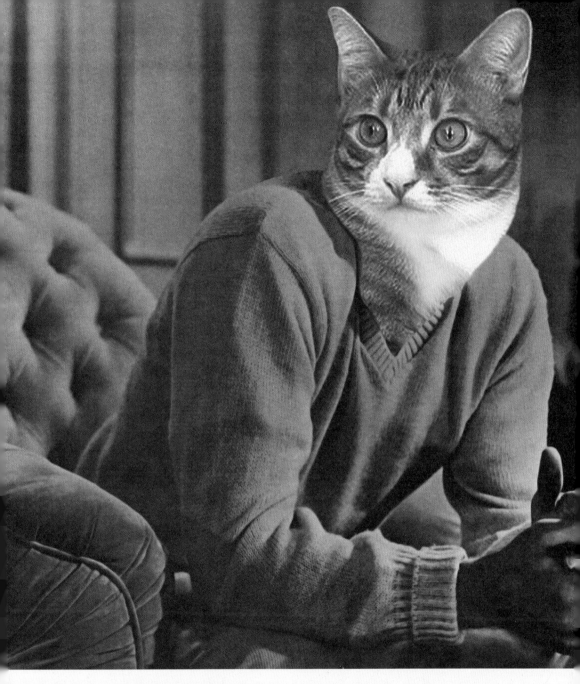

WHAT SORT OF CAT READS APOLOGY?

Meet Pickle. He reads *Apology*. He is both serious and goofy—often in the same moment, but not usually in equal measure. Pickle is alienated by the twee, mannered nature of so-called indie so-called high culture today, but he still hasn't given up on poetry. Pickle cries alone at romantic comedies when he's hungover. Pickle likes to vaporize a little marijuana now and then. Pickle owns too many books and has too much music on his hard drive. Pickle often does well when playing along with *Jeopardy!* at home, but he also sometimes likes to roll around in garbage, gurgling like an infant. Pickle is suspicious of the internet. Pickle doesn't believe that a callous glance at human suffering qualifies as journalism. Pickle likes detective novels.

Don't you want to be like Pickle? If so—hell, even if not—*Apology* is for you. Learn more at apologymagazine.com.

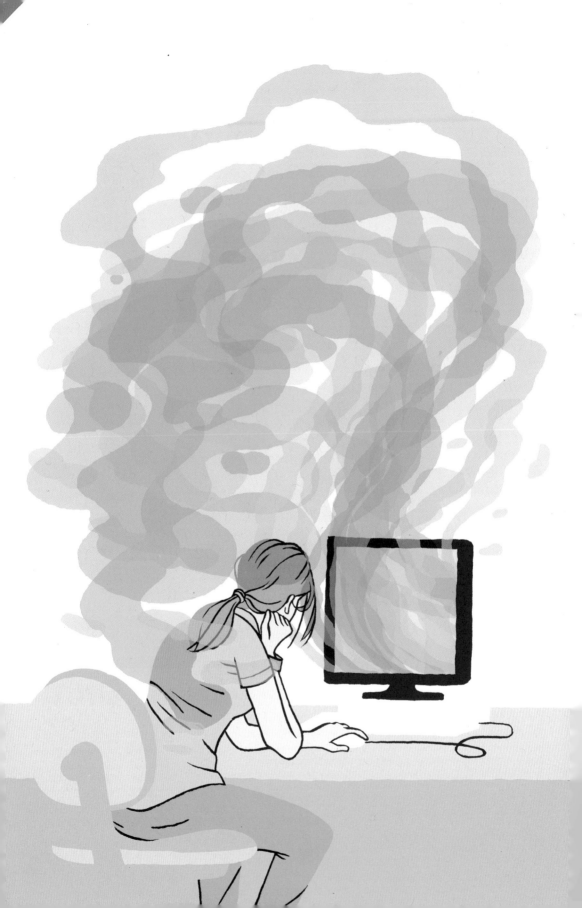

FROM *OPPOSED POSITIONS*

By Gwendoline Riley

Drawing by Jordan Crane

I MOVED UP TO Manchester to do my MA. I had a friend there, Cathy, who'd been on my English course (for two terms anyway, before she dropped out). She lived in Withington and cleared out her spare room for me.

With only my slow old word processor between us up there, and with the noise from the bar downstairs a nuisance, I often used to work in the university library. I set up my first email account there, too, at the beginning of term. Not that I got much mail at first: there were some mailshots, I had a note from my mum, and one from Cathy (sent from the computer next to mine on the day we both signed up). Both had had the subject line: Testing! After a few weeks, there was one other friend with whom I settled into regular correspondence. I'd try to write to him every Friday afternoon, when the Media Centre was quiet. I'd write to him, and then do some of my own work. I was often the last person to leave.

The other messages—the ones from my dad—started a few months later, just after the Christmas break. (My name was in a directory on the MMU site, I realised later.) This was the first one I opened:

Brian Kelly *Naughty girl!*
You may consider yourself too old to be called such, but it is very easy to see you as childish.

'How strange,' Mum said. (I'd phoned her up immediately.) 'Now calm down, Ash. Tell me again.' 'Oh, now, I wonder what's triggered this. Are you sure you haven't had any other contact?'

'No,' I said. 'I've just told you I haven't.'

I was speaking far too loudly, pacing around the landing of the library stairwell now, with my voice echoing back to me.

'Oh, calm down,' Mum said, 'calm down. Don't shout at *me*. I'm in *work*. Do you want to ring me this evening?'

I tried to calm down, but I didn't manage it, I'm afraid. Had he been trying to get in touch? Was that why he was taking this tone? Were there unopened letters at an old address? The idea almost instantly revealed itself as absurd. What would my dad write in a letter? Where would he summon that kind of self-control? And what would it explain anyway? It wouldn't explain this 'Naughty girl' business, which I had no intention of replying to. He wrote again anyway, of course. I knew he would. I went in to the library first thing Monday morning and checked, and got this for my trouble:

Brian Kelly *Naughty little girl!*
Is that better?
Come on now, stop teasing me! Where are you?

And then this arrived. It arrived while I was sitting there, which was unnerving:

Brian Kelly *In Purdah!*
Okay. What am I supposed to have done now? I was brought up Catholic you know, I always feel guilty!

They just kept coming after that, often several a week, and sent at all hours of the

day (I was very stupid, I started checking every day. I fell for that). So I got:

Brian Kelly *Teasing*

*Ah, I see, do you **want** me to come looking? You only have to ask! Don't be coy!*

Brian Kelly *Pout* .

I can just picture you. Stop sulking.

Brian Kelly *fool*

Do you think I'm interested? Dream on!

Brian Kelly *My files*

Bury your head in the sand but it is clear you are doing something you don't want me to know and certainly don't want to talk to me about. You're kidding yourself. Childish.

Cathy said, 'Christ, Aislinn! You should block him!'

Mum said, 'Oh, it sounds like he's gone mad. Can't you just ignore him?'

Both reasonable suggestions. More than reasonable. But—well, for one thing, I couldn't find a way to block people in that account. That's a practical point of the kind that's often easily dismissible, isn't it? It didn't feel dismissible, though. There really wasn't a way to block individual addresses. And I didn't want to close my account. Why should I have to do that? As to ignoring him, my mum's helpful tip: that was difficult to do as well. I think I was fixed, in a way, or—I don't know what to call it, as the messages kept coming, and their tone started to really spasm. I mean, it turns out to be quite the spectacle, doesn't it? A man not responded to.

Brian Kelly *Sensible shoes!*

Do you where sensible shoes? I don't care if your a lesbian. Your mother and I knew from Day One. Do what you want.

('What's he bringing me into this for?' Mum said.)

Brian Kelly *I despair!*

You'll wind up alienating all kinds of people with behaviour like this. Cheap theatrics. Fool.

Brian Kelly *that Greer woman*

As you may recall I have been telling anyone who'll listen that Germaine's credibility was vanishing, that she was past her sell by date. Just been listening to Woman's hour and I begin to feel she's been a con all her life. She has just said she is sixty (2 years older than me!) and I don't believe that.

Certainly I was frightened, and not because I thought he was going to 'come looking,' as he kept saying. The incontinence was frightening to me. And the rapacity. And the gloating and toddler-ish glee taken in both. Also, there was that very familiar feeling from childhood, of being both his sole focus (for attack or attention), and also completely disregarded: my personality, I mean, my boundaries, my independent existence, all valued at nil. My opening of that email account seemed to have functioned as a 'tuning in' to that treatment, and to those assumptions. And why? Because I'd used my real name, and in doing so, in however oblique a way, I'd made myself available. Because of who I was, this was what I got. That was hard to think my way out of.

Brian Kelly *tasty soup recipe*

Are you still pretending to be a vegetarian? Thought not! Ask your butcher for these . . .

Brian Kelly *'A fathers thoughts'*

Oh come on. What now? You can tell me. Has another one dumped you?

Brian Kelly *Aw Diddums!*

Ooh! Did I kick a corn?

Brian Kelly *What did YOU do wrong?*

The admissions process for Oxbridge continues to fascinate. Interesting read here . . .

The subject lines of several messages I received in one morning read:

Thoughts of you
Thinking of you
Still thinking

Thinking
Rarely out of my mind
Ah
As so often: thoughts of you.

Each message was one of Shakespeare's sonnets. *Studies continue!* he wrote.

At times like that, I did wonder about replying, sending something neutral, like, *Hi Dad, No, I'm not sulking, just really busy working at the moment. Hope you're well.* (To be kind, you understand, and to keep him at bay; a quaint notion that seems now.) But then I'd log in to something that made me less inclined to do that, really. To the other kinds of message, the ones that would stoke a growing dis-ease with whatever the hell it was that I was made up of. The freckles on my arms, I remember, so like the freckles that smutted his forearms, began to be a particular torment to me at this time. The colour of my hair, too, became a problem again, and the way my face looked in repose. I started to carry myself quite differently, trying to ward all of that off.

Brian Kelly *OOH!*
Showing off again are we?
Brian Kelly *Your problem?*
Women (who can do 2 things at once) are notorious for their lack of imagination. Harry Potter is a famous exception.
Brian Kelly *Navigator*
*I went on a driving holiday back to Scotland this weekend (up to Ullapool, remember?). Could have done with my trusty navigator! The 'fried Mars bar' tendency is in full effect up there (even in the ****(*) establishments.) Sugar in the gravy! Cheese boards served with a sugary chutney! I refused all puddings. It seems I am losing my taste for sweets, and not a moment too soon!*
Brian Kelly *Am I alone?*
Beyond despair!
Brian Kelly *Inheritance*
*Goes down the male line. There's nothing in it for **you** if I die!*

Month after month, all these sullen retreats and these roaring returns. Yet I could never be sure how much of what he wrote had anything to do with him: how real these assertions were, how merely habitual, or—innate; or was this all just a nasty, idle hobby for him now, in fact? (Because that can happen, can't it? I mean, it's happened to me, I know, I've slipped my tracks with people, with work sometimes, too.) But there was no way of knowing. My instinct was the same as it had been when I was small: that he was more contraption than person. So what could I do? It didn't feel like it was my business to do anything, when I received a message like this, for instance:

Brian Kelly *Feeling distressed*
I am sick of being abused by you and your mother.

A message without meaning, without any relation to the real world. This one particularly seemed to speak of a self-abasement that I couldn't begin to understand. I really couldn't. I could try . . . But why was that my job? I told Cathy and Mum. I'd taken to phoning both of them and reading these messages out, as soon as I received them. Mum said, 'Oh dear. How strange.' Cathy said, 'Block him! Erase him from your life!'

Brian Kelly *In Denial*
I don't know who you think you are. I remember when you liked Michael Jackson.
Brian Kelly *My lawyer*
Has now sent me my files. So much I'd forgotten, obliterated. Your mothers accusations even more obscene! When I have access to fax I send.

He was distracted from that line of thought, though, when I had a book out that spring. I heard nothing from him for a few weeks after that. And when I did (with my new computer—in our living

room now—even giving a pert, doorbell-y ping to herald his bright, renewed suit):

Brian Kelly *The font!*
I like the font. Nothing else!

This being very plausibly and reasonably the case, he nonetheless typed up several quotes and sent them to me, annotated:

Oh dear!
Oof!
Posing!
Er, what?

And then:

Brian Kelly *Smelly daughter.*
*Pouting are we? I can just picture you. Ah. Why so sensitive? Am I not **allowed** an opinion? I was reading before you were born remember. If we assume we both started seriously reading at 10, I have forty plus years on you!*
Brian Kelly *However . . .*
I want my signed, dedicated copy of this 'novel' by first post.
Brian Kelly *Thcweam and thcweam!*
Do you think I'm interested in your miniature drama? Dream on. Send the book.
Brian Kelly *Cruel*
I think you're being very cruel.
Brian Kelly *My Death*
Only ocurred in your book. In reality, I live on!

Did he, though? This fraught ravening at my dusty computer screen . . . Was that life? As it went on, I began rather to think of him as the dying—although I wasn't sure what that made me. I think maybe it made me—nothing. There was a role he wanted to manoeuvre me into, certainly. But that wasn't me. The trouble was, as ever, that—because he'd take anything, grab at anything and co-opt it—my inaction was taken as assent. And what a quicksand that was. I did nothing and was railed against.

I did nothing and became more tor-

menting, and therefore—grotesquely—more supreme. I felt that happening. I then felt this imagined supremacy itself becoming a kind of gasped-after salve: each lack of reply now taken as another messy recrudescence tenderly cauterised; a fretful appeal gracefully denied; another craven strategy tactfully dismantled. That was how he set me up. So he wrote that he was very poorly.

Feeling shattered! he said. And I didn't reply. So then he wrote that he'd had a job offer in South America. It deserves serious consideration, he wrote. And I didn't reply. So it was back to the hospital, and the nurses:

With some of these women, I often wonder if they have much better paid jobs on the phone at home. It is (still) quite shocking to discover / realise / have it confirmed yet again, how easy it is for women to sound sexy, entising, seductive. Deceit, thy name is woman!

Then it was back to the job:

I hesitate, and their terms become more attractive. But money isn't the only consideration. There are several considerations.

There wasn't much to hold on to. Perhaps only an idea that the dying—because they can't help what they become either—might, in fact, hate what they found themselves to be. Perhaps they were even ashamed of it. Perhaps he and I shared that. But no—

Brian Kelly *Access*
*I fought your mother and the courts to gain access to you. **You** will be easy compared to them!*

'God, are you okay?' Cathy said, coming back in from the kitchen with our two drinks. 'Your face has gone all red.' 🕊

S⬤FTWARE 2012

TIM HECKER | DANIEL LOPATIN
INSTRUMENTAL TOURIST
DBL LP / CD / Digital

ONEOHTRIX POINT NEVER
RIFTS
5xLP Box / 3xCD / Digital

MEGAFORTRESS
MEGAFORTRESS
12" EP / Digital

CARLOS GIFFONI
EVIDENCE
12" EP / Digital

SLAVA
SOFT CONTROL
12" EP / Digital

NAPOLIAN
REJOICE
12" EP / Digital

CHUCK PERSONS
A.D.D. COMPLETE
Locked Groove Editions I–IV 7" + 7" Box

BLANCK MASS
WHITE MATH / POLYMORPH
12" EP / Digital

ONEOHTRIX POINT NEVER
DOG IN THE FOG
Digital EP

TROPA MACACA
ECTOPLASMA
LP / Digital

2013: AUTRE NE VEUT — ANXIETY, SLAVA, CO LA, PETE SWANSON, HUERCO S
SOFTWARELABEL.NET

CONVENIENCE STORE

By Bill Callahan

Granite, Oklahoma, July, 1972 *by Stephen Shore*

I HAD COME UP WITH a plan to keep my weight in check by only buying one food item at a time and always from the same store. I knew my nature would keep me from going to the same store more than three or four times in a day. I had also developed a detailed procedure for leaving and returning to my apartment that would complement my plan by making the trip more of a burden.

It was a gloomy and meagerly stocked store run by a man named Sharone. The place sold airplane bottles of liquor and wine. I'd worked those little bottles into my plan as well, to keep a check on my drinking. I was far too self-conscious to go to the store enough times in one day to drink to excess.

Tiny wine was what I was after tonight. What I really wanted was a large bottle plus a large backup bottle. Fuck a plan. But everything was a plan—plan not to drink, plan to drink too much. So fuck a plan to drink too much.

I was the only one in the store besides Sharone. I don't know how I knew his name—we didn't have that type of relationship. I'd picked it up somehow, overheard it or read it on a form while his eyes were averted. Which they always were. I was in there so long I think he forgot a customer had entered. He began singing to himself in a foreign language. In that heartbroken way of the exiled. It felt like a blanket of darkness was being drooped over me. Jesus.

I looked up at the ceiling. Mottled plastic covers over fluorescent tube lighting. All those dead bugs, lives finished and resting in peace. Resting for a long time in dry husky peace. I felt more relaxed than I could remember. There was not much to look at and that was the pleasure in it— there was space to really see everything clearly. Bag of flour. This place was better than my apartment. But it was time to go. Why was it time to go when I could have stayed there all day? I wanted to get home. I had stood long enough in this outfield fantasizing about catching the winning out.

The small bottles were in the front near the register. I walked up, plucked one, put it on the counter. Sharone's eyes remained down. I said, "How are you?"

"$3.47."

I handed him a 20.

"Have you got anything else?"

"What do you mean?"

"Big bill. You got five?"

"I don't."

I didn't much care for being asked how I was doing by store clerks. So his lack of response both irked and pleased me. I admired him for sticking to his beliefs and gave myself a little knock for not sticking to mine.

He let out a blast of air. Now I hated him. It was an unnecessary embellishment. I gave him a thank you and a good-bye knowing I would get nothing in return. Maybe a little blip of sound escaped his lips. Less than a baby ever said. If he did make a sound it blended in with the combustible sounds of the city.

Two homeless men were roused by my presence as I walked out. They wanted some of that fresh change. But I gave them none. As if Sharone would. I bet they wouldn't even ask him. I have not yet sung for them my song of the exiled. They would never stop asking me.

I walked a ways and sat down on a bench and watched the people who were in the coffee shop. A man on rollerblades skated up and almost bumped into a paunchy older man who was standing holding a coffee less than three feet away from me. I'd observed both of them before. The rollerbladed man's hands went up. Fingerless gloves. He apologized. The other guy said, "It's okay. I'm a poet." Maybe by that he meant that he understands when things go wrong or that he understands everything right or wrong. The rollerblader skated away then immediately skated back with his chin perched between his finger and thumb. Fingerless gloves, fingerless gloves.

"I'm reconnecting with this person, a woman I had a brief liaison with several years ago. I need to tell her something that shows the depths of my feelings for her."

The poet man listened and thought like a doctor, then said, "Hands of love... each to each."

The rollerblader absorbed and carried this away like a command.

When I got to my apartment building I listened at the door. This was the beginning of the returning protocol. Well, it really started just before this first step—surveying the area to see if anyone appeared to be making their way toward the door. Then I listened. It was a flimsy door made of balsa wood, toy-glider wood.

There were only two apartments in the building—the street-level one and mine. I had never met the man who lived below me. Two times I had listened at the balsa-wood door, heard someone

bustling and decided to come back later. If I met whoever lived here, that would make my town that much smaller. I would then have to avoid him on the street, in a store, everywhere. It was all just easier this way.

After opening the door, I took a pause on the fourth step, where I'm obscured from view, to see if I could determine whether he was home. The place was quiet tonight. I thought, "Probably in an alcoholic stupor. Passed out on a stained couch." There's reason enough, I thought, if his apartment is as drab as mine.

The wine was thin and acidic. There was nothing to enjoy about it. And the bottle was so small as to not even give the gift of drunkenness. I put the half-finished bottle on the counter. Maybe Sharone hadn't even heard me say "thank you" and "good-bye." I have a tendency to mumble through the pleasantries. The bitter taste of the wine clung to my mouth. I thought maybe I'd get something sweet to change the taste out.

I had violated my plan of eating only one food item at a time earlier in the day. Had lunch at a restaurant. Sausage and sauerkraut and fried potatoes. I can't follow my plan all the time.

I looked out the window for a while, down onto the sidewalk. The sun had set and the world had turned black-and-white. I thought maybe that would make things simpler, easier to read. People walked by and they all seemed to be looking up at me. Their dogs looked up too, like they'd been told about me. "You have to see this guy. I'll take you for a walk so you can look at him."

On my way out for a Cherry Zapper Log I noticed how many live oak seedlings had come up between the big flat walkway stones. I tried pulling the tallest one up. It was only about eight inches high but it wouldn't budge. Some leaves ripped off in my hand and almost put me on my ass. I tried another and it flipped the flagstone

over but stayed rooted. I tried one more and it started to bring another flagstone up so I let go.

The TV was on in the store when I walked in. The news. I left the door open to announce that I would not be lingering. I didn't see any candy. Sharone was giving me his usual wide berth of contempt or apathy. I gave him a little chuckle on my way in. It was a surprise to me. What does that mean when someone comes into your store laughing? Looks at you and laughs. I went up and down all the aisles. Nothing sweet.

I pelted, "Where's the candy?"

"No candy."

Where did he get his TV? It looked to be 40 years old. It was in this country before he was.

No candy. There were only large bags of potato chips. Buying something I didn't want and would feel nasty after eating was what needed to happen now. Missed punches are more draining than punches that land. I pushed the bag toward him. I wasn't going to say anything this time.

"$3.28."

As I walked out with my purchase I saw that there was a short rack of candy that had been hidden by the open door. Cherry Zappers, too. I thought about going right back in but that would violate my plan. Checkmate.

THE POET GUY was still outside the coffee shop talking to some other people. Always some other people. More people. I thought about attempting to talk to him but couldn't think of what fake story to tell him. That I was also a poet or a professor at the university. Something like that. Back at my place, the usual precautionary measures at the main door were performed.

The phone rang. I let it. Once it had stopped I picked it up and called the toll-free number of a televangelist's organization. It was in my speed dial.

They collected money with their TV show. A machine answered and asked me to hold for the next available operator. I held until someone picked up. Must've been four or five minutes. It was relaxing. Like the store, it was nice to be in someone else's space. And I liked to spend their money. The money old ladies were sending them. Tithes. I listened to the volunteer say hello a few times, then she said, "God bless you," and hung up.

I went into the bathroom. The lightbulb was out. I looked in the mirror. Nothing, almost nothing. A dark form. A Japanese mountain. It could be anyone. I'm a philosophy professor down at the local university. Single. Never really found my wife, gave up on that. There was one woman. She died when I was young. I overheard you say you were a poet. I collect Civil War shoes. What's your size? I'd like to see you in a pair. Interesting fact, they were actually one-size-fits-all.

In the kitchen I looked at the receipt for the potato chips. There was a phone number on it. I dialed and it rang nine times then Sharone picked up,

"Tayis?"

I realized I hadn't thought of what I was going to say or even what I wanted to say. I decided to be honest.

"I'm not sure what I want to say to you, but I feel I should say something. This is the guy that comes in all the time. I was just in there. I wanted candy but I bought potato chips. I was in there a bit earlier buying wine. My name is Myles."

"What do you want?"

"Do you remember me?"

"Yes, I remember you."

"Say something about me. So I know you remember me."

"Big chips. Little wine."

I said, "God bless you," and hung up.

I wish he'd said more.

My roots were deep, my song was the song of the exile in the promised land. 🐾

GARBAGE

By Arthur Bradford
Trash *by Willy Chilton*

THE GARBAGE WAS just building up inside my house. And now it was beginning to stink. I knew of a few places where I could put it, but I had delayed the action of taking it there for some time. Overall it was maybe eight or nine bags full. I was careful at first not to throw foodstuff into the garbage because I knew that this would be the first to take on unpleasant odors. And for the most part I don't eat red meat. So what was stinking? Anything that was wet, I deduced. I don't generate that much garbage and my house has several rooms, so it wasn't like you would walk in and right away see garbage bags strewn all over the place.

It occurs to me now that you think I'm nuts. I'm aware that garbage hoarding is the type of thing insane people do. But really the simple fact was that I had neglected to go through the various procedures necessary to arrange for garbage removal. I live out in the country and many folks around here have less scrupulous ways of disposing of their trash. I was just holding on to mine.

Anyway, I own a station wagon. I loaded it with the bags of garbage. Actually, I think there were only five or six of them, not eight or nine like I'd said before. The car was very full, though and it did smell bad, too. I put the dogs in the front seat. I have two dogs, both fairly large. They often accompany me on trips away from my home. They didn't mind the smell at all. It was amazing, actually, that they never thought to rip those bags open while they

were in the house. That should give you a good idea of how little meat or foodstuffs were involved.

We drove along the road, me and the dogs and the garbage, until we came to the post office. It's a small post office out here. Next to it are the dumpsters where town residents can throw their trash. I backed up my station wagon and got out to unload my bags. The postmistress came running out.

"Don't you dump that here," she said. "You have a sticker?"

She was referring to a blue sticker that residents received after they paid some kid of garbage tax. I hadn't paid it.

"No, I don't have a sticker," I said.

"Then you can find another place for that trash," said the postmistress. I knew her pretty well. I believe she regarded me as a nuisance. I was often showing up right at closing time with parcels to mail. I'm a procrastinator, in case you haven't noticed.

I got back into my car and drove away. I forgot to mention that I did manage to toss one of the bags in the dumpster before I'd gotten caught, so it wasn't a total loss. At least I think I got rid of one of them. I think my load was lighter at this point, but to be honest I'm not sure.

The next stop was the gas station where they have a set of garbage cans next to the pumps. I pulled up and pumped some gas into my car. As I did this I noticed that the garbage cans were pretty full and also I remembered that I liked the owner

of the gas station, a fellow named Bill. I would have felt bad unloading all that garbage on him. So I just paid for my gas and drove off.

I knew there was a dumpster over by the local school. So I went over there. It was around the back and I figured I could unload the whole lot without anyone knowing. When I got there though, it turned out the dumpster was locked. Imagine that, locking up your garbage! I wondered if it was to protect against kids falling into the dumpster while playing. That's not too far-fetched an idea, you know. Another possibility was that they didn't want people stealing their trash. Most likely, however, was that they didn't want folks like me dumping garbage into a dumpster that the school had paid for. I was beginning to see the logic behind getting one of those blue stickers at the post office.

Over at one of the state parks they have some barrels set out for people who are having picnics and such. I went there and was surprised to see that those barrels were full, for the most part. I couldn't believe that picnickers had generated that much trash and wondered how many other garbage scofflaws like me there were in our town. My options were dwindling.

There was this guy Fat George whom I knew, and I felt pretty strongly that he was some kind of prick, so I drove by his place to see if I might just toss the garbage onto his yard. It would be a win-win situation, as it were. I'd be rid of the garbage and feel good about inconveniencing George as well. He had a fence around his house and I stood there holding a bag, ready to hoist it over and run. But then I began to wonder whether there might be some kind of identifying evidence inside the bag. Fat George could open it up and have me arrested.

So I drove to the town dump. They make you pay to unload your trash there, but I could see that things had finally come to this. The dogs in the passenger seat were getting restless and I had wasted half the day on this project.

When I got to the dump an older man emerged from a shack and said, "What can I do for you?"

"I need to dump this garbage," I said.

The old guy looked in the back of my car and said, "What garbage?"

I got out and looked back there too and I couldn't believe it when I saw that there wasn't any trash in my car at all. It was gone!

I shook my head, bewildered.

"I'm sorry to have bothered you," I said to the old man.

"It's no problem," he said. He wandered back inside his shack.

I drove back toward my home and realized that I had in fact dumped a bag of garbage at each of the several places I had stopped. My load had diminished so gradually I hadn't even noticed. Sort of like how if you place a frog in a pot of water and heat it slowly it'll just stay there until it boils. Except this was the opposite effect. Conditions had actually improved in my case.

I told you the story like this so that you would understand just how I felt. I felt as if I hadn't dropped anything off, but actually I had. This is an illustration of how it works when you do just a little bit of something at a time. Slowly it begins to add up and the task gets done. Before I knew it, I was rid of that trash. Likewise, before I knew it, I had accumulated all that trash.

Perhaps this is a good fable for all of the problems we are currently facing in this country and in the world at large for that matter. Garbage is building up all around us. But if we just start looking for a place to put it, and preferably not some far-fetched idea like launching it into outer space, then eventually the garbage will simply disappear. This may well hold true for all of our problems in life. Eventually they will just go away. 🐾

HELLO PEOPLE,

MY NAME IS WILLIS EARL BEAL.
YOU KNOW, LIFE MAKES A GOOD DEAL
OF SENSE. I'VE ALWAYS KNOWN THIS.
EVEN THROUGH THE MEDIOCRITY, THE STUPID
PAIN, THE TEDIUM.......... THIS HAS BEEN
APPARENT TO ME. THERE HAVE BEEN SIGNS
ALONG THE WAY. THESE SIGNS HAVE
INFORMED ME, GIVEN ME A SONG TO SING.
THIS IS A COLLECTION OF SONGS I WROTE
& SANG DURING A TIME WHEN, OUTWARDLY,
I HAD NO LOGICAL REASON TO BE HOPEFUL.
I ONLY KNEW THAT THINGS NEEDED TO BE
DONE IN THE MANNER THAT I WAS DOING
THEM. THERE WAS NO DOUBT ABOUT THIS IN
MY MIND. FOR THIS TO HAPPEN IS BOTH
A REVELATION & A MANIFESTATION OF
"SORCERY" ON MY PART. YELLING AT THE
SKY, SELLING WOLF TICKETS, GETTING DRUNK
& LOSING OUT GENERALLY. SO, IN CLOSING,
I AM A PRIMARY EXAMPLE AS TO WHY
ANY BODY CAN DO ANY THING
THEY WANT TO DO WITHIN THE CONSTRUCTS OF
CONVENTIONAL CIVILIZED SOCIETY.

WILLIS EARL BEAL
ACOUSMATIC SORCERY
Out Now

OKAY THEN,

WillisEarlBeal

WILLISEARLBEAL.COM XLRECORDINGS.COM

UNFINISHED STORIES

STORIES

BY RIVKA GALCHEN

GENERAL BONAPARTE BY JACQUES-LOUIS DAVID

WHAT BECOMES OF the short story that is started but then abandoned? It's filed on a hard drive or it sits in a drawer. It languishes and is forgotten. Maybe, at best, it's cannibalized by a stronger story, like one twin consuming its partner in the womb.

There's a kind of fetish for unfinished paintings. Maybe that's because we look at them and feel a sense of ghost-liness—not of the half-emerged subject, though it can be phantomlike—but because we see the artist's hand through his or her sketchy bits: the unembellished schematics or the place where the paint trails off into unadorned canvas. It's the death of the work. The artist is absent—conspicuously so—and has left us this memento mori. Unfinished paintings, portraits especially, have an uncanny quality.

Unfinished fiction is different. Reading relinquished work can feel by turns dreamlike, invasive, rueful, frustrating, and more. Sometimes you wish like crazy the story would go on, and sometimes you're sure the writer was correct to drop it. At its most rewarding, reading an unfinished piece feels like catching a glimpse into the writer's way of working and even into their psyche. An unfinished work could be more revealing of the author as a person than a published story is.

When I asked the writer Rivka Galchen whether she'd submit something to *Apology*, she didn't have any finished pieces ready to go. But she thought I might want to see a few other things that she had around—orphaned openings to stories that she doesn't intend to finish. "It could be a kind of morgue," she wrote in an email, "to stack a few dead story openings together."

And so three of Rivka's corpses appear on the following pages. But first, there's a brief exchange that I had with her about process. We did this via email because, as Rivka told me, "Live talking turns me into a five-year-old."

—Jesse Pearson

APOLOGY: How do stories usually come to you? Do you get inspired in the shower like so many people do, or on walks like Wallace Stevens did? Or maybe you keep a notebook of ideas and first lines, which is the Woody Allen way.

RIVKA: I only have a bathtub, and no shower, and I really do think it's possible that this is a serious writing obstacle, this lack of a shower. Because, like a lot of people (so I hear), I only get decent ideas when I am not trying to think of them; it's sort of like how you can't remember the capital of, say, Slovenia, until you stop trying. Then you go to the post office to renew your passport and you realize you know how to spell Ljubljana and then you wonder, why am I thinking about Ljubljana? And then it all comes together. And so, eliminating the shower eliminates one of the reliable space-out moments of the day. I often find that my stories fail when they have come to me too conceptually, like homework, or a plan to get stronger abdominal muscles. So I try and make plans to not have plans. Like I'll hear or read about something interesting—I opened a file recently and found a note about how they had to blindfold the animals when removing them from a flooded Prague zoo—and I try and take note of it and then forget it and maybe later it'll go fungal behind my back and then I'll have something. I really do believe in putting in the boring hours of trying to write even when I have no ideas, but at the same time I think there's a lot of essential "work" that can only happen when one is not working, but instead eating ice cream. The working brain is always personal and, therefore, stupid; whereas the spaced-out brain, I believe, is—forgive the New Agey sound of this—tapped into something larger and smarter and collective.

Can you tell me about the boring hours of trying to write even when you have no ideas?

On the one hand, I absolutely believe in just showing up and trying to work, and in developing a space and time that is designated for working. But also I think you know when you are just calling it in, and doing a dry and joyless study of how "a story works." And nothing that comes out of that place is worth its weight even in straw. I imagine everyone gets really frustrated and discouraged, and I know that I do. When I read work that I have written that I feel like comes from the workmanlike place of pure effort, I feel absolutely ashamed, and sort of like I am catching sight of myself making faces in the mirror. Which is not cute at all. It feels like an allergic reaction, like I need an EpiPen so that I don't pass out from the horrible falseness.

On the flip side of that, do you know when you've got something hot going? Like, take the things you've written that you feel the best about. If you think of them right now, what do you remember of their starts?

What makes me feel not ashamed is when I read something that I've been working on, and it feels like it has been written by a stranger with whom I have an intense kinship. When I feel like I encounter something I wasn't totally in control of, but that rebelled against my instinct for privacy with honesty—that's something that makes me happy. Like I actually liked a story that I wrote about a woman whose furniture moves out on her. I knew that I was haunted by an old story that was sort of having its way with things. And that felt honest, and I still like that story, which isn't always the case.

Do you do the thing where you write the start of a story, or even finish the entire thing, and then put it away for a prearranged span of time before reading it again?

I only and always do that. It's a handy way to make something familiar seem foreign again, so that it can be seen more honestly.

How does it make you feel to look at the three story openings you've given me?

I think artists working in visual forms are much better practiced at letting a little sketch just be a little sketch, at being fine with tossing something out or painting over it, or even keeping it without feeling like the runty sketch is looking at them with judgment. When I look at these now, I think maybe what they have in common is that they each only had one main idea, and that maybe I was too deliberate about that idea, and so they each died their own little under-oxygenated Cartesian deaths. I see now how it's as if one were titled Error, one Charisma, and one Nontransferable Experience, and those paper dolls just wouldn't animate for me. In the first one, I see a little spark of life in the pen sliding into the digression into the fact-checker.

Do you have any thoughts as to why these stories didn't work?

I think what made these story starts dry out is that nothing sufficiently foreign or unexpected by me contaminated my starting ideas. But I'm always happy to be reminded that it's fine if only a few of any crowd of pea shoots takes off; maybe the ungerminated ones end up feeding the soil of the thrivers, somehow. →

ERROR

Our last name is one letter off from the name of a private detective much more esteemed than us who not long ago got a mention in a celebrity gossip magazine. Business picked up for our agency after that. The uptick was due to an error, sure, but seeing as it was making my recently post-coronary-bypass boss (aka my dad) so pleased, I couldn't bear to let on, to him or to anyone, the truth about why this fortune had befallen us. As to the misled clientele, I imagine many a plumber or hair stylist in this vast city has now and again found himself engaged in a similar small passive deception. And besides, the official record has been cleared. The magazine ran a correction on the spelling of the other private detective's last name a week after the error; people don't take much note of details, I guess. I could picture the weary fact-checker of the original article; he opens up the phone book, and our agency is listed in the yellow pages—the fancier one isn't—and so he assumes the spelling is correct, and then he heads home to takeout Chinese and a wavering internal dialogue about whether or not to send an email to an old girlfriend. That's life. At least I suppose it is.

CHARISMA

I was down in Mexico City, just for a couple of months, it doesn't much matter why, I was alone. Suddenly I could afford things. They were cheaper, but not so very much cheaper that I just felt awful all the time. Just cheaper, like the way Detroit must be cheaper, like in Detroit I could probably afford to eat out most of my meals, and there in Mexico City, I felt I could afford to eat out most of my meals, and so, maybe this logic seems hard to follow, but I found myself getting a manicure and a pedicure, and I found myself in conversation with a woman who was a TV news reporter, who had been dating the son of Norman Mailer for a spell, who had become very depressed once after a car accident and had put on lots of weight and her TV news channel had given her four months to trim down again, it was a hard time but she had done it, and she invited me to watch the Mexico-Uruguay soccer game with her the next day, she seemed to like me very much, though I had said almost nothing. Perhaps that was why she liked me. She was soon going to be covering the midterm elections, she might have to go to Sinaloa, or Chihuahua, either way to a place where the narco wards were very much alive, her friend was in Juarez, he said he saw bodies in the streets, it was a hell on earth. One thing very nice about getting a manicure is having the hand massage. I guess I was lonely, I guess I thought it was my job to "get to know" some people, we ended up spending quite a bit of time together.

NONTRANSFERABLE EXPERIENCE

There might be a strange woman—Grace is a strange woman—who sometimes feels pain, more or less just like I do, but whose pain differs greatly from mine in its causes and effects. My pain is caused by paper cuts, backing into a radiator, gastric distension, prolonged exposure to the cold…; her pain is caused by the sight of green in the afternoon. My relationship to my pain is aversive. I wear mittens or take painkillers or count to 100 in order to avoid it; when I'm in pain, I can't do much else. For her, pain is an unparalleled memory aid. When in pain she can recite long passages from Thucydides; in fact when in pain she can do little else. Pain doesn't make her cry or moan; she isn't strongly motivated to avoid or alleviate it. In what way then is it pain, do you ask, and I understand why you ask, because it's hard to imagine the pain of others. But trust me, she feels pain, her pain just doesn't occupy the typical causal role of pain, and understanding this kind of pain is a necessary step.

Ernest Alexander

NEW YORK NEW YORK

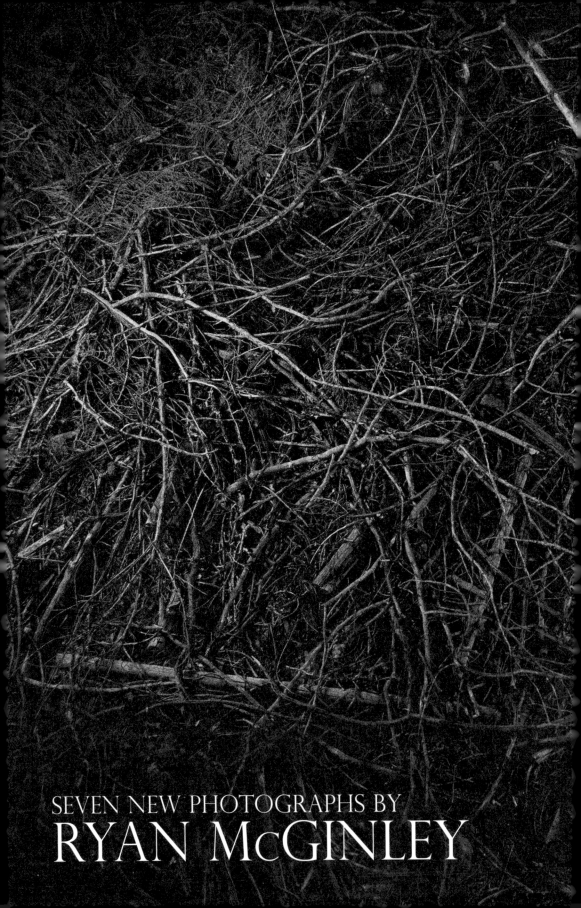

SEVEN NEW PHOTOGRAPHS BY
RYAN McGINLEY

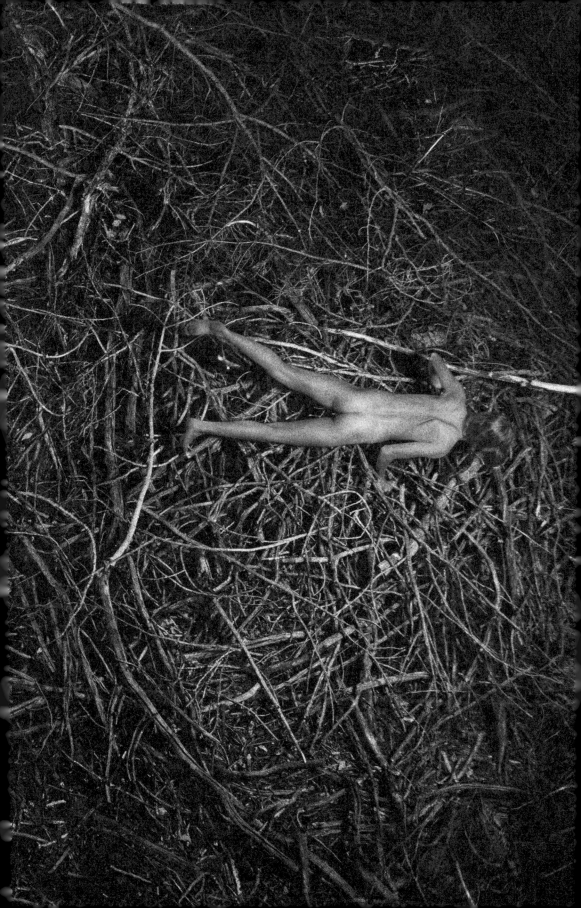

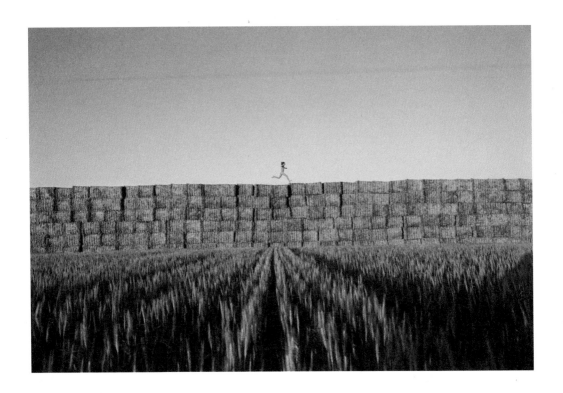

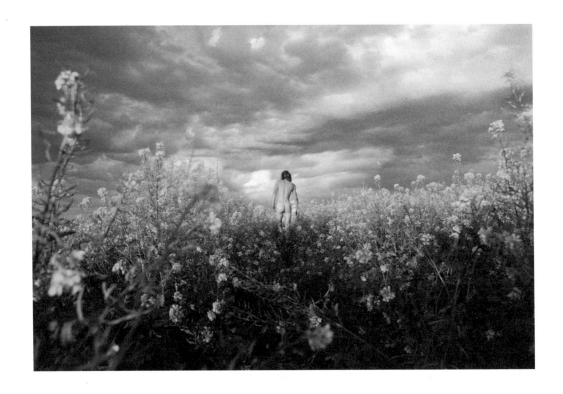

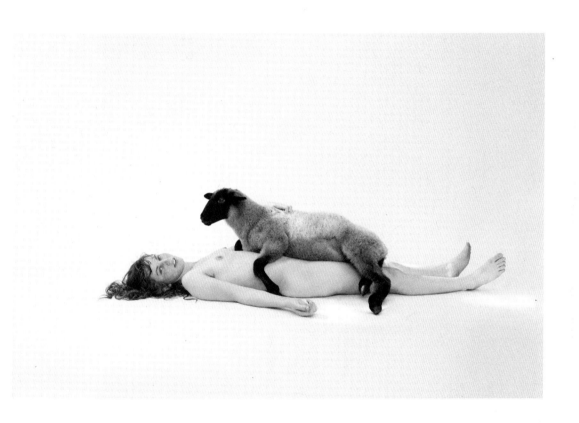

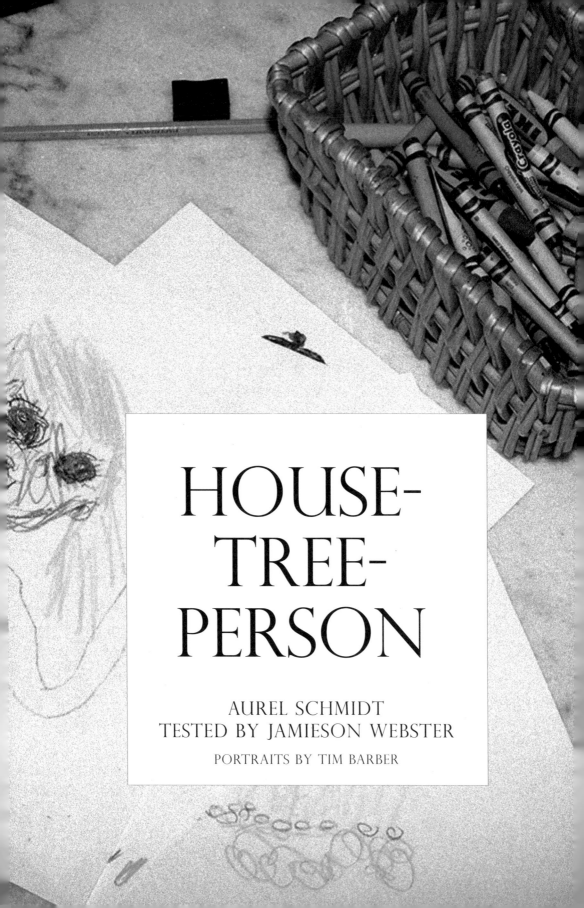

HOUSE-
TREE-
PERSON

AUREL SCHMIDT
TESTED BY JAMIESON WEBSTER

PORTRAITS BY TIM BARBER

AUREL SCHMIDT, 30, MWF, Canadian living in New York, lauded artist who has shown around the world and in the most prestigious institutions and yet, by choice and because she is smart, does not have a gallery but instead flies solo and does what she wants, and who executes heavily detailed, lurid, funny, tragic, and expertly drawn pieces, recently visited the far-west Soho office of…

JAMIESON WEBSTER, PhD, psychoanalyst, psychotherapist, and author of the invigorating book *The Life and Death of Psychoanalysis*, who is both forward-thinking and versed in tradition and focuses in her private practice on the treatment of children and adolescents as well as counseling adults on issues of anxiety, loss/grief, and relationships while at the same time writing on topics such as love and shame, Jacques Lacan, and—along with her husband, the philosopher Simon Critchley—*Hamlet*.

A U R E L C A M E T O Jamieson so that Jamieson could, at the suggestion of this magazine, administer to Aurel the House-Tree-Person test, which is an arguably outmoded diagnostic tool in which the tested makes one drawing of each of the three titular subjects. Is a drawing a projection of one's inner world? That's the hope of the test. Is the mind far more complicated than such a simple process can assess? Probably certainly.

But, still, it's fun to try. Once settled across from each other, Aurel took her time while using crayons on white paper. After the drawings were completed, she moved to the requisite shrink's couch, where Jamieson asked her a series of scripted questions. What follows is a slightly edited transcript of that talk. Along with each drawing, Jamieson has also offered an assessment based on the guidelines of the 350-page House-Tree-Person manual. Please remember that these assessments, while adhering to the gospel of the test, are not necessarily the conclusions that Jamieson would draw in her own therapeutic relationships with her clients. Also note that Jamieson does not administer the H-T-P in her professional practice, and that we subjected Aurel to a slightly simplified version of the traditional H-T-P drawing process.

HOUSE

JAMIESON: How many stories does the house have?
AUREL: Just one.

It looks like there could be one or two. Is there an upstairs?
Oh, *stories*. I thought you meant stories. [*laughs*]

[*laughs*] Stories as in floors.
It has two stories then. It's a real house, in real life.

It's a house that you know?
It's my house. I own this house. It's in Kamloops, British Columbia. It's got a balcony and some spiderwebs under the porch, and rock walls. It's got a pool that's green, and log siding. It's kind of chilly so there's a little fire going, and some smoke. It's got a tin roof that's also green. There's a garden over here and some grass.

Which room does the chimney go into?
The fireplace downstairs.

How long have you lived there?
I've only lived there for three months and three weeks. It's new. But my parents live next door, so this area that it's in is an area that I have deeply rooted in my childhood mind.

You bought a house next door to your parents?
Yes. A trailer. It's a double-wide trailer.

Tell me about the door.
It's supposed to be over here in reality

- Green-Black color combination suggests schizoid-affective reaction patterns.
- Heavy baseline/foundation of house: anxiety and inability to control oppositional tendencies.
- Heavy detailing emphasized around bedroom window suggests preoccupation with intimacy, inaccessibility.
- Accessibility of front door obscured, pathway narrowing and blocked closer to entrance, suggests ambivalence about opening up, withdrawal.
- Smoke from chimney blowing from right to left shows pessimism about the future or preoccupation with the past.
- Window panes indicated by single dissecting vertical line suggest fixation on female genitals.

[*gestures to the drawing*], but when I started drawing it... I don't know, it just looks nice.

And the black on the door is...
It's the horse doorbell. It's a bell that you ring that looks like a horse.

I noticed that when you were finishing the drawing, you added the black at the bottom—the cobwebs.
Yeah. I guess that it makes it a more interesting picture because you can see the dark stuff hidden under the house. I guess I was cheating a little. It's good to have the dark side underneath the house. And there *are* a lot of spiderwebs under there. It's really cool.

What's the weather like in this drawing?
It's crisp.

Where's your room?

The whole house. It's all mine. [*laughs*]

It's one big room?
Well, I didn't draw it correctly. This is like an idea of the house but it's not the correct layout of the house.

You seemed happier with your drawing once you started doing the landscape.
When I was growing up, through my whole life, even into my adulthood… you know how sometimes you have a landscape that you go back to? There are different places you can go where it's always the same. And it's not necessarily what's really there. Well, I would always

have dreams where bad things would be happening, like my parents would be coming after me, and I would run across the street and down into this field and escape. I'd be kind of lucid dreaming. And that field was freedom. In the dream, that's where I was safe. There was never anything bad there. It was also the place where, if I could get there, I knew I was dreaming. And I didn't know I was ever going to buy that property in real life, but that's the property that I bought. So it's kind of cool. Like, I own that field now. It's 25 acres. There's a big field, and the house, and more field. And then it goes down to a river. It's on a cliff.

TREE

Let's talk about your tree.
This is a pine. You might want to know that I just got back from three months in Canada, so everything is about Canada. So this is a pine, kind of at night, kind of not. There are magpies in the tree, and that's a vulture on the top.

What's a magpie?
It's a bird that most people consider a pest, but they're really cool. They're black and white and big, with a long tail, and they steal stuff—they steal garbage—and they make a lot of noise. I have tons of them, like 30 at a time, just hanging on the property.

They steal your garbage?
They're mischievous. And that's a turkey vulture on the top. You can see it has a red head. And, I don't know, that's the story of the tree. It's kind of spooky.

Where is this tree?
Probably on my property. [*laughs*]

Is it an old or a young tree?
It's pretty old. I mean, it's pretty big. I don't know how fast pine grows, but this is probably at least 30 years old.

What's going on here, at the bottom?
It's kind of nighttime. It's just showing shadows and scariness.

Does the tree look more to you like a man or a woman?
A man. It's phallic. Pointy. Red head at the top. Don't you think?

I don't know…
I mean, it's a bit pear-shaped, like a woman. I guess it could be both. Maybe the top is more masculine and the bottom is more feminine.

It's messier on the bottom.
I just wanted it to look good. I knew it

```
▪ Trunk outlined in black,
  heavy lines suggests anxiety
  about control, need to
  maintain stability, and some
  depression related to ego
  weakness.
▪ Animals are a segment of
  the personality that are
  pathologically free from
  control, dissociated from
  more central identity.
  They presumably have some
  destructive potential.
▪ Emphasis or loosening of
  control below the waistline
  of the tree suggests
  preoccupation with the
  genitals.
▪ Shading suggests some
  agitated depression.
▪ Tall and narrow tree
  suggests a tendency to fear
  seeking satisfaction from
  the environment; excessive
  fantasy; feelings of not
  having large structure for
  support; feeling alone and
  without a strong base.
```

would look cooler if it was messier. And also I get really bored drawing trees.

And what's the weather like in this one?
Crisp, again.

Does the tree remind you of anything other than a tree?
It's a little spooky. Like, haunted. Like *Antichrist*. Do you know? Like that movie.

Mm-hmm.
A little like that. A little bit. The vulture is a scavenger. He's watching over the landscape from the top.

"Nature is Satan's church."
Nature is pretty brutal. It's shocking how brutal it is and how many things are dying or dead all the time. It shows how fast things disintegrate and die. It's really kind of awful. But it's cool. It's just scary, I guess. It makes you think of your own death.

PERSON

How old is she?
Thirty.

Tell me about her.
It's me. [*laughs*] It's me, drunk, waving at some friends.

What were you thinking about when you were drawing her?
I've been thinking that I'm struggling thinking about which things I want to prioritize. Part of me is still caught up in social life and wanting to be with my friends and that can be destructive in the face of wanting to get a lot of work done. So this is partially about wanting to have fun and it's partially monstrous because I'm not sure. It's kind of out of control. Maybe this is about being afraid of drinking because then I'd have a hangover. I guess it's something I have a weird relationship with. It's something that I'm not sure I want in my life, but it's something that still has some control over me.

If you separate what you're thinking about right now from the figure in the picture, can you tell me what *she's* thinking?
She's probably like, "Does anyone have any coke?" And she's probably kind of horny and happy and sloppy. She's excited to see her friends.

You didn't put your glasses on her.
Usually when I draw pictures of myself, I'm naked and there are no glasses. I don't see my glasses, because I'm wearing them. So I don't always think to draw them in. And I don't necessarily want to wear glasses or think of myself as a glasses-wearing person. My drawings will be naked because it's supposed to be my inner self, not my physical self in real life. She's a symbol of my self—not *really* my self.

- Red suggests a need for warmth.
- Paper-chopped drawings at bottom of page suggest a need for support/depression. Bottom half of person is chopped in an act of erasure with regard to genitals, an act of suppression to maintain integrity. As well, the erasure of legs represents a lack of autonomy or loss of autonomy.
- Emphasis on orality and oral-seeking satisfaction related to maternal dependence and feelings of immaturity; displacement from genital to mouth.
- Cartoonlike appearance shows self-deprecatory attitude.
- Ears emphasized suggests sensitivity to criticism.
- Movement shown in drawing suggests inner turbulence.
- Nudity: rebellion, exhibitionism, or awareness of sexual conflict.

You drew her eyes first. I thought that they were going to be breasts.
Really? I guess eyes can look like breasts. If the boobs are round, with black dots for nipples.

Is this person well or unwell?
Well.

What is it about her that gives you that impression?
She's happy. She's up. She's waving. She's smiling.

What is the weather like in the picture?
Probably dank. Dark and dank, like at a bar.

And what does this person need most?
Love. 🐾

JIMMY DE SANA, *UNTITLED*, FROM THE
SERIES "DUNGEON PHOTOS," 1977-78.
ALL PHOTOS COURTESY THE JIMMY DE
SANA TRUST AND FALES LIBRARY, NYU.

DIS

CIPLINE

THE LOST COLLABORATION OF TERENCE SELLERS AND JIMMY DE SANA

BY JOHANNA FATEMAN
PHOTOGRAPHS BY JIMMY DE SANA

In 1977, the twenty-four-year-old writer Terence Sellers worked in a dungeon—that is, a one-bedroom apartment in a high-rise on East 51st Street in Manhattan. →

Photographs from that year and the next, shot by Jimmy De Sana in his signature amateurish style, show a small room with wall-to-wall carpeting and floor-to-ceiling mirrors, overwhelmed by a rough wooden bondage table. Sellers appears in an equestrian costume with stiletto boots, or a leather skirt and heels with delicate straps, but her face is rarely in the frame. Instead, we note the position of her legs or the angle of a riding crop and, especially, the creative predicaments of her submissive clients.

"I used to think Jimmy was like Warhol," she told me in a recent email, "He was ultra-cool, and often had only bland things to say. But somehow he would incite all kinds of crazed activity." When Sellers was in the mood to be photographed at the dungeon, and had a willing slave on hand, she writes, "I'd call Jimmy, he'd come to my setup, take dozens of photos and go… He was a silent witness, and the activity gratified us both."

The curiously intimate black-and-white photographs capture a moment when the interests of two very different artists aligned. For De Sana, this work was an evolution of themes already apparent in his 1972 proto-punk snapshot series "101 Nudes," in which he depicted the unglamorous nudity of friends and acquaintances in and around his family's suburban home. For Sellers, these sado-masochistic vignettes were meant to be illustrations in her first—and what would become her most famous—novel, *The Correct Sadist.*

Things did not turn out as Sellers planned. But, as she writes in her 1998 essay "Famous Versus Infamous," a striking account of her brief collaboration with De Sana, "Nothing creative is ever wasted, as long as you keep good files." I discovered De Sana's "Dungeon Photos" from 1977-78 in Sellers's excellent files, housed in the Downtown Collection of the Fales Library at NYU—along with

JIMMY DE SANA, ABOVE: *PLIERS*. AT RIGHT: *ROPE*. BOTH FROM THE SERIES "SUBMISSION," 1977-78.

JIMMY DE SANA, *UNTITLED*,
FROM THE SERIES
"DUNGEON PHOTOS,"
1977-78.

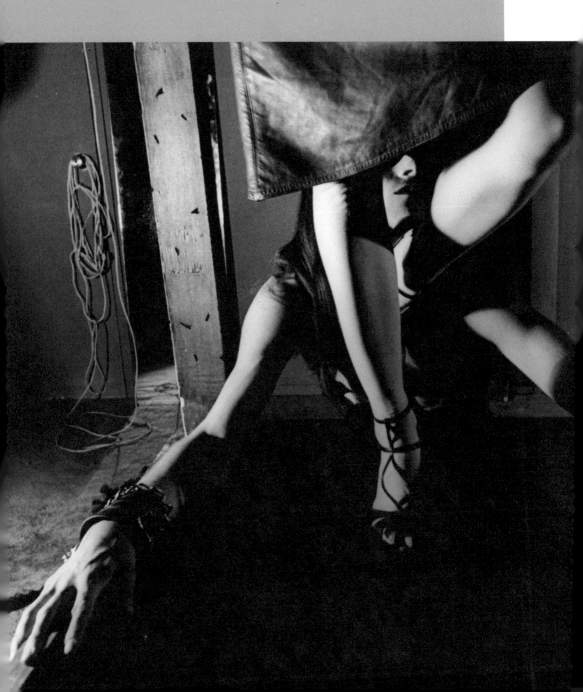

the other fascinating *Sadist*-era material that she diligently saved.

Her archived journals, written in her romantic script, contain drafts of works-in-progress, charts of daily tarot-card readings, detailed accounts of her studies and travels, and eloquent handwringing over both her literary career and her relationship with the painter Duncan Hannah. Her meticulous correspondence files include photocopies of her outgoing mail—notably her cackling missives to experimental author Kathy Acker. In one letter from the summer of 1980, full of both lighthearted gossip and barbed descriptions of their New York social world, Sellers instructs Acker, "Forget the shit of the art scene, the literary poseurs that make you wish you didn't understand English. You think, 'These are my contemporaries—we have something in common'… It's a lie."

Sellers is not one of the scene's best-known figures (artist-provocateur David Wojnarowicz and musician-poet Richard Hell are among the Downtown Collection's bigger names), but she was both an ardent critic of it and an accomplished participant. Sellers acted in Amos Poe's grainy, meandering, 1978 classic of No Wave cinema *The Foreigner*; and she read her work at the "The Times Square Show," the massive 1980 exhibition mounted in a former massage parlor by the artist group Colab. Her art world—experimental, cross-disciplinary, and inflected by punk—flourished in Soho loft buildings, Tribeca clubs, and Lower East Side galleries, but was shortly decimated by AIDS. De Sana succumbed to the disease in 1990; he was 40.

Sellers writes in "Famous Versus Infamous" that while De Sana photographed her at work in the late 70s—as she whipped a cross-dressed slave or threatened an eyelid with a lit cigarette—she had a "spiritually correct nausea" against selling her art: Her work as a dominatrix funded her literary efforts. But it also provided

the material for her book, which she be-
gan as a diary the morning after her first
night at the dungeon.

Initially self-published in 1982, *The
Correct Sadist* is part instructional manual
and part manifesto, packaged as a fictive
memoir. It's bookended by dark, first-
person reflections, but composed mostly of
sample scripts between mistress and slave,
such as "Coprophagi & Urinology: Filth
Dialogue" (which begins with the ques-
tion *"How many gallons can you drink?"*), and
concise, expository chapters with titles
like "The Penis as Torture Device" and
"The Shoe."

Sellers's practical advice is nuanced—for
choosing a method of bondage, she notes
that "a dull steel shackle and chain is rath-
er comic and theatrical," while "a dirty,
greasy, hemp rope evokes a more nasty,
butch atmosphere." Interwoven with such
observations is her compassionate, often
humorous, and well-argued analysis of the
masochist's psychology. Her lofty, expres-
sive prose engages a history of sadomas-
ochistic literature (Victorian psychiatric
theory as well as Sadean philosophy), but
with *Sadist*, Sellers contributes something
new to the tradition—the viewpoint of an
unapologetic sex worker.

From the novel's imperious tone, one
would never guess at Sellers's vulnerabil-
ity during its writing, but she explains in
"Famous Versus Infamous" that as her col-
laboration with De Sana grew, the photos
began to take on "a talismanic power."
She felt she needed him. In his studio
and in his boyfriend's apartment, she and
De Sana made household objects into re-
straints or torture devices—in the photo-
graph *String*, packing twine traps a masked
slave in the lotus position, his erection
poking through his cat's-cradle bondage.
They took that same slave—Marco—to
the beach, where Sellers trained him as a
pony and punished him on the sand. In
Auto, Marco is splayed out on his back,
bound to the roof of a car, the stately foliage

JIMMY DE SANA, *UNTITLED*,
FROM THE SERIES
"DUNGEON PHOTOS,"
1977-78.

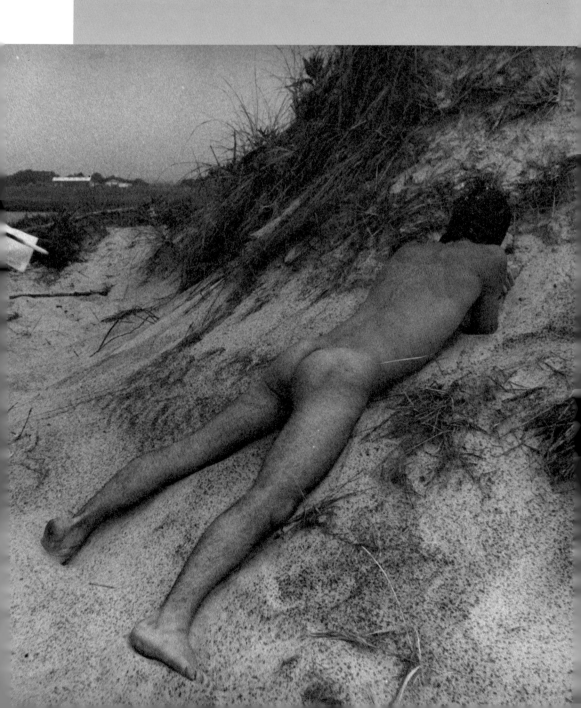

of East Hampton in the background. As they worked, Sellers suppressed her anticommercial nausea: She believed that De Sana's photographs, and his art-world connections, could sell her book.

They didn't. The betrayal began, she says, with good news. De Sana had shown William S. Burroughs the pictures, and the legendary writer was so impressed that he promised to write an introduction to the book. For a time, Sellers basked in her implied, anticipated, and unbelievably prestigious association with the Beat Generation's icon of bohemian deviance. While she didn't list his 1953 autobiographical novel *Junky* in her canon when I asked her about the works that influenced *The Correct Sadist*, I found, in one of her journals, that she reread it during her years working in the 51st Street dungeon. Though unlike in style and in structure, *Sadist* shares with *Junky* its confessional mode and, more profoundly, its romantic notion of an outcast status as an innate quality of the antiheroic temperament—as well as a superior aesthetic position.

But Burroughs held sway over Sellers not only for any bearing his work had on her own but because he was famous. As she writes in "Famous Versus Infamous," Burroughs signified, to the then 25-year-old Sellers, "ultimate New York hipness." But recalling this radiant phase is, she explains, "especially degrading," because within a few weeks the catch was revealed: De Sana told her that Burroughs did not want there to be any text—aside from his introduction—in the book.

In response to her ousting from the project, Sellers writes in "Famous Versus Infamous" that she "became savage." She invoiced De Sana for her work at the going rate at the dungeon ($75 per hour), and she wrote a three-page poison-pen letter to him, which she photocopied and distributed to everyone she could. Twenty years later, smoothly punk in the age of the internet, she laid out the text of "Famous Versus Infamous" over the photographs that De Sana had cut from the project and posted the illustrated essay as a PDF on her website.

In it, she does not mince words about the devastating episode, though, interestingly, her special rage is reserved for Burroughs. Perhaps De Sana, her friend, she found guilty of a somehow understandable careerism. But regarding the dismissal of her text by Burroughs, she writes—with a disgust not dampened by her concession that she can't be sure he read the manuscript—that she was naive to think for a moment that "the famous man" would compose an introduction to her work. After all, she was an "unknown, young, female, 'sex worker,' professional sadist, weirdo, nobody, downtowner—who besides had cluelessly worked for NOTHING."

Sellers shies away from calling Burroughs a misogynist ("It's a cliché with regard to his accidentally shooting his wife and being homosexual," she writes in an email), but she goes on to call him something that's perhaps, to her mind, worse: "utterly bourgeois." She believes that her work was rejected because she was a sex worker. The slight was a revelation because, as she saw it, "those famous outsiders, so-called non-conformist bohemians... Even they loved to trash a whore."

De Sana's 1978 book *Submission* begins with a cursory, forgettable two paragraphs by Burroughs. The text by Sellers, and the photographs in which she appears, are not included, and she is uncredited in the book, though she claims De Sana used some of the shots that she styled. Yet—unfortunate backstory aside—De Sana's book is remarkable. Most of the photographs he selected depict the masochist in isolation, unhinged from the narrative of a sadomasochistic tryst, abandoned. Without Sellers, or any dominant female figure in the book, it is, for better or worse, more abject, more surreal—and more gay.

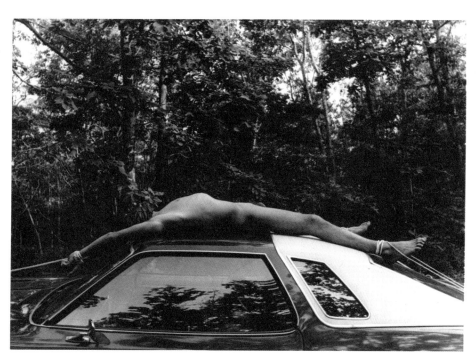

JIMMY DE SANA, *AUTO*, FROM THE SERIES "SUBMISSION," 1977-78.

The group of photographs is less slick than Mapplethorpe's S/M series also from 1978. *Submission,* with its humble production values and sometimes makeshift, domestic bondage scenarios, seems not to depict the practices of a subculture, but, rather, lonely compulsion. Sellers, noting another quality of the work, identifies how De Sana's aims diverged from her own: "Somehow I was absorbed into this zeitgeist, which became a trademark of Jimmy's," she writes in "Famous Versus Infamous," "When I look at Marco stretched over the car's glossy flank like a slain deer, it strikes me as more of a comment on economics, than on sexual perversion…" In De Sana's photographs we see the decidedly uncommercial seeds of what would become a winning trope of 90s (and beyond) art/fashion photography— a scene of consumer luxury that comes alive with a signifier of sexual deviance, or just a whiff of abjection.

While Sellers says, in light of Burroughs's mediocre introduction, that De Sana would have done better with her, in truth they both did better on their own. *The Correct Sadist* attained cult success without the photos, on the strength of her writing and the novelty of her perspective. A year after Sellers printed it with her own savings, it was picked up by Grove Press, and she found publishers for UK, Italian, and German editions. I asked Sellers whether the incident—De Sana's betrayal and Burroughs's slight—affirmed her in some way. She writes in *Sadist,* after all, recalling her school days, that she "took as a mark of distinction the scornful treatment, jibes and petty snubs I received." Sellers responded with a line from Sartre's protagonist in the play *The Devil and the Good Lord,* whom he based on one of her heroes, the great outcast Genet: "Reject this world that rejects you. Turn to evil; see how light-hearted you feel." 🐾

ZURICH WEST

PHOTOGRAPHS BY ROE ETHRIDGE

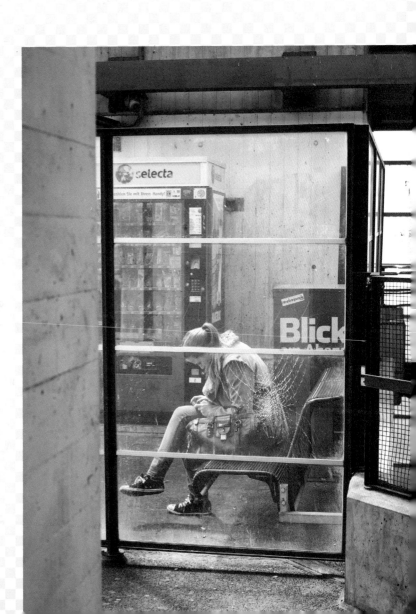

Für Ihre Sicherheit

10

Achtung!
Hundewache

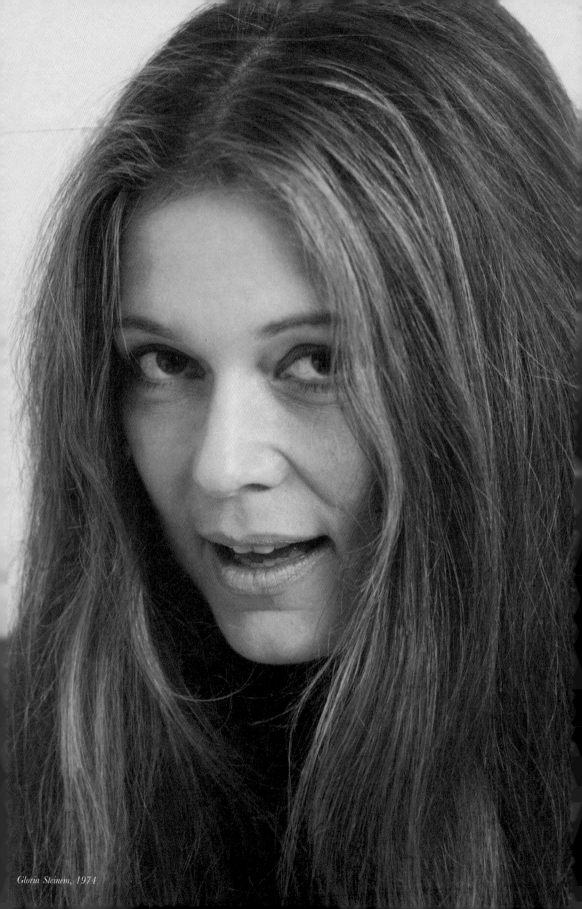
Gloria Steinem, 1974

QUESTIONS FOR GLORIA STEINEM

BY FREDERICK EXLEY

Frederick Exley's 1968 novel, *A Fan's Notes*, belongs to the noble, small, and sort of sad pantheon of great later-20th-century writings that—though underappreciated on their release—became cult classics. Along with John Kennedy Toole's *A Confederacy of Dunces*, Leonard Gardner's *Fat City*, and anything by Gina Berriault, Exley's debut novel deserves as vast an audience as any canonical work from the same era. But it just never happened. →

How and why a great book becomes a cult book is not the question here, though it's a good one for another story. To be quick about it, the usual path is that other writers pick up on something that's too raw, too quick, too bleak and funny, and maybe too pained for a mass audience (*A Fan's Notes* is all of these things), and those writers foster that book, nurture it, talk it up, pass it around like a brood of hens caring for an abandoned egg. Eventually it hatches, they nudge it out of the nest, and it's grown into a very special, unexpected bird with weird plumage and a call all its own. Bird aficionados—careful readers, in this case, if I can get myself out of this metaphor—hear about it and become the second circle of enthusiasm for it, and they pass it on in, ideally, widening gyres each time.

Exley followed up *A Fan's Notes* with two more books: 1975's *Pages from a Cold Island* and 1988's *Last Notes from Home*. Note the gaps in time. Exley was troubled: a heavy drinker and a lonely man with that rough mix of arrogance and insecurity that so many writers have. Maybe this contradictory nature was stronger in him because he truly was capable of greatness and he truly was unappreciated in his time. He died in 1992 at age 63, one day after suffering a stroke at home, alone. The cover of the first edition of *A Fan's Notes* features the caveat "A Fictional Memoir." All three of his books are that way. Drawn from life, diaristic, full of association and musing. Sometimes his work reads more like a treatise on modern masculinity and isolation than as a *novel* novel.

An extended passage in *Pages from a Cold Island* deals with Exley's fascination with Gloria Steinem. Steinem, for Exley, was an emblem of much more than her pioneering feminism. For him, she represented a journey through the 1960s that was a total inversion of his own. "If I had entered the Sixties more given to dark derogation than to joyous celebration," Exley wrote, "I'd at least been an articulate, relatively hopeful creature. But I had crawled out of the period on my knees, a simpering, stuttering, drunken and mute mess." In Steinem (who, like him, was

a child of the Great Depression), Exley saw someone who had "come out of the putrid years so splendidly, refusing to live a disappointed life." She represented a mode of life that could have been his—but wasn't.

In *Pages*, Exley writes that he was on the brink of suicide—with a borrowed .22 pistol in hand—when the thought of Steinem, along with the horror that comes from standing in a shower stall with a gun in your mouth, propelled Exley over the hump. And so he set out to interview her for his book, to find out who she was as a person—apart from her cause. In response to his request, Steinem asked Exley just what he wanted to talk to her about. Exley, drunk, rambled into a tape recorder for 30 minutes and mailed the cassette off to her. He was, he wrote, later mortified by cloudy recollections of what was on that tape. But before too long, Steinem let him know she'd be in Florida for a speaking engagement and he could come down there from his home in Watertown, New York, if he wanted to speak to her. He set off for Miami, armed with a sheaf of typewritten questions. On meeting her, he wrote, he "fell totally, dizzyingly in love with [her] almost immediately."

His questions are what we have for you to read here. Taken together, they constitute a classic, lost Exley short story. Their tone is conflicted. They are by turns cajoling, self-deprecating, self-aggrandizing, flirtatious, chivalrous, insulting, and condescending. They betray Exley's desire for Steinem, as well as his dismissive and perhaps jealous feelings about the elite intelligentsia of New York at the time. He had been a part of that scene as it burgeoned, when he lived there as a young writer, drinking at the Lion's Head in the West Village and hanging around with other writers. But Exley's demons intervened, and he fled the scene to a solitary life upstate. He speaks to Steinem in these questions as an outsider who was once an insider, a man who perhaps begrudges the other men who live in that world. In these questions, we see Fred Exley doing what he often did in his work: trying to puzzle out just where things had gone wrong. —Jesse Pearson

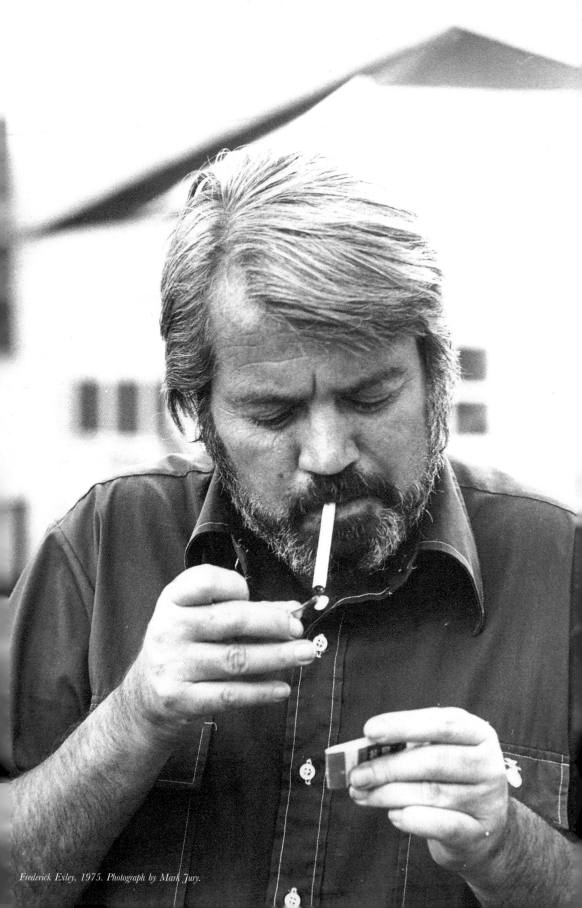

Frederick Exley, 1975. Photograph by Mark Jury.

—1—

I'm not clever, I'm not charming, I'm not a trained reporter; believing in nothing I occasionally wax eloquently on behalf of causes which mean not a fucking thing to me; therefore if you take offense at anything I say I'm going to ask you please not to withdraw, to clear the air with me, and accept as absolutely true that what I'm feeding you is pure and simple rhetoric in an attempt to find out who you are, not <u>who you imagine you are</u>. Please believe also that ... I admire what you're doing too much to willfully hurt you, which is not to say I might not have some fun at your expense—I mean I've already written the lead paragraphs to this, detailing my efforts to get you in this room, this day, and I think they're the funniest thing I've yet written. I'm genuinely and unalterably committed to offsetting the kind of thinking that runs through this quote from a friend of yours: "Steinem's accomplishment consists of absolutely nothing more than sleeping with the right men at the right time." Obviously if I believed that I wouldn't be here wasting your time and mine. Further I'm committed, if you permit me, to efface this kind of thing!

—2—

In both the *Newsweek* and the *Esquire* pieces it's implied that you profess naivete as to why anyone would be interested in you, that is, you wouldn't pose for a cover of *Newsweek* and wouldn't talk with *Esquire's* Levitt until it became apparent that he was going to do the piece with or without you. Recently I heard a movie actress on one of the talk shows say that at a Hollywood costume party half the starlets who attended came dressed as Steinem—whatever the fuck that means. On another talk show Harriet Van Horne, a woman I admire very much, said that you were the woman she most admired in America. At the press conference at which you announced the impending publication of *Ms.* I read there was standing room only. Certainly, then, you must appreciate that as of December 2, 1971, you are, for lack of a better word, one of the most quote-notorious-unquote women in America—and I mean to both men and women—envied, damned, adored, and cursed by turns. In light of this don't you think your surprise at your prominence is 1) unbecoming if not phony and 2) isn't that what you've thirsted after all these years? If for no other reason than that you've now reached an eminence whereby you can help effect the changes you want to see effected in this country?

—3—

Many months ago, in your miniskirt days, I once saw you in the Lion's Head and when Pete or Joe or somebody asked if I'd like to meet you I said, "What the fuck for?" I'm sorry I said that. A few weeks ago I saw you—even switched from the 49ers game to do so—on *The Loyal Opposition: A Democratic Reformation* and at the risk of appearing to fawn,

and looks aside, I thought you the most forceful personality on the panel and I was immediately struck with the notion that as you are yet in your mid-thirties, in twenty years you will be only in your mid-fifties, and I'm not being in the least facetious when I say this, I was struck with the thought that if I saw a woman president in my lifetime it would be you. Care to comment?

—4—

Here are two asides that you can comment on or not:

1) Get contact lenses for TV. You not only looked myopic but at times you appeared to be exuding nothing less than a censorious scowl and

2) Mary Lou Burg doesn't like you.

When you were introduced you were introduced as a writer first and I thought I definitely detected a self-mocking self-effacing smile. Was that my imagination?

I've already written this scene but my set is black and white. Would you describe the dress you were wearing?

—5—

Believe me when I say that I'm not trying to bait you but I want to get this out of the way and it's truly something I know nothing about. Can you describe the outfit you arrived in this morning, tell me what you intend to wear tonight, tell me things like who does your hair, what your makeup consists of—I mean Greer recommends Aziza for the eyes and homemade perfumes from spirits of camphor, oil of cloves, crumbled lavender—I like that—patchouli—whatever the fuck that is—that you act as your own coiffure, etc.

How much do you spend a year for clothes and have you ever accepted clothes from a designer who may have been trying to get his creations seen in the quote right places unquote?

You told *Vogue* that anybody who spends more than fifteen minutes making up is fucking herself. C'mon, Gloria?

How tall are you and what do you weigh? You stuffed your Bunny's costume with athletic sox. Are you small breasted?

—6—

I'd like to get an idea of what your pace is like by, say, having you tell me what you've done since last Sunday, beginning with last Sunday morning going through last night, where you spoke, what the turnout was like—incidentally is $750 an accurate fee and does half of it still go to Women's Lib—what you try to tell the kids, everything that happened in the three days preceding your sitting down in this hotel room with me, and ending with precisely what is taking place tonight, the where of it, the why of it, etc. In other words my writer's instinct tells me I want to end this describing what you're wearing tonight

whether I see you in it or not—I'll take the liberty—while you go off and do those things you have to do while I in turn go back to my fleabag hotel on Singer Island, crawl into bed, stare at the ceiling, and hopefully try to come to some kind of artistic structure out of what I've seen and heard here today. Okay.

—7—

Let's go back to Toledo. You were born to Leo and Ruth Nuneviller Steinem on March 25, 1934 or 1936? To describe your childhood I've read "child of an industrial slum," "the poorest house on the block," "similar to *Augie March*." Tell me what the neighborhood was called as, for example, the Throggs Neck section of the Bronx, what the industries were, what your house was like, your schools, your classmates, things that stand out in your mind—I mean I want to smell your existence. I haven't read Augie in years but it's still as poignant to me as the odor of decaying fish, Granma, Mama, Simon, Georgie the idiot, and so forth. I happen to think Augie and Mama's taking Georgie to the institution on the streetcar, Granma who had insisted on it and locked up in her room refusing to come out and say good-bye, to see what she had wrought in other words, Augie going to the Army and Navy store to get poor Georgie a little Gladstone bag and teaching him how to work the locks because Augie wanted Georgie as he went from place to place to be, I believe it was, "somewhat a master of his own," then finally at the institution Georgie's wail when he realizes that they are to leave him and how Mama takes him by the "hair of his very special head" to comfort him—happen to think it one of the very great scenes in American fiction—something your old buddy Norman won't live long enough to write—and this is what I want to try and get from you.

Both parents educated—why so poor? Things like what was a treat by way of food, entertainment. What were the bad things?

—8—

Your elementary and secondary education. You were obviously always bright but were you always a good student? Dicky Boeth implies that when you joined your sister in Washington some miraculous transformation occurred, that everyone sat around reading Dostoyevski together while at that same period in my life, quite frankly, all one worried about was who was going to win the game on Friday night and which cheerleader would one dry fuck—do you know what I mean by that expression?—after the game. In other words aren't you perhaps toying with history?

Levitt says that you left Toledo during your senior year. Wasn't that somewhat traumatic? I mean, I can remember parents of some of my schoolmates moving away at that late stage and leaving their children with friends so that they might finish school with their classmates. What was your proudest accomplishment to this date?

Surely not what you gave Levitt—third place in the Miss Capehart TV contest at 14—what is that?—and that as a teenager you danced at the Eagles club!

—9—

Mrs. Joseph Pauline Steinem. Do you remember her at all and what influence do you think she had on you? I mean, my father was a great minor athlete, and as a child I can remember reading through the stacks of scrapbooks that had been kept for him by his mother, so that even today, and I haven't seen those scrapbooks in well over 20 years, I can tell you in some detail of his accomplishments.

—10—

Can we talk about Leo Steinem? Guinzburg is quoted thusly: "It was a most complex relationship of which we are all the beneficiaries." I don't understand that at all. If he'd said, "It was a very simple father-daughter relationship, they loved each other unreservedly and we are all the beneficiaries," I'd be able to understand that. But to Leo—what prompted your adoration? What about this gypsy-like existence in the early years of your life? What did he sell, where did you go, how? ITINERANT ANTIQUE DEALER.

—11—

Neither piece mentions much about your sister or her family save that she has six children and Chotzinoff claims she had given up a career for that family and further implied that you were always haunted by the vision of her being saddled with her family. Is that fair, and can we elaborate? I mean, when you think in terms of "family," do you think of her and her husband and the children? Is that where you go for holidays and so forth?

—12—

For reasons which will become clear only when you read this, I want very much to try to get the feeling, the colors, the odors, everything I can about your career at Smith, doing so by concentrating on your senior year, the girl or girls you lived with and where, what their ambitions were, what you talked about in the wee hours, what professors you admired and why, whether you worked to supplement your scholarship, what you did for fun, whether you were ever made conscious of being an itinerant salesman's daughter surrounded by wealthier girls, whether college bored you as it so often bores bright students, the kind of things you wore in the mid-50s, the songs that were the rage, anything that stands out that will help me understand who Steinem was in the academic year of 55-56.

—13—

We cannot discuss your senior year without talking about Blair Chotzinoff. Was this your first affair? Though I'm not so interested in that as in discovering whether your first fuck was entered into voluntarily, without modesty or a premonition of guilt, with in other words a certain amount of joyous exuberance or whether it was the type of thing the movement now decries, that is a kind of passive, lethargic, might-as-well-fuck-and-get-it-over type thing.

　　Incidentally, is Chotzinoff some kind of clown?

—14—

Greer remarks some place that if a woman is not docile, that is, if she never suggests to a man she is in any way tameable, she never has any trouble breaking off with men as she's never suggested to them that she was theirs in the first place; you are quoted to the effect that you despise your past passivity. Jane O'Reilly also claims that you have been too passive with men and adjusted yourself to their image of you, that you have at least surfacely been tamed, yet you seem to have had very little trouble breaking off with men. How do you account for that—are they just sick of you?

—15—

It appeals to the writer in me that you came to New York City in 1960, the year of John Kennedy's election to the presidency, that you came to the capital of the world—where, as they used to say, it's all happening—totally unknown at the beginning of the decade, a decade that began with infinite promise but that ended, I would guess, breaking as many people—as witness me—as those like yourself who had the resiliency to endure and come out of the decade a better, more committed person than you went into it—in your case nothing less than a rise from utter obscurity to national eminence—a decade of great excitement to be sure, a decade of rubbish, one of violence, one of revolution, a decade of almost immeasurable grief, this the Kennedy Decade and I want very very much to talk about Steinem in the 60s with special reference to the impact the Kennedys made on you as one American beginning with the president's assassination on November 22, 1963, telling me what your lifestyle was at the time, where you lived, what you were doing for laughs, the lifestyle, I repeat, then tell me all you can remember about where you were when you heard about the assassination, what you were doing at the time, what your immediate reaction was as well as the long-term reaction, and so forth. Shall we begin? 🐾

AT HOME WITH JOHN ASHBERY

AS TOLD TO
ROBERT POLITO AND
KARIN ROFFMAN

PHOTOGRAPHS BY
BRIAN DeRAN

JOHN ASHBERY is America's greatest living poet, and that's a quantifiable fact—if prizes can be used to gauge such things. Ashbery has won the Pulitzer, the National Book Award, a Guggenheim Fellowship, and more. He's received official accolades beyond counting, really, starting with the publication of his second collection, 1956's *Some Trees*, which took the Yale Younger Poets Prize.

But prizes aren't what matters. The work is the thing, and Ashbery, over the course of seven decades writing, has built an oeuvre that is vivid beyond imagining. A revolutionary in form and in language, an iconoclast and an experimentalist to the core, Ashbery has

always written poetry that stands up, radical and daring, next to anything being produced by the generations that have followed him. As poetry has wound and twisted through movement after movement, Ashbery has remained a constant source of surprise and beauty. Free, playful, funny, filled with reference and complication, his poems challenge us—they sometimes even baffle us—but they never sacrifice the pure thrilling

mastery of language that reminds us that we're dealing with the real thing—a poet to the bone, a vessel for the cosmic muse.

Recently, *Apology* had the chance to visit Ashbery at his home in Hudson, New York. He lives with his longtime partner David Kermani in a stone and clapboard house that faces a small park.

Their home is full of art and objects that have been collected by the pair over the years. It's a gathering of such interesting things with such great stories behind them that the New School in Manhattan is currently in the midst of a project that will document and catalog all of it. We sat, first in the downstairs music room and later in an upstairs sitting room, with Robert Polito, the head of the writing department at the New School and the steward of the Ashbery cataloguing project; Karin Roffman, who is currently at work on a biography of Ashbery; Kermani, and, of course, John Ashbery himself. We spent the afternoon listening to stories from him about some of his favorite things. Before we get to them, however, let's hear some thoughts from Robert and Karin...

ROBERT POLITO

ASHLAB is an ongoing project at the New School that proposes a digital mapping of John Ashbery's Hudson house via his work—and the reverse: a digital mapping of his work via that Hudson house. I conceptualized ASHLAB during the fall of 2011, after conversations with the generous, gracious, and resourceful David Kermani, and launched a multiyear sequence of courses with an expert instructional team composed of two brilliant poets, Tom Healy and Adam Fitzgerald, and a genius information and interaction designer, Irwin Chen. Our students work on various Ashbery-inspired operations—annotating objects in the house, such as paintings, curios, architecture, and mementos; anthologizing and annotating poems according to various subjects and themes, such as music, childhood, art, cinema, games, architecture, or nature; and defining and mapping routes through the house and work, his prose as well as his poetry. The courses are inherently multidisciplinary, drawing graduate students and undergraduates from across the New School—the Writing Program, Parsons, Media Studies, and the Riggio Honors Program: Writing & Democracy. How is it possible, these courses ask, to archive and map the interiors of (arguably) America's most important and influential living poet, John Ashbery? I've come to think of our adventure as spanning three houses simultaneously—a literal house upstate overflowing with objects, art, people, and continuing production; a virtual house, someday to reside on the internet, where students and faculty will represent, document, and annotate those objects, art, biographies, and artistic productions; and finally a sort of metaphoric house, accommodating Ashbery's digital archive, with many routes leading from and into Paris, nineteenth-century upstate New York, and twentieth-century painting, music, literature, and film. ASHLAB in that respect can be approached as a Memory Palace, in homage to those imaginary spaces Renaissance philosophers such as Giordano Bruno or the Jesuit missionary Matteo Ricci, advanced for storing and retrieving memories from visualized locations along chains of resonant associations.

KARIN ROFFMAN

My work on John Ashbery's biography began in 2005 as a project on Ashbery as a poet and collector in his Hudson house. I knew Ashbery only from his poems and so, like many other first-time visitors to his home, I was quite surprised to discover that this very contemporary poet lived in a dark and gloomy 1894 Victorian. In 2009 I received an NEH Summer Stipend to deepen my research and writing on the house, and it was during that summer of interviewing Ashbery and David Kermani on the provenance and history of objects and collections that I also, without initially realizing it, began to research my book on Ashbery's early life. Everybody's home is autobiographical in some way; Ashbery's much more than most. His numerous and eclectic collections are personal, carefully chosen and artfully arranged—often most when they don't seem to be—and assembled from a combination of objects his parents and grandparents once owned, works his artist friends gave him, accidental discoveries (including things abandoned by the family who originally owned the house), and Ashbery's own purchases. The house is both a sly performance of autobiography and—since he really lives in it, uses it, loves it, alters it, and is inspired by it—a practice of it. It is the only home Ashbery has ever owned and is the realization of a process and practice of collecting and thinking about decorating houses that he began as a young boy living on a farm in upstate New York. At 13, he spent long days antique-hunting with his great friend Mary, explored old houses with his childhood playmate Carol, borrowed books on decorating from family friends, and lay each night on his twin bed conjuring in his mind all his plans for the kind of physical, emotional, and imaginative environment he hoped one day to create and inhabit.

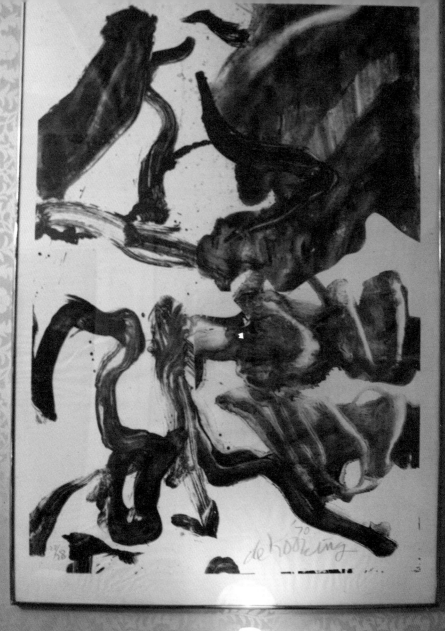

|6|

|2|

|2|

|4|

|7|

JOHN ASHBERY: |1| I got this in Paris. It's Daum. Nancy, France, is where the Daum glassworks is, so people always say "Daum Nancy" together. My friend James Schuyler once wrote a poem called "Who is Nancy Daum?"

Anyway, I think that Daum is still in business. They're particularly renowned for their Art Nouveau period. This is obviously a winter scene, with the sort-of sickly winter sun setting in the right. There's also another socket in it, which lights up the base of the lamp, but I've never been able to find a bulb to fit it. I used to have one I got in France, but I don't think they make them here.

I lived in France for about ten years. 1955 to '65. I had a Fulbright for one year, then it was renewed for a second year. Then I actually came back to New York and took some graduate courses in French at NYU, with the idea of going back and doing a dissertation on Raymond Roussel, a writer I had discovered thanks to my friend Kenneth Koch. And I did a lot of work on that before realizing I didn't really want a PhD—I just wanted to live in Paris.

I had very little money all the time I was in Paris, so I couldn't buy any of the lovely objects I would see in store windows. And I never thought I was going to come back with more money. I had just enough to barely live. But then I went back in the fall of '68 for three months; I had a Guggenheim Fellowship and a little extra cash, so I picked up a few things—including this lamp. It was in an antique store, I think on the Boulevard Saint-Germain near Saint-Germain-des-Prés. There was another very beautiful lamp there that I could have gotten, by a lesser-known glassmaker called Muller. The base was all glass mosaic and the shade was blue and yellow. It was really beautiful. But I guess I thought that Muller wasn't famous enough. [*laughs*] So I bought this one instead.

|2| I've always been interested in trompe l'oeil objects, like this dish with a faux nutcracker and walnuts and that other one which has a dice cup and dice, which was given to me by a wonderfully eccentric old English lady who lived in Hudson when we first were here. Her name was Edith Lutyens Bel Geddes. She had been married to the designer Norman Bel Geddes. She reminded me of Madame Arcati in the Noel Coward play *Blithe Spirit.*

|3| This was given to me by de Kooning, I believe, via his dealer. I was an editor at *Art News* for a number of years, and I wrote an article about de Kooning's lithographs, which he didn't do many of. That series was all black-and-white, which had some connection with a trip to Japan he'd made at the time.

I never really could understand how lithographs were made, so I went to the firm that was making these for him, and the owner explained the lithography process, and I still didn't understand it. So he said, "Why don't you make a lithograph and then you'll know how to do it." So I actually did, and I still couldn't understand it. [*laughs*]

Later, a friend of mine, Gerrit Henry, a poet and art critic, got a job at *Art News* and I went to see him at his office one day. I noticed that on the bulletin board was my lithograph—signed by me. I said, "Where did that come from?" Apparently the lithography company had sent them all to *Art News*, which had never bothered to give them to me. So I at least got that one.

|4| I like very much that score that's over on the piano, which is for French nursery rhymes, with beautiful drawings by an illustrator named Louis-Maurice Boutet de Monvel. He was one of a bunch of marvelous early-twentieth-century illustrators. Edmund Dulac, who was mentioned in a Yeats poem, was of

course another. And George Carpentier, who did fashion illustrations.

|5| Neither of these is original. The one, I think, is a plaster copy of a bust by Houdon. The other one I once thought was an original by Philippe-Laurent Roland. But I showed it to someone I know who is a specialist in French sculpture at the Met, who said it's a fake. I guess these were very popular for decorating purposes around the turn of the twentieth century, when faux-eighteenth-century stuff was in style. In fact, a lot of furniture in this room is in that genre.

|6| My favorite piece of furniture in this room is that little sofa over there, which is the one genuinely eighteenth-century piece in here. I got it from an antique dealer who sold me much of the stuff that I own, Vito Giallo. He's still in business, I think—not in a store, but online. He was a very nice guy with an incredible eye. He had a series of tiny little shops on the Upper East Side. I used to drop by almost every week to see what new things he'd got in. He was wonderfully open and, well, unaffected—considering the sophistication that was evident in his eye. Not what you would think of when you hear the words "Upper East Side antique dealer." He was very basic, nice, and honest. And he also charged way below the market rate for his stuff, which is one reason why he was so popular. He was extremely sought after by, among others, Andy Warhol. Vito and Andy were actually roommates when they first came to New York—long before anybody had heard of Andy. And then there were these society matrons who were always referred to as "Vito's ladies." They were always there pestering him.

When I was first living in New York after moving back from Paris, I lived in a brownstone that belonged to the abstract expressionist painter Giorgio Cavallon and his wife, Linda Lindeberg, who was also a painter. They were friends of Rothko, who was a neighbor of theirs—just in the next block, actually, on 95th Street. It was they who told me I should check out Vito's store. Rothko was also one of his clients.

|7| Jean Hélion was a painter I always found fascinating, even before I went to Paris. And when I got there I actually got to know him. We became quite good friends, and he gave me a number of his works. He was born in 1904, I believe. Although he was well known in France, he never really had the reputation he should have had—in my opinion and also in his. I frequently wrote about him for *Art News* and the *Herald Tribune*, among other places. He was very grateful for the attention. His widow has just brought out a catalogue raisonné in Paris, actually. She's a wonderful person, half French, half American, but I think she's lived in Paris most of her life.

Anyway, Hélion, in the late 20s and early 30s, was an abstract artist. He kind of gravitated toward Mondrian. And at that point, nobody was interested in that kind of art in Paris. Then, in the mid-30s, when they finally were, he had moved toward figurative art. In 1943, he was a prisoner of war in a German prison camp. He somehow escaped and made his way to America, where I think he had already lived in the 1930s. He wrote a book about his escape, called *They Shall Not Have Me*, which became a best seller in the U.S. I think he was married then to an American woman in Virginia. But I'm not sure of the details. After the war he became sort of semi-abstract, I guess you could say, and finally a realist.

| 8 |

| 11 |

| 10 |

| 9 |

|8| The large painting of a rose is by Alex Katz. It's a fairly early painting, and it was a gift from him. It's from 1966.

|9| I've always been attracted by figurines like these. The two dogs are Staffordshire. The bride and groom on the end are also Staffordshire. There's a GI, but I don't think he's Staffordshire. And there's Daffy Duck, one of my cultural heroes. There's a little painting behind them all by Fairfield Porter. It's a sort of talismanic painting, I think, of his. He always kept it on the mantel in his living room. It shows the shore of the island in Maine where he had a house. I should take those vases out, so that one could see the painting. And there's a Trevor Winkfield collage hanging on the wall above all of it.

|10| The paintings on this wall are all by women artists. So I think of it as the "Women's Wall." The one on top is by Elaine de Kooning. It's a sort of abstract landscape, which I believe was a gift from her. And the one underneath is by Nell Blaine. The one in the middle is by Anne Dunn, an English friend of mine. And the still life on the end is by Jane Freilicher. It has a copy of *Art News* in it. I forget exactly how it wound up in my hands. I'm sure she gave it to me, but I forget when, or whether there was some connection to when I was at *Art News*.

|11| I don't exactly remember sitting for this portrait. It was done by the painter R.B. Kitaj, who was a friend of mine, and whose work I liked very much. He also did portraits of the poets Robert Duncan and Robert Creeley, who were good friends of his. He was another case like Hélion. He was well known, but it seemed he was never well known enough, both to me and to him. He was also figurative when everybody was abstract. He lived in London for many years. I wrote several articles about him. In one of them I compared him to other American gadflies in England—Whistler and Ezra Pound. Like them, he too was constantly warning against English stagnation and impending Americanization.

He finally had a wonderful retrospective exhibition at the Tate, which later came to the Met in New York, but which a number of English critics panned. And then his wife, who was younger than he was and also a painter, died suddenly. I think he felt that her death was partly a result of the attacks on him. He was very angry about that. So he uprooted himself and went to live in LA. He died in 2007.

|12| At one point I decided I would collect miniature shoes. One of those pairs, at least, belonged to my grandmother. The ceramic ones with flowers on them. Maybe I decided that would be the foundation of a new collection. And it's quite easy to find miniature shoes, it turns out. James Tate, the poet, a good friend of mine, collects them, and I think that's what gave me the idea. He has a lot of eccentric collections, too.

|13| I remember sitting for this. I was about 30 at the time. I think I was spending the week at the Porters' house in Southampton, which I frequently did. That was during the winter I spent back in New York, after my first two years in France. I was probably feeling very depressed because I wanted to be back in Paris. I was probably trying to figure out ways to get there. If I do have a favorite portrait of myself, I guess it would be this one.

|14| I like David's bronzed baby shoes. They somehow express his personality. I think I'd better not elaborate. 🪶

THIS ROOM

The room I entered was a dream of this room.
Surely all those feet on the sofa were mine.
The oval portrait
of a dog was me at an early age.
Something shimmers, something is hushed up.

We had macaroni for lunch every day
except Sunday, when a small quail was induced
to be served to us. Why do I tell you these things?
You are not even here.

—John Ashbery

THE ENDANGERED SEMICOLON

The semicolon was born in 1494, fairly recently as punctuation goes, periods and commas having come along centuries before. →

A PANEL DISCUSSION WITH APOLOGY
(REPRESENTED BY PAUL MALISZEWSKI),
BRYAN GARNER, AND GEORGE HODAK

According to Malcolm Parkes, a professor of paleography, the earliest semicolon in print that can be reliably dated occurs in the first edition of *De Aetna*, an account by the poet Pietro Bembo of his journey to Mount Aetna. Parkes, the author of *Pause and Effect: An Introduction to the History of Punctuation in the West*, credits the Venice-based printer Aldus Manutius the elder and his punch-cutter Francesco Griffo with the publication of *De Aetna*, which includes, translated from Latin, the following passage:

> While I hurry on to the subject of fire for your sake, that part of Aetna; which was the one remaining to us of the three (so I generally divide them up); and without which one cannot come on to fire itself; half forgetting I had almost omitted: thus Aetna, like the Chimaera, we had cut up, and like a criminal, we had rashly deprived of her rights: but now, I shall behave with more caution; and talk about both at once.

The semicolon was not greeted warmly. Some resisted the new mark; others saw no need for it; still others could not understand it. Parentheses, by comparison, were adopted more quickly. In 1566, 72 years after the publication of *De Aetna*, the printer's grandson, Aldus the younger, explained that the semicolon was meant to fall, as Parkes writes, "between that of a comma and that of a colon." As Nicholson Baker points out in his review of *Pause and Effect* for *The New York Review of Books*, "[S]hockingly, its use was apparently not fully understood by some of those assigned to work on the first folio of Shakespeare."

These problems and this resistance, or even outright suspicion, have hardly gone away. If anything, the semicolon's critics and detractors have dug in, like soldiers refusing to recognize an armistice. In *Look at Me Now and Here I Am*, Gertrude Stein argues that the semicolon is useless, redundant. She writes:

> Semi-colons and colons had for me from the first completely this character the character that a comma has and not the character that a period has and therefore and definitely I have never used them.... I think however lively they are or disguised they are they are definitely more comma than period and so really I cannot regret not having used them. They are more powerful more imposing more pretentious than a comma but they are a comma all the same.

In 1974, Edward Abbey complained of "the maddening fuss-fidget punctuation" an editor at J.B. Lippincott was trying to impose on his novel, *The Monkey Wrench Gang*, singling out the semicolon as particularly offensive:

> I said it before but I'll say it again, that unless necessary for clarity of meaning I would prefer a minimum of goddamn commas, hyphens, apostrophes, quotation marks and fucking (most obscene of all punctuation marks) semi-colons. I've had to waste hours erasing that storm of flyshit on the typescript.

New York mayor Fiorello La Guardia associated the semicolon with crafty lawyers. According to Thomas Kessner, author of *Fiorello H. La Guardia and the Making of Modern New York*, the mayor said lawyers had done more to harm civilization than smallpox and cancer. To him, "they were the 'semi-colon-boys,'" Kessner writes, "always finding some new wrinkle in a plain English sentence, squeezing forth another technicality."

In 1977, detectives with the New York Police Department who were investigating the Son of Sam murders believed that

the presence of semicolons in the killer's letters, one left at a crime scene and another mailed to a journalist, might offer a clue. Covering the investigation for the *New York Times*, Howard Blum detailed the competing theories. "The killer could be a freelance journalist," he reported. "In his letters Son of Sam writes with clarity and wollows [sic] punctuation rules, including the use of a semicolon." *Daily News* columnist Jimmy Breslin, who received the second letter, recalled in a later interview, "I've made a conscious effort to not remember what it said…. [B]ut I will say he is probably the only serial killer in history that knew how to use a semicolon." The killer, David Berkowitz, turned out not to be a freelancer, nor was he a taxi driver, a laid-off police officer, or, most novel of all, a compulsive walker, as other theories speculated; he worked for the U.S. Postal Service, operating a letter-sorting machine in the Bronx general post office.

The semicolon was becoming so rare, apparently, that the discovery of one, in 2008, on a New York City Transit public-service placard ("Please put it in a trash can; that's good news for everyone") was, for the *New York Times*, ample occasion for a news article ("Celebrating the Semicolon in a Most Unlikely Location"). It was as if an ivory-billed woodpecker had been spotted nesting atop an apartment building on the Upper West Side. The picture was that dark, the forecast gloomy.

We are, frankly, worried for the semicolon. One day, not too far off, could it become extinct, like those encrusted bits of Victorian punctuation that Nicholson Baker calls "the great dash-hybrids… the *commash* **,—**, the *semi-colash* **;—**, and the *colash* **:—**"? Or might the semicolon continue to thrive, like some hothouse orchid cultivated by devotees and kept alive under highly artificial conditions? And is the semicolon's threatened existence warning us of larger problems—mass extinction, a gradual dying out—problems that the language will one day face, much in the way, to employ another biological metaphor, the disappearance of some rare species of tree frog may indicate that the ecosystem itself is next to go? Seeking to understand the resistance to the semicolon and wanting, too, to hear from its defenders, we talked to usage expert Bryan Garner and copy editor George Hodak.

Garner is the author or editor of more than twenty books, including *Garner's Modern American Usage*, an indispensable user's guide to the language now in its third edition. Reviewing Garner's *A Dictionary of Modern American Usage*, David Foster Wallace wrote:

> The book's "feel-good" spirit (in the very best sense of "feel-good") marries rigor and humility in such a way as to allow Garner to be extremely prescriptive without any appearance of evangelism or elitist put-down. This is an extraordinary accomplishment… both historically significant and (in this reviewer's opinion) politically redemptive.

That marriage of rigor and humility captures Garner quite well. He maintains in his work the highest standards and reminds you of what the English language can and should be, but he expresses no cruelty or glee over your mistakes.

George Hodak edits copy for the American Bar Association's *ABA Journal*. He has worked at *In These Times*, *Playboy*, *Stop Smiling*, and *The Baffler*, where the masthead, back in the day, listed his department as "Hodaktion." Anybody who has received copy back from Hodak, as I have, knows that he deserves a special title. He does much more than catch comma splices and check hyphenation: He improves one's style, leaving it Hodakted.

—Paul Maliszewski

1.

APOLOGY: Is the semicolon in decline?
BRYAN GARNER: I think that's fair to say. And it probably tracks the simplification of English syntax in edited English. My impression is that it was much more common in Victorian prose than it is today and, unfortunately, it now appears frequently after salutations. So where it does appear in unedited English, it is often wrong. I know a number of people from Ivy League schools who mistakenly put a semicolon after "Dear Bryan."

APOLOGY: Microsoft Word's grammar checker recommends a semicolon more often than you actually have to use it. I wonder whether Word is suggesting that salutation semicolon, and people are blithely going along with it.
GARNER: Surely not. I mean, Microsoft Word does some bad things such as tell you not to begin a sentence with "and" or "but," which is the opposite of what it ought to be doing. But I don't think that grammar checker actually recommends a semicolon after a salutation. That would be a new low, and it strikes me that we would have heard a much bigger ruckus.

APOLOGY: Has usage of the semicolon declined in British English as well?
GARNER: The British tend to omit punctuation marks even more than the most open style of American English would.

APOLOGY ASKED A FEW WRITERS FOR THEIR THOUGHTS ABOUT SEMICOLONS.

JOHN McPHEE

If it came down to a choice between life without chocolate and life without the semicolon, I would be stricken with the utmost dismay but would choose to live on with the semicolon.

John McPhee has been writing for the New Yorker *since 1963. We really like his books* Oranges *and* La Place de la Concorde Suisse, *about the Swiss Army.*

LEWIS H. LAPHAM

The semicolon is not as literal-minded as the conjunctions "and," "but," "yet," "or," and "so." It forces a slight hesitation between a first and second clause, allows for the rounding up of a tangential or subsidiary thought that sometimes achieves the rank of metaphor. I'm very fond of the usage; wouldn't know how to leave home without it.

Lewis H. Lapham is the editor of Lapham's Quarterly, *the editor emeritus of* Harper's, *and the author of* The Wish for Kings, *his analysis of the 1992 U.S. presidential election, which we have reread and recommend highly.*

That's particularly true of apostrophes. But I think in popular writing—let's say, newspaper journalism—semicolons are probably every bit as rare in British English as they are in American English.

APOLOGY: What do you mean by open style?

GARNER: Well, in closed punctuation you would tend to include all discretionary commas—so "But, alas, …." But in open punctuation you would tend to omit all discretionary commas ("But alas, …."). And as you know, we have a lot of discretionary commas in American English. But I think the British omit obligatory commas left and right.

GEORGE HODAK: It seems a fairly sustained discussion about the semicolon arose a few years ago largely due to the popularity of *Eats, Shoots & Leaves,* by Lynne Truss, the "stickler wannabe,"

as Bryan called her in his review of the book in the *Texas Law Review.* One result was that a distinction was drawn between the U.S. and Europe, in that the semicolon was said to be more widely used in Europe, where a more nuanced mode of expression was favored, as opposed to the U.S., where a more manly, straightforward, declarative style was said to be preferred. That's an oversimplification, of course, but maybe there is something to that.

APOLOGY: What is Truss's opinion of the semicolon?

HODAK: I don't know that she was necessarily trying to resuscitate it, but she certainly thinks it's somewhat neglected. I wonder—has there been an ebb and a flow to the semicolon's usage, or has it been in terminal, inexorable decline since the Victorian period?

ELLEN ULLMAN

Punctuation is interruption. It is akin to tonguing in the playing of a wind instrument: a means of expression by way of modulating rhythm and flow.

It is all a question of "stops." The hardest sentence stop is the period; somewhat softer but still brutish is the colon; softer yet is the comma. The semicolon, however, is a chameleon. The semi lets you take sentences that can be complete on their own, but, by being joined, may create some overtones. The semi also allows you to convey a certain stutter of emotions, as in this top-of-the-head example:

> She wanted to leave the room; get away from the unendurable complications of dinner-party chatter; relax into the clean talk of code, the bounded—familiar, understood—conversation with a machine.

Ellen Ullman is the author of Close to the Machine, *a book of essays about being a computer programmer, and, most recently, the novel* By Blood.

ALEXANDER THEROUX

Aesthetically, I have always felt that the semicolon never deserved itself. It rarely looks right from a typographical perspective, at least to me, undecided as it is—diffident—between the colon, the perfect amber light, and the solid red light of the period. My thought is that it is not quite *definitive* enough. I find an uneasy and illicit compromise in its peppery appearance. It is

APOLOGY: I found a graph on Wikipedia, so take that for what it's worth, but someone searched Google Books, and what it shows is that there was a peak around 1800, when semicolons constituted almost one percent of the total characters in the scanned books published that year. Since then, it's been a straight decline. In 2000, semicolons were down to about 0.3 percent.

HODAK: A lot of trends militate against its usage.

GARNER: One is the rise, in the mid-twentieth century, of readability formulas based on sentence length. Rudolf Flesch wrote a number of books on plain English, relying heavily on average sentence length to compute readability. There

was a kind of fetish for a time about achieving short sentences, and an easy way to do that is to take out the semicolons and put in periods.

HODAK: It's certainly the case that you don't often see the semicolon in day-to-day journalism.

Recently I was looking at the *New York Times Magazine*, and I was struck by a semicolon in a fairly large readout. I thought, "Well, maybe the spacing was too tight, and they wanted dashes but had to go with the semicolon."

GARNER: It's considered a complicated punctuation mark. People are unsure how to use it, and it is associated with more complex syntax. And the fact is that people just do not read—people you would expect to be serious

ALEXANDER THEROUX, CONT'D

in its awkward untwinship somewhat unbalanced. Robert Frost explains in his "Mending Wall" how for balancing exactitude two men (even though in the poem one is old-fashioned, a slave to tradition, the other not) must be involved in restoring a wall in need of repair, both fellows walking and working on each side as a corrective, to verify the others' work, supervising:

> He is all pine and I am apple orchard.
> My apple trees will never get across
> And eat the cones under his pines, I tell him.
> He only says, "Good fences make good neighbors."

The task requires the perspective of two sets of eyes, the combination providing stereo vision and depth perception—two things that unilateralism cannot give. If you must insist on the semicolon and its virtue of tentativeness, I would simply reply, conversely, that it does not quite wall in, does not quite wall out. It is not binocular, in short. It conveys in its asymmetrical shape a kind of unnaturalness, like an odd-eyed cat, suffering a form of heterochromia. "Something there is that doesn't love a wall," notes the poet. He is right. One such thing is the semicolon.

Many a page of Victorian prose has been ruined for me by the sight of a semicolon combined with a hyphen, which kills me. Thomas B. Macaulay, Matthew Arnold, even the otherwise graceful Walter Pater are culprits and leading perpetrators of this particular indiscrimination. Charles Dickens relied heavily on the semicolon, which is fair enough—one can find a slew of them in the early pages of *David Copperfield*—but did he have to combine it with a hyphen

readers today are simply not serious readers.

HODAK: There's such a fragmented culture now. I mean, how does one speak of a general reading public anymore? You used to hear talk about a national conversation, and I don't know if there's been one since "Who Shot J.R.?"

GARNER: People don't read anymore.

HODAK: The other thing about the semicolon is—apart from a list or series with internal punctuation, where you'd better use a semicolon—it's almost entirely discretionary. To my mind, of course, it's indispensable: if you're looking for a certain nuance, balance, or contrast, it affords the most elegant formulations. On the other hand, we could if need be do without it.

GARNER: I think that's fair to say; there are other ways to punctuate. So there's more uncertainty among even serious readers about exactly where semicolons should go.

HODAK: And that leads to a certain hesitation among editors to introduce semicolons into a piece of writing.

APOLOGY: Do you add many semicolons at your work, George?

HODAK: It comes up more in freelance work, in the essays and books I edit, but yes, I will hesitate. There's just a certain discomfort: you want to be absolutely correct about it, and you don't want to shift the intended meaning. If I see one wrongly used, though, I grant the writer a narrower berth and look more closely at everything.

But if you see semicolons in a good piece of writing, they tend to be by design, from an author who's thought about it, and if it's used properly, then it comes off quite well. I'm not inclined

ALEXANDER THEROUX, CONT'D

so often? I have to say that its employment has the effect on me of a person wearing two sets of underwear or, worse, a rube smoking while eating. The semicolon has to be the most confusing of all the punctuation marks, saved only by the fact that it is invariably softened by the amenable and deferential and always rich, orotund, mouth-filling conjunctive adverbs that follow hard upon it—*consequently, conversely, finally, furthermore, however, moreover, nevertheless, nonetheless, otherwise, similarly, subsequently, therefore*—generous multisyllabic stalwarts, all, willing to compromise as they arrive to save it from its pusillanimous self-doubt and untoward Hamlet-like reticence.

As a punctuation mark, the semicolon permissively allows for even the most absurd possibilities of disagreement ("Harriet Prickle rarely dated men; on the contrary, in fits of retribution she often wanted to knife them standing in their hideous socks"); of symmetry ("Israelis were illegally snatching anybody's land they wanted; on the other hand, who was there to stop them?"); of continuity ("They bailed frantically; meanwhile, it kept on raining"); of logic ("The Lakota Sioux lived where gold had been discovered; hence, they were removed"); and, in most cases, of what amounts to the congenial transitional ("Harvey worked full-time in his florist shop; nevertheless, he was not so involved in the workaday world that he was willing to forgo spending every other weekend with Henry, his dwarf poodle, in sunny Provincetown"). I will confess to loving the semicolon for the discretion it allows in lists, groupings, collocations. In place of a comma, it lengthens the pause and lends more sobriety and stateliness to phrases. "The bullet hits its mark, Lincoln's head suddenly dropped, the man said not a word, the coun-

to take it out, thinking, "Well, a certain percentage of the readers will be thrown off by this."

GARNER: You might call it a connoisseur's punctuation mark.

HODAK: Absolutely.

GARNER: If you are reading a piece that has semicolons correctly used, you can predict that many other aspects of the writing are going to be sound, especially in punctuation and word usage. If, on the other hand, you see them misused, it's going to be a very bad piece of writing on that molecular sentence level.

HODAK: At one of my first jobs—this was at UCLA, in the oral history program—we edited these sprawling, often quite lengthy transcripts of interviews that had been conducted over maybe a year or so. So we listened to the tape and tried with our edits to preserve the cadence and rhythm of the speech, even the false starts and interjections. Dashes worked quite well, as did colons and ellipses. But when it came to semicolons, I hesitated. I was always a little bit uncomfortable because it seemed like I was imposing something that doesn't quite work with oral text, something more like a literary device.

GARNER: When you're transcribing an interview or a speech, there's a lot of discretion about how you punctuate, and even how you decide where a new sentence begins—whether it's a comma-and or a period and then a capital-A "And." These are difficult calls to make.

APOLOGY: When you do that kind of transcribing, do you use semicolons, Bryan?

GARNER: Well, I'm looking at my interviews with the U.S. Supreme Court justices, published in the 2010 edition

try's leader had been assassinated." When connected by commas, this sounds reportorial. When connected by semicolons, by dint of the pauses, especially when read aloud, the punctuation gives the sentence more dignity. There is also something of equity reinforced in the fact that with the semicolon—like BBPeopleMeet.com, where "big and beautiful singles" can meet each other—things of equal weight can be joined, whereas with the colon you can join things of equal or unequal weight, which is perfectly fine if it doesn't lead to unfair comparisons and accusations later.

Alexander Theroux is the author of, among others, Estonia, *a travelogue.* The Grammar of Rock, *his book about rock lyrics, is forthcoming from Fantagraphics.*

JAMES McCOURT

Whenever I think of the semicolon, some strange not quite free association makes me think of, and actually see what is known as the French curtain call—especially as demonstrated at the Comedie Francaise.

In the American and British curtain calls, forthright, no-nonsense phenomena, I always see a period, then another period, and so on; until the final period is written and the curtain is rung down for the last time.

What happens in the French curtain call is entirely different, and creates the same kind of "suspense" as does the semicolon.

You know the drill—of course there has to be a curtain, a thing increasingly rare—although

of *The Scribes Journal of Legal Writing*, and I'm really not seeing very many semi-colons. But I do find one from the chief justice's interview. It's about shuffling cards, and he says:

> Then I'll start again and I'll look down. Okay, my first point is going to be C; and then from point C, I'm going to move to point E; and then from point E to point A. You develop practice on those transitions.

HODAK: That certainly works. I mean, without getting the raw transcript, that's the preferable way, I would think.

APOLOGY: It's hard to imagine the first part on its own, as a sentence. You haven't been given enough.
GARNER: I find another in an epizeuxis by Justice Scalia. Epizeuxis is one of my favorite words; it means emphatic

repetition. Justice Scalia says, "You can tell; you can tell." I would not have wanted to make that two separate sentences. I suppose, though, it could've been a dash.
HODAK: The dash is much more widely used, and writers and editors are more comfortable with it because you can't be as wrong.

APOLOGY: You can't misuse it?
HODAK: It's harder to misuse than a semicolon, and I've wondered if I might use dashes more frequently than I need to, when a semicolon would be prefer-able. I do think the dash works well for emphasis. Bryan, do you think people rely on the dash as a bailout, a sort of fallback?
GARNER: Lawyers are reluctant to use it. I think it's the second most under-used punctuation mark in modern legal

JAMES McCOURT, CONT'D

perhaps not necessarily—a blackout will do. In any case the actors appear from last to first, usually in twos and threes until the stars emerge one at a time. Amid roaring applause the company proceeds as a unit down to the footlights (although there are no footlights anymore). There they bow together. The applause roars on as the curtain falls (or the onstage lights go out), until a second call then repeats the form of the first. The company bows as a unit. Gener-ally they stay together, bowing again and again until the curtain finally drops for the last time. Each of these curtain calls is a period—declarative, no surprises. *Punto final.*

The French curtain reaches its erotic perfection at the Comedie Francaise in Paris. It be-gins in exactly the same way as the English, except after the first curtain falls there is a longer interval until it is brought up again to reveal the entire company, or sometimes just the princi-pals, walking upstage and suddenly stopping as if they'd been frozen in character behind the dropped curtain and could only walk into their only safe ground of being—the play. They, then having reached mid-stage, and with the applause augmenting, turn in mock surprise, holding the pose for several seconds, thrillingly suspended in space and time, as if to say, "You want to see us down at the footlights again; you want to tell us again how much you love us?" This is a curtain call that brings the audience to its feet (although you won't ever have seen it done after a performance of *En attendant Godot* or *Fin de partie*).

In conclusion it is the ambiguity of the semicolon: does its shape signify more the modifica-tion of the mood of the period or that of the colon? (In music if both G and A are periods, then the semicolon is either G-sharp or A-flat, depending on the tonality of the key.)

writing, the most underused being the period.

APOLOGY: Is that because the dash is open to interpretation?

GARNER: H.W. Fowler disparaged dashes and said they were typical of schoolgirls' letters, that they give this breathless quality to writing. And many schoolteachers over the years denigrated dashes and told students not to use them. So a lot of people in this country grow up thinking there's something naughty about dashes. When I interviewed Justice Judith Kaye of New York State, she said with some qualms that she likes dashes: "I have to admit this to you, but I use an occasional dash." Her embarrassment in the video clip was palpable.

I use them a great deal; they're part of any good writer's arsenal. It's hard to find a page of the *Economist* or the *New Yorker* without a dash or two, and as I look over these Supreme Court interviews, there are dashes on virtually every page, but not so many semicolons.

HODAK: Could the dash be overused?

GARNER: You should never put more than two in a sentence—and that's if you have an interruptive phrase in the middle. I think three dashes in one sentence is a rhetorical mistake. If you have more than four in a paragraph, that's too many. And that would have to be a pretty substantial paragraph, to take four.

HODAK: That's where a semicolon can be useful, where there's a certain rhythm and cadence that it affords you, complimenting the dashes or just interspersing them.

GARNER: It gives you some variety, so that you're not over-relying on one punctuation mark.

HODAK: On the other hand, if you write

All hail the semicolon; it gives us all yet another chance.

James McCourt is the author of Mawrdew Czgowchwz, *which is easier to say than it looks.* Lasting City, *a memoir about his family in America, is forthcoming from Dalkey Archive Press.*

LYNNE TILLMAN

The semicolon can save me from involuntary syntactical error. Indulging the pleasure of writing a very long sentence, I blaze ahead. I'm ecstatic with words, and mindless of them too. I reread my glorious sentence and discover it's a bloated renegade, a rebel with too many clauses. Where is its subject? Nope, it can't go home again. So I find a spot in the fat thing, and judiciously tap semicolon's key. I divide my sentence into two equals, each maintaining its own integrity, while augmenting the other. Bliss.

A grammatically unhinged, distended sentence causes temporary cognitive dissociation to a reader; these readers are Grammar's Orphans. My belief is that readers shouldn't be aggravated by the peregrinations of an inconsiderate or ignorant author, or a writer promiscuously in love with words. (Save me from those overwritten, "lush" sentences; in prose, they're sometimes named "poetic.")

While I rely on and love the comma, I know it can't do everything. And writers can't always claim, "I'm doing stream of consciousness." Some must admit to excess and error, and manage their sentences better. Those who regularly write stupid, ugly sentences, without style and content—the semicolon can't help them.

today like Carlyle or Ruskin or Hazlitt, it's going to be seen as a pretty quirky, idiosyncratic style, where you're exposing yourself to all sorts of—I don't know if ridicule is the word—

APOLOGY: It's like you're putting style first. That's the charge.

HODAK: One of the main complaints about the semicolon is that it can be seen as an affectation.

GARNER: Mannered, yes.

APOLOGY: Straining for effect.

HODAK: But a lot of writing today is edited to be read, ultimately, online, and I wonder if that's the death knell for the semicolon—or for proper punctuation in general. You can sound unduly alarmist and see everything in terms of a decline in standards—I think things are a little more complicated—but I do see a lot of bad grammar, bad punctuation, and bad word usage.

GARNER: Well, increasingly we're all seeing unedited text. Ten or 15 years ago, it was almost impossible to read something that had not been professionally edited. Even newspapers are dumping their editorial staffs. It's rare that people are reading the kind of writing you're talking about—Carlyle and Ruskin. Not even 5 percent of lawyers could tell you the first name of John Ruskin or Thomas Carlyle, or really tell you anything about them. They wouldn't even recognize them as English writers.

HODAK: Would that have been true, say, 50 years ago?

GARNER: The profession was a little better read and probably more homogeneous, which has some advantages. It also has disadvantages, of course, but at

LYNNE TILLMAN, CONT'D

Some writers reject the semicolon as old-fashioned and fussy. I believe it rises above trendiness and fulfills purposes other punctuation can't.

Lynne Tillman is the author of American Genius, A Comedy. *Her most recent book is the collection of stories* Someday This Will Be Funny.

MARGARET HARRELL

I was, for a time, Hunter S. Thompson's copy editor. I worked with him on his first book, *Hell's Angels*. This was in 1966 at Random House, where I was employed with four other copy editors. We worked at the Villard Mansion, at Madison and 51st, and sat in a row of partitioned office cubicles, which offered sufficient privacy that I once kept Hunter's five-foot-long blue indigo snake in a cardboard box for a few days without anyone objecting. We met with authors in person to go over their edits, then a Random House tradition. John Irving protested once, not wanting to fly in from New Hampshire for copyediting, but even he was made to appear. Hunter was the exception. He and I interacted long-distance, with countless phone calls from San Francisco and Colorado (paid for by the publisher), and also letters, which I kept.

Hunter had nothing against semicolons. On the first page of *Hell's Angels*, he writes:

> ...like Genghis Khan on an iron horse, a monster steed with a fiery anus, flat out through the eye of a beer can and up your daughter's leg with no quarter asked and none given; show the squares some class, give em a whiff of those kicks they'll never know...

least people had read Shakespeare and had that in common. As George was saying, today there is very little sense of cultural commonality.

HODAK: If you write today, you're quite often writing for a niche audience, and so you might find more semicolons in certain niches, while you're not going to see them as frequently in other spots. But I wonder too where communication, where expression, is going. I mean, will we be looking at a world of emoticons ten years from now? Or people communicating with hand signals? I'm exaggerating, but it's hard to see the countervailing pressures.

GARNER: I've been driven crazy lately by having to do business with someone who uses no punctuation in her emails and no periods, even at the ends of paragraphs. The idea that I would receive emails from this person, I mean—

I'm trying to be thick-skinned, but frankly it's impossible.

APOLOGY: Is it because she's using some mobile device?

GARNER: She's not texting, she's emailing. I use correct punctuation in my emails.

HODAK: And so do I. I don't find it a problem.

GARNER: I do on my Twitter account as well, even though it uses up extra characters.

APOLOGY: Of your allotted 140…

HODAK: Yes, you're limiting yourself, Bryan. I was a latecomer to email—a latecomer to anything technological, I suppose—but I feel I'm the last person who still writes an email like a letter, though I suspect Bryan does as well.

GARNER: I do indeed.

MARGARET HARRELL, CONT'D

And later: "The aggressiveness went out of them; they lost the bristling, suspicious quality of wild animals sensing a snare."

Hunter was strongly against any meddling with his punctuation and formatting; he was not shy about insisting that he didn't want it tampered with except by someone who had a feel for his rhythms, timing, effects, and so forth. In a letter to *Rolling Stone* editor Jann Wenner in 1975 regarding *The Great Shark Hunt*, he wrote, "I think you know me well enough to know I'm going to brood & bitch over every comma & column breaker all the way to the press." He continued:

> [S]ome poor, unsuspecting woman, unknown to either of us right now, is going to have her hair turn cotton-white on this one… and now that I think on it, the only person I know who could naturally handle a nightmare like this is a girl who used to work for Random House who did all the editing on *Hell's Angels*; her name is Margaret Harrell, and Silberman could probably find her if necessary.

People ask why he preferred me. It came down to a feel for words. When we finally met, in New York, in 1967, he asked, "Do you write anything yourself? I've almost never met anyone who feeds on words the way you do. Like a cow. You chew on them, swallow, bring them back up." Hunter had "word highs" and "rhythm highs"; it had nothing to do with drugs. He would just soak himself in words, in inspiration. Deadline highs as well.

At the end of *Hell's Angels*, in the much-reproduced description of himself on a motorcycle,

For a while now we've been reading for semicolons, on the lookout for them. Here, below, are some finely placed ones we found. In the Proust, the clauses are short and direct, physical, but then the sentence opens up, spreading out into a longer, more abstract reflection that builds on the earlier images. The Gass is just a beautiful thing, like watching a person cross Niagara Falls on a tightrope.

EXEMPLARY SEMICOLONS

Nature was resuming its reign over the Bois, from which had vanished all trace of the idea that it was the Elysian Garden of Woman; above the gimcrack windmill the real sky was grey; the wind wrinkled the surface of the Grand Lac in little wavelets, like a real lake; large birds flew swiftly over the Bois, as over a real wood, and with shrill cries perched, one after another, on the great oaks which, beneath their Druidical crown, and with Dodonian majesty, seemed to proclaim the inhuman emptiness of this deconsecrated forest, and helped me to understand how paradoxical it is to seek in reality for the pictures that are stored in one's memory, which must inevitably lose the charm that comes to them from memory itself and from their not being apprehended by the senses.

Marcel Proust, *Swann's Way*, translated by C.K. Scott Moncrieff and Terence Kilmartin, p. 606, The Modern Library edition, 2003.

2.

APOLOGY: You both agree that semicolons are largely discretionary, but you're also staunch defenders. So when a semicolon is used properly and well, what's singular about it?

GARNER: Well, I think it's particularly effective for antithesis: where you say, "Some people have it; some people don't."

HODAK: It allows for a kind of compression, too. I think there's value in that: the antithesis or contrast, a certain kind

of balance. The one thing you want to avoid is connecting two clauses and making the reader stop and wonder, "What is the connection?" If it's that elusive, you might have gotten too cute. The semicolon also has to be part of the larger rhythm of a paragraph or a page. I mean, you have to put all these things into some kind of alignment.

GARNER: Visual variety is a definite part of it. All these things make the reading experience a little more interesting and a little smoother.

As an interesting exercise, if you took a paragraph from the *New Yorker* or the *Economist* and took out all the punctuation and then asked somebody to supply punctuation, you'd realize as an editor that a lot of these things are discretionary. There's no absolute science about it. But the other thing is that people, maybe 90 out of 100, would have little

MARGARET HARRELL, CONT'D

Hunter employs a medley of punctuation, including semicolons, to create the rhythm of the ride:

> ... but in a matter of minutes I'd be out at the beach with the sound of the engine in my ears, the surf booming up on the sea wall and a fine empty road stretching all the way down to Santa Cruz... not even a gas station in the whole seventy miles; the only public light along the way is an all-night diner around Rockaway Beach.

Of the same ride, he adds, "You can barely see at a hundred; the tears blow back so fast that they vaporize before they get to your ears."

Hunter sometimes, though rarely, uses two semicolons back-to-back in one sentence. There is no rule to apply in those places. He just knew how it felt in his fingers as he typed those passages: the flow, the pause, the move forward, and also the relationship of the content. Instinct, as he said in another context. He liked to go with his instinct.

Even in the more informal format of a letter he would use a semicolon. "My affairs," he wrote me, "have become tangled; people demand money from me almost constantly—vast amounts; I seem to owe about $25,000 at the moment, all overdue."

Punctuation was once taught in terms of oratorical pauses. Remember that Hunter read his work aloud or had others do it for him, often conducting them as they did. He followed the music and the oral impact. *Bibliotheca Technologica*, a 1737 encyclopedia, offers the following guidelines on how punctuation corresponds to counting, or "telling": "The *Comma* (,) which

EXEMPLARY SEMICOLONS

I certainly didn't resort to the letter out of shyness or some belated sense of discretion; but as I got my 'facts' straight (clubs, crops, products, prospects, townshape, bar- and barn-size), I remembered how eagerly I'd come to the community, how much I'd needed to feel my mind—just once—run free and openly in peace, in wholesome and unworried amplitude, the way my legs before in Larimore, N.D., had carried me through streets scaled perfectly for childhood; and I slowly realized, while I drew up my lists (jobs, shops, climate), marking social strata like a kid counts layers in a cake, that I was taking down the town in notes so far from sounding anything significant that they would not even let me find a cow; yet I figured my estimates anyway (population changes, transportation, education, housing, love), and I took my polls (of churches and their clientele, of diets and diseases); I made my guesses about the townspeople's privacy (fun, games, hankie-pankies, high or low finance: pitch or catch, cadge, swap or auction), just as any geographer would, impressed by the seriousness of habit, too, of simple talk or an idle spit or prolonged squat—a reflective shit in a distant field; and as I started to distribute my data gingerly across my manuscript, a steady dissolution of the real began; because the more precisely one walks down a verbal street; indeed, the more precisely trash heap and vagrant shadow, weed stand and wind-feel and walkcrack are rendered; when, in fact, all that can conceivably enter consciousness—like snowlight and horse harness, grain spill and oil odor, hedge and grass growth, the cool tin taste of well-water in a bent tin cup—enters like the member of an orchestra, armed with an instrument (the bee's hum and the fly's death, for instance); the more completely, in short, we observe rather than merely note, contemplate rather than perceive, imagine rather than simply ponder; then the more fully, too, must the reader and writer realize, as their sentences foot the page, that they are now in the graciously menacing presence of the Angel of Inwardness, that radiant guardian of Ideas of whom Plato and Rilke spoke so ardently, and Mallarmé and Valéry invoked; since a sense of resonant universality arises in literature whenever some mute and otherwise trivial, though unique, superfluity is experienced with an intensely passionate exactness: through a ring of likeness which defines for each object its land of unlikeness, too (though who says so aside from Schopenhauer, who was also wrong about the world?); and consequently the heart of the country became the heart of the heart with a suddenness which left me uncomforted, in B and not Byzantium, not Brookston, far from the self I thought I might expose, nowhere near a childhood, and with thoughts I kept in paragraphs like small animals caged.

William H. Gass, "Preface," *In the Heart of the Heart of the Country*, pp. xlii-xliii, David R. Godine, 1981.

clue about how to make it a meaningful passage. Punctuation is a professional skill that is not all that widely followed or known.

HODAK: The *New Yorker* has always been known for more than a touch of idiosyncrasy in its house style. And yet that's one of the things I like about it: that so much thought has gone into that style. And you can say, "Well, it's contrarian," or "It's drawing too much attention to itself," but there's definitely the sense of a legacy, of a certain standard that's expected to be maintained and isn't going to quickly vanish.

GARNER: The *New Yorker* has the most mannered punctuation of all major publications. *Harper's* would be hard to distinguish from *U.S. News and World Report* or the *New Republic* or any other well-edited journal. But the *New Yorker*, with its dieresis over the second "o" in "coöperate" and "coördinate"—that is unusual. They also tend to have closed punctuation; they include all discretionary marks.

APOLOGY: Does it ever feel to you like too many commas?

GARNER: Not to me, because the syntax is sophisticated—it's pleasing, the sentences are well phrased.

APOLOGY: Going back to your exercise, if people can't put the punctuation back in themselves, more or less how it belongs, how are they able to read something that's properly punctuated? Do they hear it as it's punctuated, or are they just stumbling through and getting the gist out of it but not the music?

GARNER: I don't know the answer to that, but I do know I've stopped calling on lawyers to read things aloud, because

MARGARET HARRELL, CONT'D

stops the Voice while you tell *one*. The *Semicolon* (;) pauseth while you tell *two*. The *Colon* (:) while you tell *three*; and the *Period*, or *full Stop*, (.) while you tell *four*."

Hunter, I think, was happy to see the semicolon in that way: in terms of the weight of the pause. But basically, it was always in the fingers. He knew to insert a semicolon at a point.

Margaret Harrell is the author of Keep This Quiet! My Relationship with Hunter S. Thompson, Milton Klonsky, and Jan Mensaert. *The second volume of her memoirs,* Keep This Quiet Too!, *is forthcoming.*

SUSAN BERNOFSKY

I don't know if anyone actually likes semicolons; less than a full stop, more than a comma, they're a stab and a drip that make a sentence seize up in the middle. Donald Barthelme disparaged them ("ugly as a tick on a dog's belly"). The thing is, it turns out that they're useful: they link ideas when an author wishes to juxtapose more than to explain, and they help with those pesky lists interspersed with supplemental clauses where commas would merely confuse. They are also a handy tool when translating from languages in which run-on sentences are more acceptable as a stylistic feature than in English. German is one such language, and some of the authors I specialize in (I'm thinking above all of Robert Walser and Jenny Erpenbeck) are in love with sentences that go on and on and on, carrying their speakers quite some distance in space (Walser) or time (Erpenbeck). To chop up each sentence into several, as many a copy editor might prefer, interferes with the sense of fluidity these long sentences create. A Swiss neighbor of mine in Zurich who'd read some Walser but wasn't particularly

it becomes embarrassingly obvious that a high percentage of people cannot read aloud well at all.

HODAK: Do you mean the inflection, or the pronunciation?

APOLOGY: Or the structure—they have no feeling for the structure of sentences?

GARNER: It just becomes apparent they're not accustomed to reading all that much. They're the kinds of readers who, if reading silently, would be moving their lips with every word.

HODAK: In many high schools, the semicolon is the one form of punctuation that might have went undiscussed.

GARNER: When this is transcribed, they're going to have to change that to, "Might have *gone* undiscussed."

HODAK: Oh, I knew I was going to get a smackdown at some point in this conversation.

GARNER: No, I'm sorry, I just want to be sure that's not transcribed exactly as you said it.

HODAK: If dashes were once thought of as dubious, it seems that semicolons weren't given any thought.

GARNER: The received opinion is probably that the dash is highly informal and the semicolon is highly formal. And maybe as writing has gotten less formal and more conversational—there's more use of contractions, for example—semicolons have become like nineteenth-century cravats: you just don't see them anymore.

APOLOGY: I don't remember learning about dashes in school. Semicolons we were introduced to in conjunction with a type of argument—and this goes back to the antithesis Bryan was talking about—where you're developing this on-one-

bookish once referred to his prose as made of "tapeworm sentences"; she understood that their length was a characteristic feature. The same could be said of Thomas Mann, but nonetheless he suffered Helen Lowe-Porter—whose translations he praised and officially approved—to chop many of his long sentences into easily digestible tidbits; there are up to ten English sentences for each German sentence in his story "Disorder and Early Sorrow." I disapprove of such sentence-chopping, but I can see why she did it and why he approved. What to do with long sentences written in languages more hospitable to the run-on is a problem faced by many translators. Maureen Freely, the novelist who translates Orhan Pamuk, has written that adapting his "long, winding sentences" so that they don't sound "foolish" in English sometimes requires a semicolon, which Pamuk at first objected to but then came to accept. I'm with her. I personally have a great deal of tolerance for comma splices in English and will fight to keep enough of them in my translations to drive any good copy editor to despair. But sometimes they get confusing, or come out seeming pointlessly long-winded or wrong; and sometimes the English reader just desperately needs a place to plant her feet for a moment and catch her breath. At such moments, I tend to start doling out the semicolons—sparingly but gratefully. And to me they look less like ticks than *Kümmel*, the caraway seeds that give many a Swiss or German dish its flavor.

In any case, my authors often enough use semicolons on their own. Here's a sentence from Jenny Erpenbeck's *Visitation* with semicolons by her:

hand, on-the-other-hand opposition and so require a semicolon to make clear the relationship between these two ideas you're juggling through the whole paper.

3.

APOLOGY: I wanted to ask you about the semicolon's detractors, who are, it seems, legion. One argument they make is to take an anti-intellectual position. For instance, Kurt Vonnegut, in his lesson on creative writing, says, "First rule: Do not use semicolons. They are transvestite hermaphrodites representing absolutely nothing. All they do is show you've been to college."

GARNER: It would be fascinating to find out whether Vonnegut used semicolons. I mean, I would be amazed to think he went through his entire career without using more than a handful of semicolons, but maybe he did. And maybe his big hero was Hemingway. He liked those very short, clipped sentences.

APOLOGY: He later uses a semicolon in the same essay, and he draws attention to that fact, writing, "It is to make a point that I did it. The point is: Rules only take us so far, even good rules." He was known for being against semicolons. John Irving, who favors the semicolon, had him as a teacher at Iowa and has talked about Vonnegut's disdain for them.

GARNER: It sounds like reverse snobbery. What is the second argument?

SUSAN BERNOFSKY, CONT'D

Her sisters, both of whom have meanwhile become mothers, watch from the dock as she swims the crawl, crossing the steamer's route and then going much farther out until her swim cap is visible only as a pin-sized dot, while they themselves stay close to shore, splashing about in the shallow water with their children; her sisters like to eat crabs, but they screech when their younger sister picks up the flailing creatures by the scruff and throws them into the net with no sign of disgust; when the swing for her nieces and nephews gets tangled in a branch of the big oak tree, she is the one who at once digs fingers and toes into the furrows of the tree's bark, quickly ascending, then straddles tree limbs to slide forward to where she can release the loop of rope caught in the leaves as if it were nothing.

Here's a sentence in which I've added a semicolon:

To them, the village they owed their life to was occupied territory; to the Belgians, it was home, and quite possibly the front ran right between the whiskers of the sleeping cat.

And here's a description of a walk from "Good Morning, Giantess!" from Robert Walser's *Berlin Stories*:

Statues beckon you from gardens and parks; still you keep on walking, giving everything a passing glance: things in motion and things fixed in place, hackney cabs in-

APOLOGY: The second argument has to do with aesthetics, this quest for something more streamlined and modern, with fewer ornaments to slow the eyes. Samuel Beckett and Donald Barthelme would fall into this category. It was Barthelme who wrote, "Why do I avoid, as much as possible, using the semicolon? Let me be plain: the semicolon is ugly, ugly as a tick on a dog's belly. I pinch them out of my prose." Cormac McCarthy doesn't use semicolons either. They have, according to him, no place in literature.

GARNER: Really?

APOLOGY: When he appeared on *Oprah* to discuss *The Road*, he said "If you write properly, you shouldn't have to punctuate." He also said, "I believe in periods, capitals, and the occasional comma, and that's it." He told this story, too, about a professor in college who was putting together a textbook that included some eighteenth-century essays, and the professor asked McCarthy, who was a student, if he would re-punctuate them. "They wrote so well," McCarthy said, "and punctuated so poorly." So he rewrote them in some places, and he cleaned up the punctuation to his liking, and the professor praised his work.

GARNER: I would be tempted, if I had a free hand, to do the same thing; I was trying to update Aristotle's *Rhetoric*

dolently lumbering along, the electric tram just now starting its run, from whose windows human eyes regard you, a constable's idiotic helmet, a person with tattered shoes and trousers, a person of no doubt erstwhile high standing who is sweeping the street in a top hat and fur coat; you glance at everything, just as you yourself are a fleeting target for all these other eyes.

The first semicolon is original Walser; the colon and second semicolon are by me.

Susan Bernofsky is the translator of the great Robert Walser and is at work on a biography of him, which we look forward to reading.

STEVEN MOORE

I'm always surprised how little advantage writers take of the expressive possibilities of punctuation. Most of them, even the flamboyantly creative ones, limit themselves to the meat-and-potatoes basics of the comma and period, ignoring the colon, the dash, the ellipsis, the parenthesis, emphatic italics, and especially the semicolon. Flipping through most novels, you rarely see a semicolon, even though creative works like novels are precisely where you would expect to see creative use of punctuation. I grabbed two at random from a stack of galleys I'm preparing to sell, Bret Easton Ellis's *Lunar Park* and John Updike's *The Widows of Eastwick*.

I found a few colons in Ellis's novel, some expressive use of dashes and ellipses, but not

a few years ago, before I decided the whole book was so unmanageable it can't be done.

APOLOGY: I think all that punctuation comes from the various translators. The ancient Greeks used little punctuation, and no spaces between words, even. What's there is just our best guess, really.

APOLOGY: Could the semicolon become extinct?

HODAK: I think you'll see less and less of it in certain quarters, that's for certain. But there will always be a place of refuge—how would you put it? A last bastion.

GARNER: The thing about the semicolon is that it never occurs to people to use it until they've become accustomed to a fairly sophisticated sentence structure. I think that, along with the decline of reading, best explains the semicolon's relative demise.

APOLOGY: I've been wondering whether written expression has become less complex and thus the semicolon is less in use, or whether people have become skittish around the semicolon and that's taken its toll on writing.

GARNER: The semicolon may become like the footnote; increasingly, publishers don't think they can print a book that

STEVEN MOORE, CONT'D

a single semicolon, even where his sentences cry out for them. Wouldn't "Please, I thought. Please let someone save him" read better as "Please, I thought; please let someone save him"? Wouldn't a semicolon work better than a full stop in the middle of these two sentences: "I kept my gaze fixed on the horizon. The sky was turning black, and the clouds roiling in it kept changing shapes"? You could argue that those are two separate actions—the narrator fixes his eyes on the horizon and *then* notices the sky is turning black—but since the second clause is the consequence of the first, a semicolon would be better.

"Consequence" is the word William Strunk and E.B. White use in their famous *The Elements of Style*. (I have the illustrated edition of 2005, which sports a big semicolon by itself on the back cover.) When there is a "cause and consequence" relationship between two independent clauses, they suggest it is better to use a semicolon than a period. Yet many writers, especially minimalists under the influence of Ernest Hemingway and Raymond Carver, prefer to use full-stopped sentences rather than link them via semicolons. Here's Ellis again: "I could hear the soft, snapping sounds of something approaching. And it was moving eagerly. It wanted to be noticed. It wanted to be seen and felt. It wanted to whisper my name. It wanted to deceive me. But it wasn't making itself visible yet." Ellis was probably trying to create dramatic tension, but it's more like being stuck in stop-and-go traffic.

In *The Widows of Eastwick*, I saw one semicolon at the beginning of chapter two: "Satan's mark is upon our pleasures; else we would not be driven to repeat them, even when sated, until they devour us." Most writers would have used a comma there—indeed, this is a misuse of the

has footnotes, because people will rebel. But I rebel at that idea.

APOLOGY: It seems as if changes in the language come about from the top down or, in the case of the increasing number of people who declare that they could care less, the bottom up. Though some of us are still fighting the good fight against "could care less."

GARNER: Absolutely.

APOLOGY: But other fights about usage feel like losing battles.

GARNER: Self-deprecating would be an example. Despite its mistaken origins, it's now 50 times as common as self-depreciating, which is correct.

The semicolon is getting pressure from above and from below. From below, people consider it extraneous and strange, and they're not accustomed to seeing it. From above, the reverse snobbery that we heard from Vonnegut is probably more rampant than I realized when we began this conversation. Only a few at the top are defending it.

HODAK: It becomes a matter of where you draw the line in terms of standards. There are any number of things that I cringe at and yet, on the other hand, I see that the usage is so widespread that you feel it's not worth complaining about.

APOLOGY: Right.

HODAK: So you can say, "Well, 50 years ago this was a battle to be fought," whereas today, if people know how to spell properly, that's good. And that sounds snobbish, I know, and I don't want to sound like some grand arbiter of high taste, but it's a legitimate concern where this is all going. 🐾

semicolon per Strunk and White, but the semicolon creates more of a pause than a comma would: not as much as a full stop, just enough to let us feel Satan's mark upon our pleasures of reading well-wrought prose. I didn't see any more semicolons, not did I see any instances where they are called for; Updike knew what he was doing.

Other novelists known for their elaborate style use semicolons sparingly, it seems. I saw only a few in William Gass's *The Tunnel*, even fewer in Alexander Theroux's *Darconville's Cat*. (There are more in his *Laura Warholic*, but only because I put them there while copyediting the manuscript.) David Foster Wallace goes out of his way to avoid semicolons in *Infinite Jest*, even when he knows full well they're called for, as here: "A big one being this pretense that overt eccentricity was the same as openness. I.e., that they were all 'exactly as crazy as they seem'—the punter's phrase." Every copy editor in the world would instinctively add a semicolon after "openness," but Wallace flouted the rule in an act of "overt eccentricity."

While I don't expect writers to be as creative with punctuation as the late German novelist Arno Schmidt—a typical sentence in John E. Woods's translation of *The School for Atheists* reads: "TIM : »Keeps all Your senses fully occupyd. – *HEARING* ? : one door sighs; the next griggles; the third farts"—I do wish they would realize that semicolons and other wallflowers deserve an occasional spin on the dance floor of prose.

Steven Moore is the author of the two-volume study The Novel: An Alternative History. *He's written and edited many books on William Gaddis, most recently* The Letters of William Gaddis, *published by Dalkey Archive Press.*

JOSEPH McELROY

1. Semicolon? A period above? The comma below, relaying us onward. You could do without the semicolon but choose not to. I speak for myself, who don't dislike it, even imagining that when I was nine, a close relation of mine read a wild and touching story I'd written and commented only that it was missing a semicolon. *Need* a semicolon? To put where? And how often do we need the question mark? If you need that comma to flag a pause or a separation, maybe recast your words.

2. Words make the best punctuation, but Gertrude Stein's going-on sentences often charming or would-be historical or psychic or overbearingly funny with almost profound momentum on being that sentence unit nonetheless call attention to what she has artily omitted. If you have to use punctuation, go by the rules; that way it's more likely to be invisible for the reader—even that "period put just at the right place," Isaac Babel instructs us: "No iron can stab the heart with such force..."

3. The semicolon, though, presents a problem because it can seem to pose as a period— what the English call a full stop. How full a stop? I ask in the construction of my only sometimes long sentences which become narratives in themselves. Isn't a stop also looking ahead (or back)—even after the final sentence?

4. Henry James uses semicolons to divide and connect independent clauses that are close in thought, almost never more than one to a sentence. Often, Isabel Archer's struggles to be fair to others and clear in her mind are best embodied in sentences in which an independent clause—virtually a sentence—is bound by a semicolon to the independent that follows it. Thus, James honors the character's truth; without the semicolon—substituting a period (or a comma and a conjunction)—we would still have the truth of the words. But James will follow the character's approximations and corrections—he uses dashes for this, too—yet his semicolon has a logic of honesty and intimacy. It's not fussiness, it defers to the words.

5. I have often been reluctant to declare a sentence ended. In *Women and Men* and occasionally in my non-fiction book about water, now approaching conclusion after eight years, I find a new way in the middle and turn, sometimes with semicolons, onto this consequence or parallel; so the sentence doesn't end but may acquire an undercurrent—like a new narrative for my prodigally extended breath, like finding a way to breathe underwater—and make turns into parallel thoughts that are able not to meet yet sustain the sentence unit, which is, beyond word and prior to paragraph, the unit I write:

> Eyes closed, resting, he's a very old man, his hat in his lap, the straw upon the heel of his palm, fingers resting in the crumpled crown, air sliding and curling like water over his skull; and he foresaw what is happening in the sun of a backyard the ownership of which hardly matters any more, only the people small and tall who use it, the little girl with long light hair throwing a ball up and up and up again and catching it in one hand nearer and nearer her grandfather in his chair; and he is not dopy, and knows his grandson whose daughter this little girl is knows he is not dopy and would not make

JOSEPH McELROY, CONT'D

anything of his not at once replying to the question his grandson asked; and when, with his eyes closed, he had an answer, he heard a powerful whoosh and did not open his eyes, it might be an exciting death coming his way and he heard a young gasp and knew his great-granddaughter had caught her ball practically in his lap, but he had the words in his throat answering Jim's question: "In his letter that he wrote me when I was all of six years old, his last letter and he was up in New York visiting the Indians and the envelope had a bright red scarab seal on it, and he said he had dreamt of swallowing something, I know what it was, it was a storm he swallowed, complete with rain, thunder, lightning, what's that other?, hail—the works—and then singing out his name in the dream which was Morgan of all things, but something else, Jim, I really forget but it had to do with the spelling."

The feeling of intimacy and comprehensiveness to be found in some of the listings and explanations in the great water section of Joyce's *Ulysses*, xvii, at no point depend on semicolons, though they could. Colon and comma sweep away semicolon implicitly, the colon, like an open valve for Joyce, boldly, ignoringly free, unlike thoughtful semi-. And the dash, yes—at the last minute a kind reader points out to me a beautifully appropriate, Ulyssean shoreline near-indeterminacy using semis: "Broken hoops on the shore; at the land a maze of dark cunning nets; farther away chalkscrawled backdoors and on the higher beach a dryingline with two crucified shirts." I believe Joyce doesn't use the semicolon much. Maybe an inked ambivalence, indecisive looking.

6. Does the semicolon bring all this up?
 If we insist.

7. Half a colon? Half*way* to a colon? Why, I have ended a long, unendable paragraph with a colon, recalling the tidal effects of A.R. Ammons's colons; and then begun the following paragraph with a colon and small-case. The semicolon is subtler.

8. Dispense, they say, with the semicolon to keep moving and not be interrupted; but by what? And those, like me, who will use the semicolon, is it to slow things down? Or the opposite: to make sure that meanings spliced or parallel are clear as we go on—or even before we do (for the reader's reading jumps this way and that, backward inherently as well as... yes, yes; no more than that).

9. Remember Victor Borge's phonetic, even spat-out punctuation, his sound for the dash, the period, the left- and right-handed comma, the beloved colon: but no semicolon— an acoustical or labial complexity?—also nothing for question mark, I think, not sure. Though I have seen his house in St. Croix. Borge felt punctuation to be communication, poignantly necessary, I believe, if slightly absurd, and in relation to words (or music) he was right enough, though forgetful of the rhythm and the scoring which punctuation, even like the melancholy semicolon, provides for the eye. Analogies are to be found in the fine differentials and intimacies of music.

10. Hence, the inadvertent frankness of those who disparage the semicolon—fear it. Claim that it gains nothing. I can kid around, imagine a Nabokovian murder mystery

turning upon a misheard semicolon. Quote the painfully severely always generously pedagogi-
cally serious Barthelme yet recall too that to crush the tick on the dog's hide (i.e., a semicolon
under the skin of Donald's prose?) is to draw blood already drawn. But I'm really interested only
in the seriousness of this. The way the sentence and the thought are never complete (there-
fore, the sentence, with its punctuations visible or audible, is speaking *to* thought and about it).
Stretching the unit; keeping to the unit. Postponing the end, or full stop, becomes a reshaping
more than a lengthening; whether short sentence or long sentence is not really the point; nor is
punctuation in James Thurber's remark about Henry James that James, whose work he loved,
is very often trying to say everything at once or all in one thought or breath or set of unfolding
qualifications (or sentence).

11. The semicolon is *the* punctuation mark that draws from some of us identity issues.
Not me. Though not just a convenience for me, i.e. apart from my largely correct use,
even in the topographical quest that all but denies horizon, the doubled sentences in which
space is extending and overlapping on itself. I write short sentences, too, and not for contrast.

12. The semicolon as an aid to navigation for the reader and the writer. What differences in
weight and subsequence exist for semicolon, parenthesis, and dash? One must know
with each chance and choice. Semi- reminds that one must know everything—though Babel,
quoting this for more than one reason, understandably in his headlong (though not pell-mell)
passion seldom allows himself a semicolon (twice at a glance, toward the end of *Red Cavalry*).

13. The sentence that begins the last paragraph of "Un Amour de Swann" ("Swann in
Love") uses the semicolon correctly, yet one feels with that freedom something al-
most permissive, the idea branching into a longer list of phenomena and Swann there, finding
unexpected reasons in it, indulging himself in what is also the endless, perhaps horizonless rei-
magining of his obsessed love. C.K. Scott Moncrieff translates:

> But while, an hour after his awakening, he was giving instructions to the barber, so
> that his stiffly brushed hair should not become disarranged on the journey, he
> thought once again of his dream; he saw once again, as he had felt them close be-
> side him, Odette's pallid complexion, her too thin cheeks, her drawn features, her
> tired eyes, all the things which—in the course of those successive bursts of affection
> which had made of his enduring love for Odette a long oblivion of the first impression
> that he had formed of her—he had ceased to observe after the first few days of their
> intimacy, days to which, doubtless, while he slept, his memory had returned to seek
> the exact sensation of those things.

Years later, Terence Kilmartin, in his Proust, carrying on but editing Moncrieff, deletes that
semicolon and thus casts the sentence adrift among a false democracy of commas.

14. The semicolon feels unfinished. Which doesn't bother me; it speculates on time but
perhaps does not mark it. Semicolonoscope. I have offered only notes here.

*Since 1966, Joseph McElroy has published eight novels and a collection of short stories. His
new novel,* Cannonball, *will be published by Dzanc Books in June 2013.*

The multitudes labor over Wikipedia just as they slaved over the Great Pyramids of Egypt—for free.

A PYRAMID FOR TODAY

~ THE LIE OF WIKIPEDIA & THE TRUE ORIGINS OF THE INTERNET ~

BY IAN F. SVENONIUS

WIKIPEDIA IS SOMETHING SPECIAL. IT IS LIKE A LIBRARY OR A PUBLIC PARK. IT IS LIKE A TEMPLE FOR THE MIND. IT IS A PLACE WE CAN ALL GO TO THINK, TO LEARN, TO SHARE OUR KNOWLEDGE WITH OTHERS.—JIMMY WALES

OH! GO DOWN, MOSES, / AWAY DOWN TO EGYPT'S LAND, AND TELL KING PHARAOH / TO LET MY PEOPLE GO. —"GO DOWN, MOSES" (NEGRO SPIRITUAL, TRAD.)

I SEE IT STILL, even in my sleep. Jimmy Wales's wistful countenance on my computer screen. He looks pained. His body isn't visible in the JPEG, but based on his expression, I wonder whether he isn't being subjected to torture, so abject does he look as he pitiably beseeches me for funds, donations, alms, and oblations so as to grow and nourish the virtual monolith he's been building since 2001. You know it as Wikipedia, the internet's publicly built super-encyclopedia. And it is our obligation, Wales says with his imploring eyes, to bankroll his creation. →

PYRAMIDS BY TARA SINN

Millions have spent incalculable hours of their adult lives laboring on Wales's pyramid: ornamenting it, detailing it; constructing new additions, spin-offs, wings, and corridors. And his uncompensated labor force has created something unprecedented. Hailed as a new Wonder of the World, Wikipedia seemed to awake a final shred of idealism in the globe's otherwise nihilistic inhabitants. The Hanging Gardens of Babylon, the Temple of Artemis, and the Statue of Zeus at Olympia were all merely wonders, but Wikipedia is something else, something more profound. We are to believe that it is a grand monument to Gnosis, that it strives to contain all of humanity's history, hearsay, whims, and wisdom in one handy Hypertext Transfer Protocol location. Its devotees believe that, through its labyrinthine vastness and puffed-up claims of democracy, it redeems the entire electromagnetic morass that is the world wide web.

Astride it all is Jimmy Wales. Like the rail barons, the empire builders, and the pharaohs of Egypt, Wales harnessed the masses to construct an edifice the scope of which boggles the mind. He recruited an army of unpaid writers, researchers, editors, and scouts/spies/policemen who jealously officiate on one another. The multitudes labor over Wikipedia just as they once slaved over the Great Pyramids. But unlike with most slaves, there's no evidence of recalcitrant bitterness toward the master. Quite the contrary: Even as they drool to take part in the endless erection of his super-fetish with hours, months, and years of earnest volunteerism, they also have generously given their money—to the tune of $16,000,000 in donations in 2011—so as to bejewel Wikipedia. The pope, puttering through Vatican City in his Popemobile, would surely be impressed. "Who is this Jimmy Wales character," Benedict XVI might well wonder, "and why does he have such a mesmeric effect over so many—and what can the

Catholic Church learn from him?" Wales's followers will give any tithe that is asked, but rather than the ancients' tributes of fragrant oils and gold, the Wikipedians' fealty is measured in writing and editing hours—and, recently, in passionate protest. When the U.S. Congress was considering legislation regarding computer piracy, Wales called his soldiers to civic action, and they mobilized most militarily.

Such is their belief in the greatness of Wikipedia that normally passive people—who couldn't give a toss about millions killed in Iraq, secret torture chambers, nuclear meltdown in Japan, or ecological devastation—were enraged and politically engaged when Wales cued them to be. The enemy: proposed government regulation of pirated content on the internet. When renegade members of Congress put forth a group of laws known as SOPA, or the "Stop Online Piracy Act," in October 2011 to halt the unregulated online pillaging of copyrighted information such as music, film, writing, photography, and TV, Wales bared his teeth. SOPA threatened the ideology of "freedom" as propagated by Silicon Valley potentates, who—though they don't give their computers away for free—believe that all writing, photography, film, television, and music is everyone's right to own no matter what the circumstance or what the production cost. Wales and his coven were determined to stop the heretic lawmakers.

Wikipedia and its partner Google therefore invoked their monopoly on truth and information to rile the mob, who were rudely interrupted from watching a YouTube video of the Olsen Twins eating pizza in slow motion. Wales & Co. declared a crusade, ordering their army, which numbers in the scores of millions, to attack those who threatened precious "online freedoms" with "censorship." Wiki-Google also made symbolic protests, breaching their own empty rhetoric about net neutrality. Google's pious

protest took the shape of self-mutilation; they blotted out their (horribly designed) corporate logo on their homepage in a lame invocation of redactions in military memos. Wikipedia, an even greater paragon of net purity, not only blacked itself out for 24 hours (from January 18 to 19, 2012) but also coordinated another 7,000 sites shuttering their webcams for the day. The action was a great success, and public servants backed off of SOPA, chastised and embarrassed by a public temper tantrum thrown by a couple of internet giants. And what was the bill in question all about? What *was* SOPA, really? Nothing more than an upper-class spat between Hollywood and the tech industry, who both know that without free porn, music, and films, $2,000 internet-enabled devices hold a lot less consumer allure.

T H E H A R N E S S I N G O F "people power" through viral grassroots campaigning by billion-dollar megacorporations was a case of mass-hypnosis reminiscent of Barack Obama's first run for the presidency. Like our 44th commander-in-chief, the emperors of Silicon Valley are supposed to represent a new paradigm, something distinct from their predecessors. But, just as Obama has proved to be another run-of-the-mill Imperial President, Wiki-Google and their ilk are not unlike old-style hucksters, porn merchants, plagiarists, bootleggers, counterfeiters, and advertising firms. But despite their true nature, Wiki-Google and the other internet czars have effectively branded themselves as fresh and uncapitalistic. Like universities and hospitals (also businesses that pretend not to be businesses) Wiki-Google present themselves as noble, selfless, egalitarian, and democratic; part of mankind's pleasant if bumpy evolution into something less savage and more enlightened—like dolphins or Pleiadians. Conversely, Wales and his army want us to believe that without

Wikipedia we would quickly revert back down the ladder of nature from civilized people to cavemen, larvae, algae, and scum. And like a new nation, Wikipedia inspires not only fanatic loyalty but also moral and civic dogmatism. Just as the U.S. uses its "Peace Corps" to rehabilitate imperial depredation with a bushy-tailed front group that teaches ancient cultures the right way to take a dump, Wikipedia gives the radioactive bacteria mound of the internet a fresh coat of paint. Thus the war against SOPA was portrayed as a band of chivalrous internet knights fighting for freedom of speech and information against an encroaching totalitarian state. Wikipedia, they wanted us to believe, was the Library of Alexandria, and SOPA was an edict handed down by Emperor Theodosius. The very sanctity of knowledge was at stake, apparently. But what was really at risk was our ability to watch *Mad Men* without a cable subscription, or to illegally download the new Kanye West album to our iPods.

In their propaganda, the Wiki-Lords invoked not the reliable chestnut of Nazi fascism, which the government predictably trots out when marketing their wars against the day's appointed bogeyman (Gaddafi, Hussein, Milošević, and so on). Instead, SOPA was compared to Stalinist authoritarianism—government as freedom-crushing busybodies who cut off the flow of information and ensure their populace a rigid, gray half-life in a gulag of privation and ignorance. If SOPA had its way, we were led to believe, the average American would transmogrify into a Soviet Bloc citizen—a tragically stunted cavefish, entirely desexualized due to an acute lack of blue jeans, Superman comics, and Chanel handbags. This is heady and effective agitprop to today's American, for whom a lack of commodities equals frigidity. Since the latter half of the twentieth century, Americans have been prohibited from learning any skill besides shopping

Wikipedia is the crown jewel atop the pile of crap on the mound of shit in the cesspit of the internet.

and watching. A life without such occupations would be an existential purgatory. Therefore, conjuring the image of Iron Curtain oppression—and fearmongering about the loss of free HBO—were effective PR tactics for battling state control.

THE DEEP IRONY here is that while the internet Gods were making reference to Stalinist Russia, they were overlooking the fact that the internet itself has its roots in Soviet control tactics. Since the silicon lords' rise to power with their world wide web came in the immediate wake of the forces of capitalism vanquishing the Evil Eastern European Empire, it could seem to the casual onlooker that the death of one precipitated the birth of the other. The dirt was still fresh on the grave of the socialist experiment when, in its place, up sprouted an Ayn Randian supercharged adult virtual playground of total freedom and caprice. Replacing commie exhortations that individualism be submerged for the good of the state were personal computers and web pages, which detailed the dull nuances of everyone's inner life. But this hyperactive orgy of individualism did more to banish privacy than any communist regime ever did. And the best part? The individuals did all the work themselves. The guard towers, the esoteric doctrines of Marx and Lenin, and the shadowy secrets of the KGB were never able to accomplish the complete disintegration of solitude and confidentiality that the internet has wrought. And what's more, the web instantaneously linked the people who had been "trapped" behind the Iron Curtain to affluent Westerners who purchased them through human-trafficking sites such as russianbrides.com. These were among the first features of the internet, and they eventually evolved into social networking sites such as Facebook and OkCupid. Would it surprise you to learn that before his Wikipedia reign, the prophet Jimmy Wales worked in this prurient field, creating porn-aggregator sites?

Let's take a step back and see the ways in which the web itself resembles the most unsavory aspects of the Soviet era. The antiprivacy environment, the vulgar transparency of the internet's ideology of "connectedness," the rampant spying on citizens committed by entities like Facebook and Google—the whole internet paradigm, really—all bear an uncanny resemblance to Stalinist Russia. But this is only natural, since the web's actual inception likely stemmed from top-secret Soviet work in the field of parapsychology.

WE ALL KNOW that the modern personal computer and the accompanying internet system were developed by the military-industrial complex and conceptually driven by Randian Objectivists. But there are clues that the whole mess has even more nefarious origins than just the accepted gospel of development at the hands of the usual suspects such as IBM and MIT. In the 1960s, when the Americans were trouncing their foes in the field of atomic-missile development, the Soviets were advancing on another, extremely cryptic front known as "psychotronics." The Soviets were intrigued by the possibilities of mind control via any and all of the following techniques: hypnosis, mass suggestion, telepathy, linguistic engineering, clairvoyance, and ESP. When U.S. spies discovered the advanced nature of this Russian program, it sent the spooks at Langley into a panic. Mere muscle and might—even if it was nuclear-powered dynamite—would be no match for brainwashing, especially if it could creep across borders undetected and infect the populace with its Marxist contamination. The Defense Intelligence Agency, National Security Agency, and Central Intelligence Agency became determined to close the psychic-warfare gap. The CIA clumsily

struck out with its own debauched foray into the field of mind control with its ham-handed LSD experiments and the MK-Ultra program (which, other than thoroughly deranging the U.S. antiwar movement, aka the "hippies," didn't succeed in bringing the populace under the government's yoke). There was still diversity of opinion and even a little nonconformity to be found in America. TV and art were fine envoys of suggestion and social programming, but they could do only so much. To really pacify the population, spy on their citizens' innermost thoughts, and control the masses, our government had to get hold of Soviet psychotronics. And with the collapse of the Soviet Union, the Americans rushed into the gap. The turncoat Gorbachev was more than willing to lay out all the hitherto hidden goodies for the victors to see, like a buffet table of techniques for coercion and control. What exactly did American operatives find there? Experts on the subject speak in hushed tones of telepathy, precognition—even sinister code words that, upon utterance, render the innocent into pliable zombies. But whatever they were, the results of this collusion have been cataclysmic for the human race. The mind-control techniques mastered by the KGB and pilfered by American agents were undoubtedly utilized by the Silicon Valley crowd (who were already beholden to their Pentagon paymasters) and have been used to instill total idiocy and complacency in the entire population of the United States. Because what is the internet, really, but ESP, clairvoyance, astral travel, and neuro-linguistic programming for the masses? Nothing—not the Spanish Inquisition or the death camps of Pol Pot's Cambodia—has come close to pacifying a population in the manner that the world wide web does. And frighteningly, we come full circle when we realize that the most profound cog in the internet's complacency machine is Jimmy

Wales's Wikipedia. For the first time since Nazi Germany, people have a single source for all answers, a direct valve that can satisfy their curiosity about why rainbows appear, what the radius of gyration is, and what make of automobile the Duke of Gloucester digs. And, through some arcane magick—or an unholy pact with Google—Wikipedia is designed to pop up in the top results no matter what topic one types into any search engine. For the lazy journalist and the average schmo alike, Wikipedia offers what they believe to be simple, pure truth.

W IKIPEDIA ALSO has a pseudo-religious aspect. It helps internet users to give penance for all the hours they've logged looking at such filth as Perez Hilton, TMZ, celebrity nudes, "12 Things to Do Before You're 25," "8 Reasons to Have a One-Night Stand," and anything involving bath-salt hysteria. Wikipedia also absolves its users of the shame spiral that comes from all that pressing of "Like" buttons, retweeting some lame comedian, and leaving hateful anonymous comments on every- and anything. Who wouldn't seek to mortify their flesh after all that? Wikipedia is a Sunday-morning salve against the lies, betrayals, and self-defeating debauchery that implicate each and every user of a computer, and for which we all feel shame, self-contempt, disgust, and chagrin. But can we blame the flesh for being wanting? Would we tease the shark with a tender child and then chastise it for taking a chomp? No. And yet we can blame the computer for what it does to us. Victims of assault are traumatized, stripped of innocence and the capacity for trust—as are we by what the internet flashes us with, molests us with, and compels us to search for. In textbook Stockholm-syndrome style we want to redeem the groping, insinuating, addictive machine with a daily bout of

worthy, earnest Wikipedia'ing; polishing the grommet on the page of this or that wretched *Star Wars* character and grimly policing our fellow citizens who post "unverified" items. This is the internet's equivalent of reciting the rosary.

And this church has priests. The Wikipedia clergy, like the East German Stasi, is anonymous, plainclothed, and ubiquitous. It comprises hundreds of thousands of seemingly ordinary citizens who present themselves as something entirely mundane by day—bakers, builders, homemakers, engineers, you name it. But when alone in their "computer room," with the screen eerily lighting up their face, they report uncertified interlopers and scour the realm for evidence of sabotage on whatever scurrilous and useless wiki page they feel is their jurisdiction. The lord's lands are determined to be free of scoundrels, and these robo-snitches hunt down outlaws like so many Sheriffs of Nottingham.

B ECAUSE THE AMERICAN educational system has become so degraded since the end of the Cold War—representing a complete surrender of humanism or any sort of hope for the future—schools are now entirely subservient to "business," which is considered the only honorable profession. Wikipedia is complicit in this because it excuses the population for its abject ignorance by replacing places of actual study with a fanciful aether campus. It champions laziness, lameness, immediate gratification, and a total lack of depth in understanding. With Wikipedia as your accomplice, dilettantism is easier than ever before. A mere 13 years ago, the film *The Matrix* proposed a world in which the protagonists could plug themselves into data and be able to forgo the sweat and tears of reading, practice, homework, and discipline. How quickly we've arrived at that place in reality. But to rely on Wiki-

pedia for facts is to manifest a helpless degree of trust in the monolith of the web. And as the populace increasingly relies on the internet, the rulers of the internet become increasingly sanctimonious about their domain. Today we see the internet marketed as a benevolent miracle, not unlike asbestos in the 1930s. Twitter seems actually to believe that it helped topple dictators during the Arab Spring and, even now, spreads the seeds of democracy in Iran and Saudi Arabia. Facebook, with its ceaseless bleating about connectivity and freedom, has all but awarded itself a Nobel Prize for reuniting lonely men in their late 40s with that one girl in high school—her name was Lauren or something—and it seemed like, if things had been a little different back then, maybe they could have, you know, gotten together. But the slant of the analysis and coverage to be found on the web—both in the social-media sphere and in online news sources—is just the same that we see from America's ideological mainstays: Bloomberg, the Associated Press, the *New York Times*, and so on. Just because a piece of news appears on a blog, delivered in snarlingly pithy blogger language, doesn't make it revolutionary. Yet this is the story that's being crafted. The web has slain the dragon of the old media. Wikipedia, the *Pravda* of the internet machine, feeds its writers—the mass of wiki slaves—an arch ideology of web as savior and life-bringer. The faithful then repeat the tale again and again, hardening myth into gospel like coal into a diamond. The internet, they tell us, is a coursing fount of liberating and redeeming goodness. And far up there in the firmament sits the benevolent titan Jimmy Wales, his fingers jerking the strings that control it all.

T HE SOPA BATTLE revealed a virulent ideology on the part of Wiki-Google. And why? Because Google is a

What is the internet, really, but ESP, clairvoyance, astral travel, and neuro-linguistic programming for the masses?

huge corporation that draws much of its revenue from the free content on the internet. In fact, computers as we know them are designed specifically to steal content from creators of content. So we saw Wiki-Google's teeth bared at the slightest sign of regulation by the elected officials in Congress. It upset the Wikipedians that a wonderful, charitable public institution such as the Wiki-Google was sad. Millions took to their Twitter, Facebook, and Tumblr accounts to register their fist-shaking indignation in support of the web-ogres. Predictably, the SOPA bill was struck down, its death accompanied by shrill cries of glee from the iMob.

But at least it led to the crossing out of one company logo for a 24-hour period. From that tiny victory, we should glean hope. The corporate signifier of a bunch of Ayn Rand cultists being invisible for even a day was a triumph for decency. That blotted-out logo became a symbol of joy. And seeing every sycophantic, lamprey-like smaller site that also went black in protest should have increased that joy tenfold. The stillness across the internet that day served to remind us

that the whole enterprise is just a phase; that one day the web will be displaced, just as VCRs, record players, and drive-in movies were. And when the internet is finally put into storage along with the 8-track, we'll see that life can go on just fine without it. Once the phantom pain in our mouse-clicking fingers subsides, the needlessness of the entire world wide web will be laid bare and humans can get on with their real lives again.

Wikipedia is the crown jewel atop the pile of crap on the mound of shit in the cesspit of the internet. We are all its victims, and now that we have identified our foe, we must stand firm. Stop Googling everything all the time. Stop taking Wikipedia at its word. Emerge into the daylight again and find some answers for yourself. Have a conversation, go for a walk in a park or a forest—maybe even journey to a friend's house to watch a film together or to play a game. Who knows what's possible next? No one can guess what form our future freedom will take. But for now, let us simply find comfort in the knowledge that, like Christianity, Wiki-Google's days are numbered. 🐾

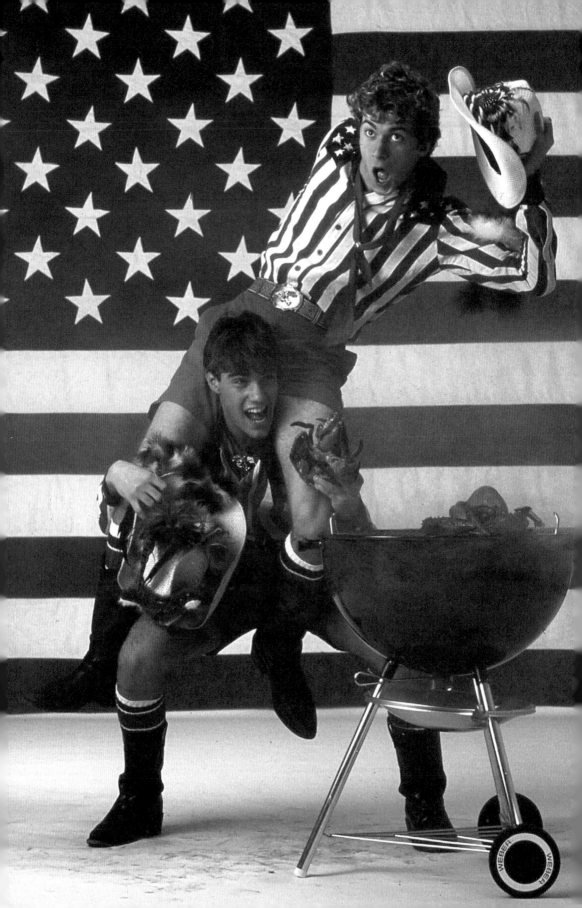

THE UTTERLY MONSTROUS, MIND-ROASTING SAGA OF O.C. AND STIGGS

Cooler than Ferris. As savage as the Heathers. O.C. and Stiggs were poised to be the ultimate teen-movie hell-raisers of the 1980s. Instead, they became pawns in a totally bananas, totally forgotten Robert Altman comedy. →

BY HUNTER STEPHENSON

I T ' S A N O T H E R unremarkable summer night in suburban Arizona in 1983. Two teen miscreants named O.C. and Stiggs are scaling the walled backyard of a well-to-do family. They've brought along bags of fireworks and two over-dressed female acquaintances they cheerily refer to as "the sluts." Beneath a pair of eccentric sunglasses, Stiggs appears to be riding out some unspecified buzz as he darts toward the swimming pool. We're observing these four teens through patio windows, alongside the family's hyperventilating son, as they proceed to skinny-dip. The rest of the family is unaware, planted in front of a television on which a dour-faced talking head is rambling on about the fall of the Roman Empire. His heated rhetoric, the drone of polarizing media, sounds strangely contemporary even in 2013. O.C. and Stiggs catch a glimpse of the pundit from the pool and give him a sarcastic shout as he rambles on about how "blood, sweat, and tears built the highways, won your wars. But the schools are telling you there's an easy way. A short cut." Suddenly one of the so-called sluts screams as a dead scorpion floats by her in the pool. The family is alerted. O.C. and Stiggs are busted. Bare-assed, the foursome scurry away, winding up in the backyard of an adjacent McMansion. In this new yard, the four teens are struck by a heavy ambience, a Gordon Gekko-in-Tahiti vibe, all Polynesian torches and power-yuppie furnishings. The home's owner appears, enrobed, dripping gold necklaces, tanned all to hell, and greets our young heroes with offerings of brown liquor. This playboy has O.C. and Stiggs's complete attention—he clearly embodies their dreams of the adulthood that possibly awaits them. "I wonder what the poor people are doing tonight," he asks, not really caring. "I can tell you where 634 of them are going to be on Monday morning. Working for me. In my sweatshop." O.C. and Stiggs nod, impressed.

National Lampoon, *October 1982*

A T T E M P T I N G T O summarize even a single sequence from any Robert Altman film, as I've just done, is futile—but even more so if that film is *O.C. and Stiggs*. So much kooky information is being communicated in the moments above, and throughout the entire movie, that it's impossible to register the film's totality on first viewing. A careful replay (or three) is needed to take in the vintage Altman density. For instance, the prototypical neocon pundit on the TV warns that Rome was "full of statues, teeming with art," and a minute later, we're lounging in the neighboring playboy's yard, where he serves Scorpion-brand liquor while nude statues stand in the background. Deciphering, making connections, and often just going along for the ride is all part of the bizarre odyssey that is *O.C. and Stiggs*, perhaps the final lost, awesome teen flick of the 1980s.

The marriage of Robert Altman—indomitable, weed-endorsing auteur behind *The Long Goodbye* and *McCabe & Mrs. Miller*—to 80s teen rager films like *Fast*

Times at Ridgemont High and *Valley Girl*, gave us the riskiest, weirdest, and most genuinely subversive film of the whole genre. And so now, on the 25th anniversary of *O.C. and Stiggs*'s troubled release, we aim to uncover the full story behind this forgotten film and to understand why it now resides in the pop-culture isolation chamber. Seriously—no one remembers this movie, including the vast majority of Altman cognoscenti and 80s-trivia fiends (and, quite possibly, even some of the film's crew). What we found in charting the history from page to nary a screen was an unexpected clash of vision between two heavyweight presences in 70s counterculture, each cynically confronting the 80s head-on. In one corner was Altman. In the other, the *National Lampoon*, America's gnarliest humor magazine.

.It was April 1970 when the debut issue of the *Lampoon* hit newsstands—only one month after Altman's definitive statement, *M*A*S*H*, opened in theaters. Both freaked out the zeitgeist like few things before or since. They both helped set the tone of the 70s—the dark, introspective, cynical hangover of the ridiculous 60s. So it was inevitable that at some point Altman and the *Lampoon* would cross paths on something. Ten years later, finally, they did.

O.C. AND STIGGS were created by Ted Mann and Tod Carroll, both searing senior editors at the *National Lampoon*—part of the same second-gen staff that included newcomer John Hughes. Mann and Carroll created O.C. and Stiggs at the dawn of the 1980s to combat what they saw as the dangerous incoming era of the Slurpee mallplex demographic, a new strain of teen consumers, lobotomized Alfred E. Neumans raised on television and sugar rather than countercultural literature and grass. And there was no doubt about it—these were the

kids who were now buying the *Lampoon* at their local 7-Elevens. So Mann and Carroll had their eyeballs, and they tried to lure them over to their way of thinking via O.C. and Stiggs, who were really just a hyper mirror id of their debaucherous creators. By inserting their own well-read, iconoclastic sensibility into these punk-kid avatars, maybe Mann and Carroll hoped to show the teens of the 80s that they too should aim higher—at being creative and destructive at once. Perhaps they felt a sense of demented responsibility.[1] After all, the *Lampoon* had (with good intentions) arguably kick-started the whole youth-chaos trend by cowriting and spearheading 1978's *Animal House*—the biggest R-rated comedy of its time. Who better to preemptively terrorize this annoyingly ubiquitous niche than the very magazine that engineered it?

In hindsight, Mark Stiggs and Oliver "O.C., for 'Out of Control'" Oglevey are the sociopathic prototypes for the long line of household-name suburban teen delinquents who followed, from Wayne and Garth to Beavis and Butt-Head to the kids of *South Park*. (The most recent incarnation of this ethos of creative destruction is probably the delinquent rappers of Odd Future. And the final drawing on the devolution chart was *Step Brothers*.) But O.C. and Stiggs were different from their successors. They were highly cunning and thus more dangerous. They thought smart and acted stupid—an absurd and explosive combination. Dearest to their dark hearts was the never-ending joy they took in harassing an upper-middle-class family of conservative drips called the Schwabs. (Always pronounced by the duo as "Schwaaaaab," using a thick patois informed by their consumption of Mexican codeine cough syrup.) To use a lame analogy, but to quickly give you the idea:

1. But probably not. After researching and interviewing Mann, I get the distinct sense that he gives not much of a fuck about anything.

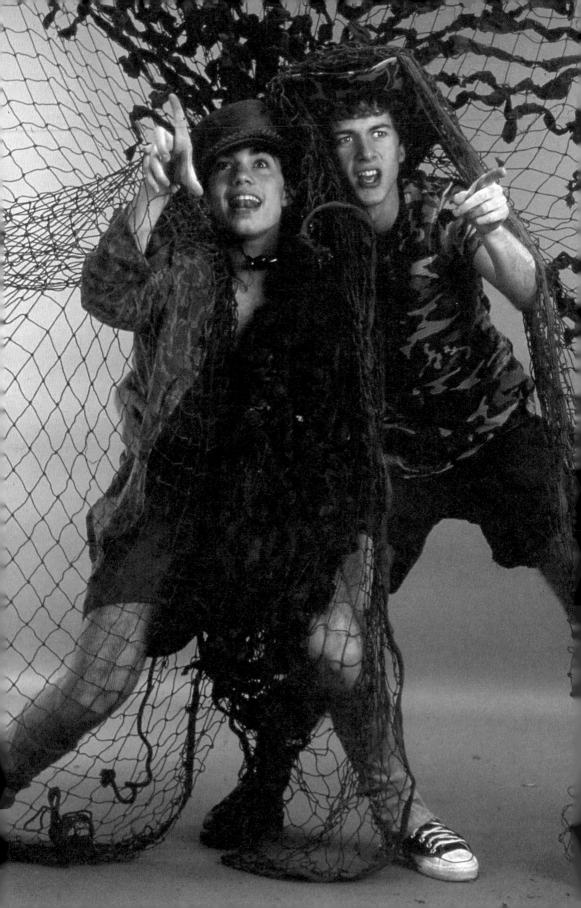

If O.C. and Stiggs are Ferris Bueller, then the Schwabs are Ed Rooney, his nemesis in principal's clothing. The Schwabs, led by patriarch Randall Sr., a bigoted Arizona insurance salesman, further consist of surly alcoholic wife Elinore, spaz hornball son Randall Jr., his frazzled, cyst-leaking "c-y-s-t-e-r," Lenore, and Lenore's new husband, the family's Asian whipping boy of a golf caddie, Frankie Tang. Like an estuary of anarchy, the boys' refined Schwab hatred flows into a more universal, proactive curation of a "monstrous, mind-roasting summer" filled with music and mayhem.

O.C. AND STIGGS made their debut in *National Lampoon* in July 1981, just a few months after Ronald Reagan moved into the White House. At the magazine's Madison Avenue headquarters, clouds of weasel dust and death loomed. The staff had experienced a passing of the torch from the mag's brilliant founding core of talent, who had for the most part decamped. Some of them had headed to the snowy Hollywood Hills to chateau it up. But one of them—the man who was the key to the *Lampoon*'s golden era, had died. The previous summer, the magazine's cofounder Doug Kenney, the bright heart and manic soul of the company and a writer of *Animal House*,[2] literally fell off a cliff while on a vacation-*cum*-detox in Hawaii. The tragic punch line was that Kenney, 33, tripped while looking for a place to jump. His nerves had been rocked after losing a nasty battle with Hollywood producers regarding his sophomore effort, *Caddyshack*. Bypassing Kenney's pleas, the film's moneymen had demanded that scenes involving a frisky Disney-style gopher be added. In the wake of his death, the *Lampoon* was feeling corporate pressure to sex up and dumb down editorial.

The pressure had always been there—it's eventually felt at all youth-driven media companies—but now the balance was tilting. It was in this hothouse that Mann began work on the project.

The actual impetus for O.C. and Stiggs occurred after a trip that Mann took with the mag's former editor-in-chief P.J. O'Rourke. Their botched and heavily inebriated mission to save a bevy of Long Island women during a nasty winter storm led to Mann being labeled "out of control." Inspiration struck. Mann's characters were the fictional ambassadors of July 1981's "Endless, Mindless Summer Sex" issue. Its cover girl was a beach bimbo with a blow-up valve on her back. Pure class. O.C. and Stiggs, seen here for the first time, were a splash of reactionary black bile wearing cheeky Hawaiian shirts. From the get-go, the duo casually advised readers on how to spend their summer break: casual sex with rich private school girls "who start fucking and eating breakfast in Paris when they're about ten," pocketing money from said girls' purses to buy lobsters, eating pages of the Bible, and "rolling" gay men to buy more lobsters (primarily for the purpose of throwing them on the freeway, because, look at them, they're horrendous). A bonus hot tip encourages readers to locate the universal neighborhood hanger-on, get him wasted, wreck his car, and pin the consequences on him. O'Rourke had issued a "counter-counterculture" take-no-prisoners editorial edict to his staff, and Mann decided to take it to the nth degree, promoting rampant destruction and nihilism and even letting O.C. and Stiggs swim unapologetically in un-PC waters. At the early-to-mid-70s *Lampoon*, it had been open season on America's filthy politicians, religious censors, and the military-industrial complex. O'Rourke's late-70s reign continued all that, while lifting the embargo on attacking liberal causes and minorities. O.C.

2. In *Animal House*, Kenney also played the small role of Delta brother Stork.

and Stiggs were satire taken so far that it risked becoming indistinguishable from what it was satirizing.[3] And it was all getting out to a rather large audience—at the time of this issue's release, the *Lampoon*'s circulation hovered around 600,000 copies per month.

> Me and Stiggs were wearing gold-and-azure-flecked Lurex tuxedos from Dee's Tuxtique—a 100-percent Negro operation, limited exclusively to colors, substances, and textures alluring to Negroes only. Because there was a filthy ethnic barbershop next to the tux place, and because this shop had 1950s magazine photos of hairstylings from the East Coast gene axis of dark, bony-foreheaded Italo-Hispanic proto-men with total petroleum bonded, boxlike formations of viscid black hair, we decided to step in for a so-called modified bop, which harmonized well with the tuxedos, as well as doing a first-class job of pissing off the Schwabs. It was great.
>
> —O.C., preparing to crash Lenore Schwab's wedding reception, from "The Utterly Monstrous, Mind-Roasting Summer of O.C. and Stiggs" issue of the *National Lampoon*, October 1982

3. MTV's *Beavis and Butt-Head* is obviously the great 90s parallel to the *Lampoon*'s O.C. and Stiggs. As satire, both sets of teen misfit characters succeed at simultaneously mocking and satiating their unsophisticated, money-to-burn teen audiences. That said, *Beavis and Butt-Head* isn't nearly as socially aggressive, nor are the intentions and temperament of the characters' sole creator so baited in dubiousness. Mike Judge's Beavis and Butt-Head are too dumb, too oblivious to their abject poverty, to spur accusations of being a voice of influence to young males. (Of course, politicians in Washington accused them of just that, but so what...) Unlike Viacom-filtered animation, however stealth, the medium of print afforded privacy and intimacy to both the reader and the faceless writers of O.C. and Stiggs's high jinks. Plus, Mann and Carroll's byline, the naked fact that two males were responsible, gave one cause to almost wonder whether these characters were not so much ids cast in their creators' image as a winking, pseudoconfessional outlet.

When researching this article, I came across a photo of Mann taken in his 80s *Lampoon* days. A deflated balloon hangs from his mouth, and the caption reads, "The craziest of them all: Mann on the day he brought a tank of nitrous oxide to an editorial meeting." Mann's darkly lit personal office at the *Lampoon* was known to have been decked out in a bewildering Colonel Kurtzian motif: Full-on tribal African spears and shields, a hammock in lieu of a desk, and tiny umbrella drinks served to visitors. (All of which uncannily resembles the bedroom of Stiggs in Altman's adaptation.) When I spoke with him recently, Mann told me, "My office's jungle motif was an affirmation of an imaginary freedom and an attempt to distinguish myself from the adman who looked out between the Tide boxes from the window directly opposite mine across 59th Street. It was a forlorn hope, and the camo canvas stunk."

Over and out. But still, Mann and Carroll raised the ante on O.C. and Stiggs's brand of funny-sick in '82. That February's issue faux-leaked the characters' "Annual Gash Report." Designed like a Wall Street firm's prospectus—O.C.'s introduction is even signed all presidential-like—the duo therein explain how they sold $4,000 worth of their dads' stocks to professionally graph a year's worth of lays. Included is an analysis of a night spent breaking into a local halfway house wearing pig masks—creepy photo included—to rape disturbed, horse-tranquilized female patients. (Is it any surprise that, in 1995, while doing press for *Kids*, Harmony Korine called *O.C. and Stiggs* one of his favorite films?) By the June '82 issue, the duo's acidic relations with the opposite sex found their nadir in a minutiae-heavy firsthand travel expose that detailed the seduction, porking, and shaming of Barbara Bush, wife of then vice president George H.W. Bush. I asked Mann what the reaction might be

if those features were published today. "I don't know," he said. "The reaction then was silence. There are people today, as then, who are not able to see shades of meaning or discern the purpose of art. Those people watch *Porky's* and *Animal House* and consider them both to be fine teen comedies."

October 1982 marked the characters' final appearance in the magazine, and appropriately, this time they hijacked the entire thing. Titled the "Utterly Monstrous, Mind-Roasting Summer of O.C. and Stiggs" issue, it's regarded as a late-inning home run in the *Lampoon's* history. Seek it out online. It's also the basis for the film's screenplay. The issue is an epic, cascading recollection of the boys' relentless criminal harassment of the Schwabs over the course of one summer. Why the Schwabs? That's just the way it is. It's never properly explained. I asked Mann why O.C. and Stiggs are the way they are. "Tod Carroll and I set out to tell the truth, in an amplified way, about coming of age in middle-class America for a certain type of kid," he said. "I find [the magazine version of *O.C. and Stiggs*] a more interesting account of American adolescent furor than Salinger's. The characters were drawn from my experiences and Carrolls's, growing up in privileged suburban North America. Many of the events were drawn from life, others from confabulations of urban legends, adolescent erotic myths, and Egyptian myth—as is usual in fiction."

These characters never lowered themselves to smashing mailboxes or leaving a flaming bag of shit on a doorstep. This wasn't mere pranksterism. The adolescent furor in the original O.C. and Stiggs pieces is turned by the characters into a self-knowing, libidinous art form. There's something vicariously clawing to the adventures here, whether the duo is checking into a local hotel to drunkenly order a fortune in room-service roses (the better to achieve the fullest petal scent possible in a tub), passing out alone on an expertly critiqued rooftop, or blackmailing a gay teacher they encounter on a train to Mexico. Personally, I think the duo's print legend is sealed when they bring "the sluts"—those timeless, pill-dispensing private school angels—to accompany them to a lavish "French lobster dinner." As the girls sit incapacitated beside them like premature 40-year-olds, the boys loudly divvy up the bill to each of the girls' absent fathers. All 12 of them. For dessert:

> Me and Stiggs ate a record of nine lobsters, although we ordered twenty altogether so we'd be sure to have enough pincers and eye stalks to cannibalize for the La Chameriquetyville Horror—a terrifying three-foot-long monster we generally like to make from soufflés, lobsters, and lettuce in restaurants where people will want to kill us for doing it. The La Chameriquetyville Horror was... designed like a giant queen termite, but with the added aspect of two hundred dorsal fins and crab fork antennae that could be moved to make a tongue of lettuce slide in and out of the mouth. "You'll have to leave," the maître d said. "Remove that pile of food from the floor and get out."

O.C. AND STIGGS were a hit. A full five years after the characters' final appearance in the magazine, a market-research poll of *Lampoon* readers ranked O.C. and Stiggs as their favorite feature by a good margin.[4] To this day, *Lampoon* readers can be found online praising their exploits. It's no surprise that this popularity—along with the recent memory of the magazine's film success with *Animal*

4. *If You Don't Buy This Book We'll Kill This Dog: Life, Laughs and Death at National Lampoon* by Matty Simmons (Barricade Books, 1994).

House[5]—led to a screenplay. But perhaps there was another impetus to get it written in a rush. In March 1982, John Belushi — the filmic face of the *Lampoon* just as Doug Kenney had been the brand's mighty pen—died of a fatal overdose in his bungalow at the Chateau Marmont. Just like Kenney, he was 33 when he died. Belushi had flown into LA for studio meetings with David Katzenberg and Michael Eisner at Paramount to consider, with heavy reluctance, a lead role in the planned *National Lampoon's The Joy of Sex*, which was written by John Hughes. The sourness of these talks was later speculated to be a tipping point in Belushi's terminal night of partying. The troubled actor, who feared being typecast as *Animal House*'s Bluto, had reportedly taken great offense at the suggestion that his character wear a diaper.[6]

For Mann and Carroll, witnessing the pillars of the *Lampoon* ethos, grown men dedicated to expanding America's idea of mainstream humor, implode over gopher puppets and Pampers may have lent an urgency to the adaptation of the "Utterly Monstrous, Mind-Roasting Summer of O.C. and Stiggs" into a script, which initially bore the same title. When it circulated to several Hollywood studios, the screenplay's edginess generated instant heat. At Paramount, Katzenberg surprised the editors by making an offer within 24 hours of reading the script. The downside to Katzenberg's offer was that he wanted to "develop" the project—which in the studio world is a code word for "tame and dilute" it. At the same time, Sylvester Stallone, who had just directed *Rocky III* and *Stayin' Alive*, totally flipped for the script and showed vocal interest in directing. No one was more shocked by all this enthusiasm than Matty Simmons, founding publisher and chairman of the *National Lampoon*. Privately, Simmons— who was avidly looking to replicate *Animal House*'s galactic success—had confided to Mann and Carroll that O.C. and Stiggs were frankly just too unlikable, too vulgar, to build a blockbuster around. He had even given them free rein to pursue a deal outside the *Lampoon*. Now he was flirting with reneging on that agreement. Meanwhile, Stallone was also weighing the lead role in *Beverly Hills Cop*. And at the same time, Mann and Carroll's coworker John Hughes was starting principal photography on *Sixteen Candles*, which would begin his run of definitive 80s youth films. As Simmons twiddled his thumbs, waiting to hear back from Stallone's camp, Mann and Carroll sought out a producer to quickly attach an A-list director, escape development hell, and get their film made.

They soon linked up with an upstart producer named Peter Newman. Today, Newman is head of the dual MBA/MFA program at NYU's Tisch School of the Arts and a sharp producer of independents like *The Squid and the Whale*, *Swimming to Cambodia*, and *Martha Marcy May Marlene* director Sean Durkin's upcoming Janis Joplin biopic.

PETER NEWMAN: The project's development was a whirlwind. One night at a bar in Manhattan, I met a fellow named Jim Goode, who had been an executive editor at *Playboy*, *Penthouse*, and *Oui*. He had devised this

5. Mann and Carroll, along with John Hughes, had been dismayed in 1982 by the inexplicable success of *Porky's*. The film was an incensing piece of shit, a no-budget rip-off of *Animal House*, down to its title and nostalgic 1950s setting. Mann, Carroll, and Hughes all felt they could outdo both those films. And all three had also written for 1979's *Delta House*—the *Lampoon*'s quickly canceled ABC spin-off of *Animal House*. Looking back, the notion that ABC hoped such a series would work, at "family hour" no less, seems ridiculous. But *M*A*S*H* had set fresh precedent for a rowdy R-rated comedy turned huge network series, so it was worth a shot, at least. And in a twist of fate, another *Delta House* writer and *Lampoon* associate, Michael Tolkin, would go on to write the book and adapted screenplay for Altman's *The Player*, for which Tolkin earned an Academy Award nomination.

6. *Wired: The Short Life and Fast Times of John Belushi* by Bob Woodward (Simon & Schuster, 1984).

system to identify magazine pieces that were ready to go as movies. He said he might have something for me and my producer partner. Great. Well, the next morning, he shows up at my office with Ted Mann and Tod Carroll from the *National Lampoon*, puts their October '82 issue on my desk, and says, "This is a movie." So I read it. It's hilarious but very provocative. I'm already picturing a movie far more controversial than *Animal House*. [But] it was clear right then that [none of us] wanted to make a broad comedy like [that]. In those days, being a producer meant you made whatever was interesting. That was the entire point of being in the business. My producing partner was a Virginia gentleman, much older than me, 65, named Lewis Allan. He'd produced Truffaut's *Fahrenheit 451* and *Annie* on Broadway, so I wasn't sure he'd want to make [*O.C. and Stiggs*]. He read the October '82 issue and also said it was the funniest thing he'd ever read. That was a signal that we had something special. We made a deal with Tod and Ted.

Lewis Allan and Newman rummaged through their Rolodex of directors and quickly got a serious bite.

PETER NEWMAN: Mike Nichols agreed to make it. I'll never forget it. He met with Tod, Ted and me, and he said, "It would be great if one of these two kids was Eddie Murphy." Tod and Ted just said, "But these two kids are white." Maybe they worded it stronger. [*laughs*] My idea, which was stupid on my part, was to cast Matthew Broderick. He'd just been in *WarGames* at MGM. We met with him, but he was just too nice to play O.C. or Stiggs. And, of course, Jon Cryer, who was then Matt's understudy on Broadway, we ended up casting later as the nerd, Randall Schwab Jr. Jim Carrey, who was an unknown then, tried out for that part, too. And Laura Dern was in the cards at some point to be one of the two "sluts."

TED MANN: Mike Nichols is a very good director. I don't believe he was entirely comfortable with the unapologetic sociopathy of the main

characters. He's more of the Salinger sort. If Nichols wanted Eddie Murphy as a lead, it suggested he hadn't read the material.

PETER NEWMAN: Nichols was taking forever due to his Broadway commitments and other projects. I was socializing a lot with Robert Altman, having made *Come Back to the Five and Dime, Jimmy Dean, Jimmy Dean* with him, but he showed little interest in *O.C. and Stiggs*. [Then] one day, he said to me, "Maybe I could do that teen movie."

Nichols had once circled *Animal House*, so his interest in the semirelated project made sense. And Altman shared a friendly competiveness with Nichols, dating back to 1970, when *M*A*S*H* overshadowed and beat out on every level Nichols's hyped and highly anticipated war film *Catch-22*. Newman's talks with Altman's team initially took place through Allan Nicholls, who was a part of the die-hard core of Altman's inner circle from the mid-70s until Altman's death in 2006. Nicholls's credits span from writing the screenplays for Altman's *A Wedding* and *A Perfect Couple* to composing music for the ensemble masterpiece *Nashville* to assistant-directing *The Player*. For *O.C. and Stiggs*, he was hands-on at every stage, serving as the film's production manager, among other duties.

ALLAN NICHOLLS: When it was offered to Bob, he was actually searching for a property for me to direct. We felt like *O.C. and Stiggs* was the one. So I met with Ted Mann and Peter Newman at this sex club in Manhattan. [*laughs*] My take was much different from Bob's, and closer to Ted's vision, where O.C. and Stiggs are totally outrageous—evil, almost. No ulterior motive. Not as intelligent as in Bob's version. Like, if you took Bluto, Belushi's character, but set an entire movie in that mind-set. Just make it insane. I could see Bob misinterpreting *National Lampoon* for *MAD* magazine back then.

Altman was moved to the director's chair, and MGM arose to counter Paramount, agreeing to an immediate greenlight. MGM was in desperate need of a youth-oriented hit. The studio had recently absorbed United Artists and its debts from 1980's *Heaven's Gate*, the notorious flop that, alongside Francis Ford Coppola's *Apocalypse Now*, signaled the death knell for the unchecked freedom and excess of 70s auteurs. For a then-decent budget of $7 to $8 million, MGM agreed to keep Mann and Carroll's R-rated script untouched. More important, studio execs ordered Altman to stick to their draft and to remain tight-lipped to the press.

PETER NEWMAN: Altman was a natural-born salesman. He was selling MGM on how great the film was going to be. It was music to execs' ears. In the early to mid-80s, when things started changing, it was becoming all about money. We slid under the gate. Bob hated the studios, and this was his last studio movie; MGM was also the only studio that would work with him. By '83, he had created a shell around himself. I think it goes back to the fact [that] he never made more than twenty grand on *M*A*S*H*. When he criticized the studio that made *M*A*S*H*, they took all his points away. So Altman saw all studios as "the Man." That said, from preproduction on through production I thought we had a sizable hit on our hands.

ROBERT ALTMAN: [*O.C. and Stiggs*] was about how two teenage boys spend their summer, and it was also about cultural anarchy. Teenage exploitation films were all the rage at the time... I agreed to do it because I hated teenage movies so much. I thought I could do it as a satire of a teenage movie. But of course it was sold as a teenage movie. It was a suspect project from the beginning.[7]

Altman foresaw the hairpin turn in early-80s Hollywood toward market-tested,

youth-oriented comedies and genre spectacle. He knew that these trends likely meant an end to the creative carte blanche he'd enjoyed throughout the 70s. Ironically, it was Altman who had first snuck a verbalized "fuck" into a studio picture with his 1970 antiwar, dark-comedy masterpiece *M*A*S*H*. But by 1982, American cinema was becoming swamped with a potty-mouthed deluge of crap that promoted boobs and juvenile antics solely to pander to a growing demographic of mall rats. And while the surprise smash that was *M*A*S*H* had anointed Altman as New Hollywood's assimilator into the mainstream of hip experimentalism and freewheeling narrative, in the following years he had refused to compromise his most cavalier stylistic whims or to lower his critical voice—and he had paid the price. By 1983, he was in his late 50s and out on the industry fringe. He was the rarest of directors: the older he got, the more heartily he channeled his inner fuck-you teenager.

When an out-of-the-blue opportunity arose to dabble in the popular teen genre he so despised, replete with a decent budget, a buzzing screenplay, and final cut, he took the plunge. He brought a dexterous grab bag of tricks to his interpretation of the material. His signature uses of the zoom and the wandering camera—gestures meant to stimulate in viewers an awareness that they were watching a piece of work rather than pure escapism—brought a sense of aquatic voyeurism to the movie. As the boys pull pranks, tolerate their dysfunctional families, nurse hangovers, surf, and skinny-dip, the drifting feel of Altman's direction leaves us ample mental reserves with which to snorkel over the wackiness on the periphery of every scene. Altman similarly taps his pioneering passion for layered sound and dialogue—an audio track that eavesdrops on impatient, absurdist currents. Visually and aurally, the film overflows with Easter

7. *Altman on Altman*, edited by David Thompson (Faber and Faber, 2006).

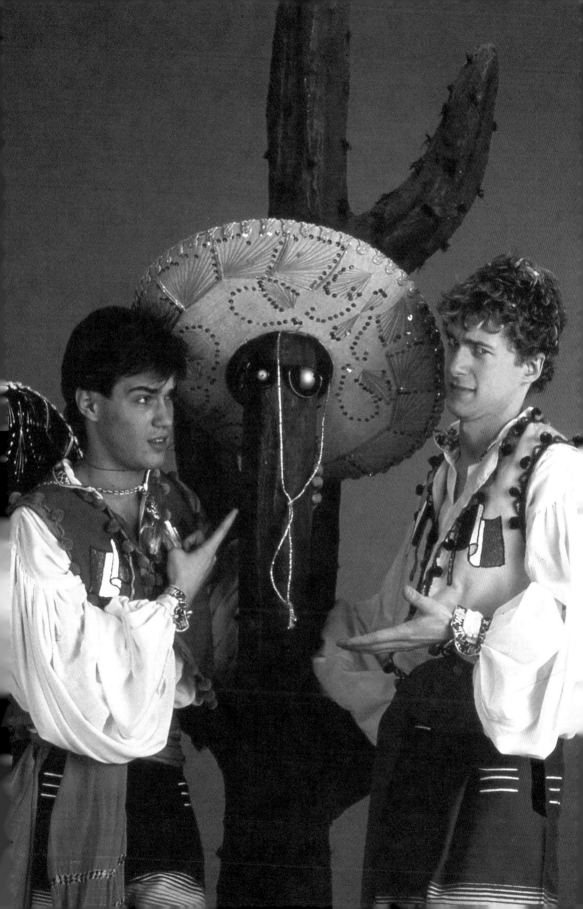

eggs and rabbit holes. It's easy to get lost. But there's substantial purpose and sense in these choices.

ROBERT ALTMAN: Many of my films, I feel you're not going to get them unless you see them twice... see it a second time: you're not faked out by the plot, you're able to deal with the corners of the frame, with the nuances... But you can't ask this vast paying public to see a film twice... So, it's a dilemma: do I worry that people are only going to see it once? Or do I go my way and think about the twenty-five people who might see it again and say, "Hey, that was really good?"[8]

I WAS CURIOUS to speak with the actors Neill Barry and Daniel Jenkins, who play Stiggs and O.C., respectively. Their comic timing and improv carries the film. Most every dude who grew up in the 80s or 90s wondered what it would be like to be Ferris Bueller or Jeff Spicoli. What if you had the chance? What if, even better, you had Robert Altman telling you insider tales about his classic films? What if he excitedly compared your characters to Hawkeye (Donald Sutherland) and Trapper John (Elliott Gould) in *M*A*S*H*?

NEILL BARRY (STIGGS): Every teen actor under the sun read for the lead roles. The auditions were at Sandcastle 5 [Altman's New York-based production company] on 59th Street. What Bob did, he had everyone come in, switch the roles up, and read. Like, I saw Jon Cryer read for Stiggs right in front of me, and he was 180 degrees different from my take, much more commercial. Even then he had that *Two and a Half Men* timing. I think Bob saw Stiggs as more organic, much cooler, deadpan. After my first audition, Robert Downey Jr. [told me], "Dude, they're all over you." The thing that put me over the top was when Bob asked us, "Where do you see Stiggs

8. From the aforementioned (and essential) *Altman on Altman*.

in the future?" I told him Stiggs would be the publisher of a magazine, like *Rolling Stone* or *Vanity Fair*. He said that was good. I was only 17. It felt like a big deal. I knew nothing about the *Lampoon* characters, but the film was already being seen as a franchise. Daniel Jenkins and I were contracted for two sequels. I was kicking around ideas in my head for the next one, you know? [*laughs*]

DANIEL JENKINS (O.C.): My audition for O.C. was the most bizarre thing ever. It was my first film. I was living on a farm in Kentucky. I had hippie parents. I was 18. I apprenticed in a Louisville theater. I don't know that I was "normal." [*laughs*] I wasn't so much rebellious as obnoxious; you wanted to shoot me when I was 18. A friend of my parents who knew Bob's casting director suggested I try out. I was aware of Altman and his use of sound and dialogue. Growing up, my family had to drive a long way just to see a movie, but I got to see *M*A*S*H* and *McCabe & Mrs. Miller*. So, I go to Sandcastle to audition. It's just me and Cynthia Nixon and Bob. I knew who Cynthia was. She'd just done a movie [*Little Darlings*] with Tatum O'Neal. Bob's looking at us, and he goes [thick Kansas City drawl], "Okaaay, sooo, Daniel, just, you know, start dancing with Cynthia, and just say, I dunno, as you dance just say words that begin with the letter 'a,' like 'aardvark.'" Neither of us could dance well. It was so weird, but I felt lucky.

The rest of the cast was rounded out with one of Altman's strong, typically untypical ensembles. In addition to Paul Dooley (who played Molly Ringwald's father in *Sixteen Candles*, which shot back-to-back with *O.C. and Stiggs*) as Randall Schwab, newcomer Jon Cryer (who before too long would, of course, play Duckie in *Pretty in Pink*) was cast as Schwab Jr., and *Saturday Night Live*'s Jane Curtin (who is said to regret her performance in this film, feeling it was a cruel representation of alcoholism) was cast as the eye-rolling, dipsomaniac mother Elinore Schwab. In the role

of O.C.'s grandfather and chief guardian, a retired homicide detective losing his mind to dementia, Altman selected Ray Walston, who had become known to teens throughout America as Mr. Hand in the 1982 hit *Fast Times at Ridgemont High*. A baby-faced Cynthia Nixon (you know, the redhead on *Sex and the City*) played O.C.'s ultimate crush, Michelle. A swell group of actors, to be sure. But the success of this movie rested entirely on its leads.

Barry and Jenkins were unknowns, so they were gambles. Altman's intuition on them paid off in funny and ace portrayals. Watching the film today and trying to picture these characters in any other teen film from the 80s is dizzying. They don't fit into the era's adolescent presets. They're not jocks, preps, nerds, goths, rebels, virgins, or loners. As O.C., Jenkins is affable and self-reliant, introspective like a young Tom Hanks with a touch of Judge Reinhold discontentedness. His O.C. is like the kid who ditches tennis lessons to hook up with some hottie mathlete while her parents aren't home. Barry's Stiggs is like the kid who ditches a chick to fill tennis balls with prescription pills from her parents' medicine cabinet, which he then sells to a refined clientele.

DANIEL JENKINS: Bob would take the temperature of the culture as he saw it and go make a movie. He was opposed to making a *Porky's* teen-exploitation movie. I remember him explaining to.me that this was an "adult-exploitation" movie. So, we took the humor a little further out than just poking fun at the genre. There was a mean edge in the film, this dark edge to the persecution of the Schwabs, that Neill and I really enjoyed. What is the point of the persecution of this family? You can get pretty deep into that. The critics back then certainly didn't go there. I think they missed a lot of things.

NEILL BARRY: Bob wanted Daniel and I to hang out and have time to develop a bond for the shoot. He wanted us to become, like, little anarchists, coconspirators, terrorists. We were being nurtured by him and his crew like a young version of Elliott [Gould] and Donald [Sutherland] on *M*A*S*H*, and so I acted out accordingly. I owe a lot to Daniel because he was the quiet to my storm, man.

DANIEL JENKINS: I felt very much like the outsider. Neill was hugely different from me. He was steeped in entertainment culture, a city kid, wild, savvy... I was anything but.

His cast in place, by the late summer of 1983 Altman was gunning *O.C. and Stiggs* into production on location in Phoenix. A little more than six months had passed between Mann and Carroll submitting their screenplay's first draft and Altman calling "Action." Even Newman was taken aback at how fast the whole enchilada had come together. He told Altman to no avail that they should hold off until after summer, when temps wouldn't be throbbing over 100 degrees. Altman wasn't having it. His plan melded an accelerated pace—guaranteeing the money would be there—to an unorthodox shooting style that kept execs and screenwriters out of his way.

PETER NEWMAN: Once Bob got on set, he had the earmuffs on. He wouldn't communicate at all with MGM. I spoke to the execs once, and he got very angry with me. He said, "How dare you talk to them! They are the enemy!"

From the start, the set had a manic energy to match the production schedule.

ALLAN NICHOLLS: When the cast arrived in Arizona, our team did what we usually did on Bob's productions, which was immediately take over the hotel, build a screening room there, and create our own culture. This set in particular was like a summer camp. We always had a big kickoff party and a big wrap party. Our kickoff, we went tubing down the river like O.C. and Stiggs do in the film. There was a big

open bar at the end of every day. Bob would screen dailies for all the actors so they could see what was working and what wasn't. Everyone wanted rooms on the ground floor closest to the party, so I got this big suite upstairs to myself. It was known as the "Barbra Streisand suite" because Streisand had stayed there.

NEILL BARRY: Daniel and I knew it was going to be fun when we arrived, because we were being paid to tan, to hang by the pool, to hang out at the racetrack with Bob. The hotel had been chosen because it was directly across the street from the dog track, so Bob could go over and gamble. I'm not joking. And Bob made sure Daniel and I had adjoining suites at the hotel. It was a Ramada. So there was this huge living room between our bedrooms. We had pretty girls dropping by the room. Everyone at the time was smoking pot except Daniel. Nobody was ever high on set, but in the rooms... I was drinking Kahlua and cream with my joints. Did I make out with the girls who played my sisters in the movie? No. The girls who played "the sluts"? For sure. More than make out. The first time I did coke was near the end of the shoot. Tiffany Helm[9] [who played Charlotte the Slut] and I did bumps. She said it would help us to keep drinking. I stayed up all night. I wasn't that into it. And I bet money constantly on pro sports with Bob. I'd win big and it'd piss him off. We were betting $100 a game, and that was just his bets with me.

PETER NEWMAN: Neill said $100 a game? I'd say that's a gross understatement. There was heavy gambling activity at the hotel. Bob bet on dogs at the track, but mostly it was pro sports. And the crew, they'd get paid on Fridays, go right to the track, blow it all.

DANIEL JENKINS: The rule of the day for the entire shoot was: Party. When there wasn't a party, there was poker. Altman's son Stevie always won. Tons of sports betting. And the

track. To me, it doesn't get any more pathetic than betting on a dog, you know? A dog is taking a shit in front of you, and Bob's like, "Good, I like him. Nice and empty." [We were] absolutely surrounded by vice. I don't remember Bob ever being stoned when we were working, though cocktail hour was hit pretty hard daily. I found that out fast. [laughs] Altman productions are like a big, hip family. When Bob wasn't showing dailies, he'd screen his other movies, like 3 Women or Images, for us.

PETER NEWMAN: They'd set up an open bar, everyone would have drinks, and people were loving the dailies—we couldn't tell if we were just dehydrated from the heat, drunk on the liquor, or just celebrating ourselves, but everyone was happy with what we saw.

DANIEL JENKINS: Everyone was laughing hysterically at dailies, [and] part of me was looking around, silently going, "What the fuck are they laughing at?" I was having a good time, sure, but I didn't get it. And people were coming up to me—you don't forget this happening when you're 18—and saying, "Hey! Enjoy your anonymity while you can, man!" At first, it's a complicated sentence to parse, but then I was like, "Wait. This guy thinks I'm going to be famous from this?"

By NOW YOU'RE probably wondering just what, exactly, the plot of *O.C. and Stiggs* is. That would be fair. But you won't be getting a simple synopsis here, because plot, in much of Altman's best films,[10] isn't the director's main concern or bread and butter. What does matter is mood. These movies of Altman's function more as immersive art pieces than as storytelling motion pictures. So, do O.C. and Stiggs go on a sort of hero journey through the course of the film? I guess. They fuck with the Schwabs a lot, try to help O.C.'s destitute grandfather, and

9. Tiffany Helm is known to horror nerds as the goth-punk trouble teen Violet in *Friday the 13th Part V: A New Beginning.*

10. See: *M*A*S*H**, *McCabe and Mrs. Miller*, *The Long Goodbye*, *Popeye*, and, sort of, *3 Women*.

they get laid, get lit, and do an intense amount of surrealist male bonding. But this isn't a movie where point A to point B is the… point. So let's focus instead, for a bit, on some of the trippiest details of *O.C. and Stiggs*.

1.

UNREALITY

Central to Altman's satire in *O.C. and Stiggs* is that the world in which the guys live has no culture. It's a bizarre, plastic expanse. The real color comes from our two protags. They arrive in each scene clad in obnoxious outfits that mock-match their surroundings—as if direct from a nonexistent wardrobe department. (The hands of the costume and production designers are everywhere in the movie.) The characters, who are in an 80s movie, are essentially approaching life like they're in an 80s movie. When O.C. and Stiggs enter a cheesy sports bar—where major-league catcher, Miller Lite pitchman, and ersatz comedian Bob Uecker is chattering at an empty table, by the way—they wear opposing football uniforms; to purchase an Uzi from a 'Nam vet, they wear camo garb; walking into a used-auto dealership, they're decked out in highly questionable leisure wear. The wardrobe in this film is perhaps the biggest giveaway that we're dealing with the hyperreal and the surreal here. No reality is to be found. The film is a total colonoscopy of "reality." Altman shows his hand even before the opening scene, when MGM's iconic mascot, Leo the Lion, appears. He doesn't emit his usual majestic roar of studio tradition and power. Instead he croaks out an unflattering human groan, saying, "O.C. [*pause*] Stiggs."[11] A rug is pulled out from under the viewer again, in an early sequence

that finds the lead characters surfing in the ocean off an expansive beach—before the camera pulls back to reveal that the boys are actually at a water park called Big Surf, an absurd, artificial destination smack in the desert.[12]

That Altman was using actual locations in Arizona to hit a stoned vibe further solidified his "arena film" signature. Arguably, no director has better captured the arenas of populist America, pockets of beauty, mom-and-pop-driven character, and flat-today, overdeveloped-tomorrow flyover ugliness. Altman almost always shot on location, foregoing what was common in a place for what was unique and unusual. Visiting an Altman film like *Brewster McCloud* (Houston) or *3 Women* (dusty California) or *Nashville* every few years reminds us how relentlessly America changes.

Altman's acclaimed use of sound is exercised on *O.C. and Stiggs* like an aural field day, a muted cacophony of phantom noises, animal calls, and deliberately hokey sitcom effects. And then there's the thread of free association that flows through the movie, such as when the character Wino Bob declares, "What you boys need is some pussy," and a barely audible alley cat is heard, and then we cut to the next scene, which holds for less than a second on a television playing *Tom and Jerry*. Further cartoon duality is on display at the aforementioned used-car dealership, which is named Bunny's and where the proprietor is said to have murdered her husband, Bugs.

In other spots, Altman gets referential with regard to his previous films. That neocon pundit the Schwabs watch on television is actually Hal Philip Walker, the

11. This wasn't the first time Altman exercised novelty at the expense of MGM's Leo (though it would be the last). On 1970's *Brewster McCloud* (1970), Leo totally forgets his line.

12. Big Surf water park in Tempe, Arizona, remains open today. When I checked its website for this article, I figured the film might get a shout, since its name and the park appear in two big sequences. Under a well-organized "History" section, I read: "Big Surf was also featured in two motion pictures: *Just One of the Guys* (1985) and *Storm of the Century* (1999)."

Laura Urstein as Lenore Schwab and Victor Ho as Frankie Tang.

Jane Curtin as Elinore Schwab.

Paul Dooley as Randall Schwab.

mysterious third-party candidate heard on the radio, but never seen, in Altman's *Nashville*. When O.C. and Stiggs uncover a Mount Weatherish survival bunker beneath the Schwab family's backyard, Walker is there again, on a small television, spouting more propaganda. It's like Altman is hinting that this sort of divisive, self-fulfilling-prophecy media will survive all else (that, or maybe that *Nashville* will). A quick chuckle is had at the expense of Altman's *Popeye* too. When the boys venture to Mexico to party, Popeye can be glimpsed as a piñata. And a harder-to-miss sight gag is the massive flock of creepy-eyed decorative birds placed, almost strategically, in every frame of the Schwabs' home. If you see a handful of Altman films, it becomes exceedingly clear he harbored ire for three things, all of which *O.C. and Stiggs* dings: fountains, chandeliers, and birds.

2.
HOPPER OF DARKNESS

In *O.C. and Stiggs*, Dennis Hopper reprises—in everything but the character's name, really—his manic photojournalist from *Apocalypse Now*. From the camera dangling around Hopper's neck right down to the goofy Doors music that introduces him, the resemblance is unmistakable. So what's the story? Why'd Altman do this? In the late 70s, the filmmaker began to decry a trend in America's younger directors to recycle—as he told Roger Ebert in a 1977 interview—"rigid film grammar" so that "their work is inspired more by other films than by life" (which, of course, is different from Altman's unsubtle, meta riffs on his own oeuvre). The original *O.C. and Stiggs* screenplay contained the very sort of postmodern riff on *Apocalypse Now* that Altman didn't care for. When the boys' ganja-farming paranoiac associate Sponson, a Vietnam veteran, assists the duo in waging climatic helicopter warfare on the

Schwab mansion, the sequence is backed by Wagner's "Ride of the Valkyries," music inseparable from *Apocalypse Now* and its village-attack sequence. Rather than shoot the Sponson scenes at face value or cut them completely, Altman cast Hopper as Sponson, thereby subverting the riff into meta-commentary on the derivative shallowness of 80s films. Also, Altman had taken part in many bombing missions during his Air Force service in WWII and wasn't an admirer of *Apocalypse Now*.

ALLAN NICHOLLS: At the time, our camp didn't quite relish *Apocalypse Now*. I think that a lot of us didn't care for the heavy metaphor, and I knew a lot of veterans at the time who didn't care for the portrayal of the violence. [And] Dennis [Hopper] was on the outs. He was pretty quiet on set. But he respected Bob's work so much. He was great in the film.

Hopper's role in *Apocalypse* had done the actor no favors. It cemented Hollywood's perception of him as a cartoon and burnout. In May 1983, shortly before he worked with Altman, Hopper attended a student screening of his own teen film, the punk gem *Out of the Blue*, and got the inebriated idea to explode himself with dynamite. The insanity was caught on camera and survives on YouTube. Just months later, after checking himself into a mental ward, Hopper was in Arizona, fragile, shaken, when no one would hire him, playing a damaged vet as comic relief. So, on-screen, we see a casualty of Vietnam and the veteran of New Hollywood turned cautionary tale, all at the beck and call of two loudmouthed 80s teens. Altman must have gotten a cynical kick out of this—the duo's raging summer as a tongue-in-cheek walkabout in which the auteur behind 1969's *Easy Rider* pilots them to a booty call, and the auteur who made 1971's influential *Sweet Sweetback's Baadasssss Song*, Melvin Van Peebles, fetches their booze in his portrayal of their

homeless friend Wino Bob. And who's the auteur stuck directing? Bob himself. To drive the point home, Altman gets in another referential riff by having Sponson's mountainous fort uncannily resemble the camo tents of the *M*A*S*H* set. It's clear who Altman believes lost the great cinema war of the 1970s. Smoke 'em if you got 'em.

DANIEL JENKINS: We'd finish our scenes with Dennis and have lunch with him. He had this guy who would sit nearby. Neill and I finally put this together—that the guy was making sure Dennis stayed on good behavior. We were, like, "Oh, now we get it. That guy is the 'Dennis handler.'" [*laughs*] Maybe it was an insurance thing? But talk about doing a freakin' Altman movie, and you're Dennis Hopper [in recovery]. Holy crap. That's not the place to be, dude.

HOPPER (as Sponson, in the movie): Guns are a disease, man. You think about that. They ravage and kill. There's nothing you can do to stop them. Except buy more of the same disease and vaccinate yourself against it. More guns. Doctors and hospitals, they, like, thrive on disease, man. Because disease is profit to them. With the profit they buy more of the same disease and vaccinate themselves with what's left over. They infect us and they kill us... Here is a standard nine-millimeter Uzi, 25-round clip. I think you'll like it. Now, you tell that lady to try that out on a dog or somethin' first.

3.
THE OPPOSITE OF LONG DUK DONG

I also contacted Victor Ho, who plays Frankie Tang, the Schwabs' caddy and son-in-law. As the mute brunt of Randall Schwab's casual racism, Frankie Tang is a minor role that differs in a major way from his supremely twisted, slanty-eyed *Lampoon* depiction—reflecting Altman's critical view of the U.S. government's rep-

rehensible treatment of Asians in conflict and of the portrayal of Asians in popular American media. Altman, for instance, openly detested the *M*A*S*H* television series. He felt it diluted his film's original message, reducing a war on Asians to a backdrop for couch-potato Americans to seek comfort and heartwarming yuks.

Under Altman's direction, Tang joins the climatic attack on Schwab—which also happens to be the scene where the mute Tang finally speaks.

VICTOR HO: When I was introduced to Hopper, they explained my character to him, and he just looked at me, puzzled. He was cool, very low-key. He was like, "You don't speak in this movie?" And I told him, "I only have one line, and it's with you." He just goes, "Huhhhh." I always saw O.C., Stiggs, Hopper's veteran, and Frankie as being on the same side. They all wanted to overthrow the Schwabs. When the time comes, Frankie hands Randall Schwab over to Hopper's character, and he just has this smirk on his face, this retribution. During the entire movie, the audience is led to believe Frankie's someone he's not, a stereotype. I was the first actor Altman hired [for the film]. I was 25. It wasn't even an audition. If I recall, I was the only one seen for Frankie Tang. Altman and I just talked about politics and the character for about 45 minutes. I understood that Altman's films opened up the underbelly of society. He explained to me that Frankie Tang is this Chinese guy who marries this family's daughter, and the father's a bigot and a racist who verbally abuses Frankie all the time, but [Schwab] gets his comeuppance in the end. I remember he described Frankie as an "Asian infiltrator, just waiting for his moment." [*laughs*] Finally he goes, "I want you to do the role." I said, "I want to do it." And then he says, "And by the way, Frankie doesn't speak a word until the end of the movie."

I actually auditioned for Long Duk Dong in *Sixteen Candles* and for a role in *Big Trouble Little China*, but I wasn't the "right type." That's one of the reasons I left acting—the roles

available to Asians were all stereotypes. The writing just wasn't there. Aside from Short Round in *Indiana Jones and the Temple of Doom*, I don't think any 80s movie got an [Asian character] right. Now you have Ken Jeong's character in *The Hangover*. He seems stereotypical, but he stands up for himself, kind of like Frankie did. But it's taken 30 years.

4.
KING SUNNY ADÉ BRINGS HIS JUJU TO PHOENIX

O.C. and Stiggs is sound-tracked mostly by one riff, repeated again and again, from Nigerian musician King Sunny Adé. An early climax of the film is a live concert by Adé and his band, who play the cool-watered style of Afro-pop known as ju-ju.[13] O.C. and Stiggs successfully pull the concert off by blackmailing the drama teacher at their high school, who is coordinating a local dinner-theater production of the farcical 1965 Broadway show and 1969 movie *Cactus Flower*. When the curtains go up, the last thing patrons expect is a brightly bedecked band of Nigerians.

ALLAN NICHOLLS: We set up multiple cameras and shot King Sunny Adé and His African Beats' performance like a concert. The group played a lot of songs—really celebratory. Only a single song made it into the film, and I have no idea where that performance footage ended up, or even where King Sunny's theme song for the movie wound up. I always thought we should have released cross-promotional music videos on MTV.

The concert in the film lasts several minutes, both serving the plot and working as a cool intermission. Most of the film's ensemble attends, dancing or moping, depending on their character's attitude.

13. This, three years before Paul Simon went all African with his *Graceland* album and decades before bands like Vampire Weekend, in turn, aped *Graceland*.

Just as O.C. and Stiggs, in the movie, are stealthily bringing their town together to witness extraordinary jams at others' expense, Altman is basically throwing the same party for his cast, crew, and visiting friends courtesy of MGM.

NEILL BARRY: Bob didn't want Flock of Seagulls in his teen movie, he wanted King fucking Sunny Adé.

MARK STIGGS (in the film, introducing himself to the band): King Sunny Adé. My name is Stiggs of Oglevey and Stiggs Booking Agents. We can understand your reluctance not to perform without getting your bread upfront, you know? Of course this kind of thing doesn't happen in the good old U.S. of A. We happened to book the Rolling Stones for a one-nighter in Phoenix, Arizona. Yeah, but they, uh, canceled because of an overdose. Of bookings. So, uh, we can arrange to put you in their spot. That's if you're interested, of course.

Incredibly, given how entwined the music is with the plot, the King was a last-minute substitution for zydeco master Clifton Chenier, who is cited heavily in the script. Chenier's part, as written, expressed a similar air of appreciation, though the culture clash gets played up more hilariously, for shock value. In the script, a dinner-theater patron, aghast, says of the Louisiana-born Chenier, "He hardly speaks English, he plays the accordion, and his two front teeth are made of metal." O.C. then smokes crack and "authentically" performs with Chenier onstage.

PETER NEWMAN: Clifton lived in Lafayette, Louisiana, and had an iron lung. He played washboard and was incredibly funky looking, so Clifton was going to play himself and perform. I had the chore of getting him to our set, but he was one of these guys who was like, "Yeah, sure, we'll do it, we'll do it." We start preproduction and he hasn't signed his contract—he just didn't conform to standard

business practices. Wasn't used to movies. Finally, I fly to Lafayette, have dinner with him, and he says, "I don't like signing things." So I fly to New York and say, "We have a problem." A friend, the night I get back, takes me to see King Sunny Adé in Manhattan. [It was] a huge show, like his first New York appearance. He had a French manager, who says, "Altman, yeah!" We make a deal. So the screenplay totally changes overnight. Six weeks later, a plane arrives in Phoenix from Lagos, Nigeria, with King Sunny Adé and his entire band—like 35 or 40 people. It's 120 degrees at the airport. It was like a hallucination. We paid them $100,000, but fully in cash. I go to the bank, get the money, drive back to the Ramada, and there, in a room, is King Sunny Adé, like royalty, with his band. He starts divvying up the money to everyone on the floor. It was easier for us to get a 40-piece band from Nigeria than it was to hire an old Cajun guy and three of his buddies. [*laughs*]

ROBERT ALTMAN: King Sunny cooked his own meals [on set]; [the band] cooked their own goats.[14]

5.
NEW IDOL: PAT COLETTI

If this movie's house were burning down and we could only save one thing, we'd throw a blanket over Pat Coletti and carry him to safety. Coletti, the raconteur who lives next door to the Schwabs and who describes his lifestyle as, "Basically, I drink and I make *a lot* of money. Hog Couture, boys. I manufacture clothes for fat women. No, it's true, seriously." Portrayed by actor and all-around funnyman Martin Mull— his credits include playing *Roseanne*'s gay boss, Gene Parmesan on *Arrested Development*, and Barth Gimble, the host of the great, little-known 70s TV series *Fernwood 2 Night*—Coletti shags a waitress in a walk-in cooler and has a license

plate that reads "COOL." In the end, it's Coletti who saves the friendship of O.C. and Stiggs by helping them turn the Schwab mansion into a rehab clinic for homeless junkies called Love House. When that goes awry, Coletti simply cuts the boys a royalty check for accidently coining a name for his fledgling line of Africa-inspired XXL dresses.[15] That money pays for a home nurse for O.C.'s grandfather, keeping O.C. in Arizona and sparing him from the indignity of having to move in with a hick relative in Arkansas.

Whoops, I just gave away the ending. But then, as I said before, plot barely registers. It's more important to note that this is one of the few Altman films where a friendship survives. O.C. and Stiggs ride off into the sunset with dreams of being as rich and wasted as Coletti, their new role model. In the script, this nonredemption is explicit. An unused monologue has Stiggs describe his trajectory as "a teen caterpillar that's got about six months before I morph into this full-blown adult moth in a sports jacket. [Teen caterpillars] crawl up real valuable trees and eat them and kill them."

MARTIN MULL: I've never talked about this film, in all these years, because honestly I don't know anyone who's seen it. How did I get the part? I was living in Hollywood. My agent calls me one morning and says, "Bob Altman is on his way over to your house right now with a script." And I thought, "Oh my God," because I didn't know him. But I was a big fan of his work. Bob's car pulls up. I meet him in my driveway. The first thing out of his mouth is, "Mull, you're my second choice." I go, "Oh yeah? Who's your first?" He says, "Walter Cronkite. But the sumbitch won't get off his boat." Cronkite at that time was, like, 60. I was in my 30s. So I'm thinking, you know, what kind of role is this? Bob literally throws me the script and says, "You're the Italian dress

14. From a brief featurette on the *O.C. and Stiggs* DVD (MGM, 2006)

15. "Afro-dizzy-acs, dizzy ass"—Stiggs reminding O.C. what they called the dresses.

designer. Don't bother reading the script. We'll never shoot it." And we didn't.

More than the film itself, I remember the nightly parties. Everyone was at those, not just the cast and crew. Relatives, visitors, Bob's special guests, help from the hotel was invited—all hanging out, big open bar, watching dailies and Bob's films. It was unheard-of. I asked Bob why he did it, and he told me, "I'm doing this film to entertain people, and how can I possibly know if it's entertaining if I can't see their reactions?" It made incredible sense. The other thing, Bob would take anyone who was standing around him who had never acted before—you're a UPS messenger, and suddenly, you're in a movie. That was a talent of his. I also met Paul Dooley on that movie, and we became fast friends. [Much later on] Paul and I ended up presenting Bob with the Lifetime Achievement Award from the Chicago Film Board. This was shortly before he passed away.

No one has ever yelled "Pat Coletti!" to me on the street. But you know, I don't think you could do a film like *O.C. and Stiggs* or [Mulls's] *The History of White People in America* now. Singling out white America, you'd probably be in deep shit.

6.
THE GILA ROARS TO LIFE

STIGGS (in the movie): Number one, we want zero miles to the gallon. Loud, real loud. It has to generate a terrifyingly loud, seismic field of noise. If we can combine really frightening noise with the ugliness of poverty, we'd have the ideal car.

Every proper coming-of-age movie needs a car. In the script, O.C. and Stiggs cash in a stamp collection they stole from Schwab the Younger to purchase a "blue, fat-tired, chopped 1969 GTO." Altman took this description into his mental what-the-fuck garage and came up with the movie version's Gila—a junkyard clunker the boys customize piecemeal (in a neat montage)

with a mean stereo, fat tires, and hydraulics that lift the body so high, the vehicle goes from silly to sublime. Like they're seriously around ten feet off the ground.

ALLAN NICHOLLS: People at production meetings on Bob's films would just shout stuff. Completely off-the-wall ideas. Very informal. Someone said, "What if we did something to their car?" Bob responded to that. He was like, "It could get bigger and grosser as the movie goes on!" If you look at the back of the car, Bob specifically requested the rear of the Gila Monster resemble a colobus monkey's butt.

NEILL BARRY: The Gila Monster's body was a Studebaker, which was insane, but that's what Bob wanted. There were two models—one with the hydraulics, the other without. They sank close to a hundred grand into it. That fucking thing, it broke down all the time. Only one side would go up. Bob would just be like, "Fuck it," and shoot. It had a stereo system. I was blasting a lot of Police. Daniel was always driving it. In town, we got a ton of looks.

DANIEL JENKINS: I was chosen over Neill to drive the Gila because Neill was from New York City. But the production never checked my driving record. It wasn't the best. I had ripped off a door. That car was the scariest thing in the movie for me. I had seen hydraulics before then, like with gangbangers on television. But this was taking hydraulics to its satirical limit. Because we were so high up, the steering wheel was also on hydraulics, if that makes sense. So there was a super-healthy delay between flipping the switch, turning, and getting a result. It did not feel safe. Today, a studio would use CGI or something.

TEST SCREENINGS of the film, for execs and talent, began in 1984. It was downhill from there. Mann and Carroll, who had been banned from the set, saw a finished project that barely resembled their screenplay.

TED MANN: Altman's movie is not an adaptation of my work. The screenplay I wrote with Tod Carroll was not shot. Carroll took his name off [the movie] because it was not his work. I chose to leave my name on, on the chance it might do me some good. It did not. I consider Altman's film of little interest and believe that the chatter of an ordinary street-corner schizo is of equal weight and consequence.

Carroll's experience on the production of *O.C. and Stiggs* may have been the final straw for the whip-smart young editor. He seemed to cool altogether on a career in magazines and Hollywood,[16] later relocating to his native Arizona. In contrast, Mann built an Emmy-winning career as a writer-producer on *Deadwood*[17] and *NYPD Blue*. He also cowrote 2012's *Hatfields and McCoys*, a History Channel miniseries that received five Emmys and 16 nominations, including one for best writing.

The screenwriters, however, weren't the only people unhappy with *O.C. and Stiggs*.

NEILL BARRY: Daniel and I were in New York, and MGM's press machine was getting ready [for the film's release]. But then the shit hit the fan. There was a screening at William Morris, a big screening room, lots of MGM execs, and five minutes in, the projector broke and Bob started yelling. He was saying, "This is your fucking cut and not mine, anyway, in the first place." I just walked out. I remember Peter Newman saying, "Where are you going?" I said, "I can't go back in there, it's a mess." That was the last time I ever saw the movie on the big screen. I ended up watching it [in full, for the first time] in '87, on a VHS that Sandcastle sent over. I had moved on.[18]

PETER NEWMAN: I actually thought the New York screening went quite well until the projector broke. I thought everyone felt good about the version we screened. But then we brought that cut out to MGM on the lot [in Los Angeles], and the big executives Freddie Fields and Frank Yablans were there, as was Peter Bart, an MGM executive and the future editor-in-chief of *Variety*. At the end of the movie, there was dead silence. No one had laughed the entire movie. You could just tell it was over right then and there. Bob kind of held it in. That night we went out, and we had a lot to drink. The next morning, at the hotel, I said good-bye to him, and he turned to me and said, "I hope I didn't fuck up your movie."

16. In Josh Karp's history of the *Lampoon* and its cofounder Doug Kenney, *A Futile and Stupid Gesture*, Carroll receives a lone, rather sad mention: "[He is] best remembered for ordering a grilled cheese sandwich for lunch each and every day via a speed dial button on his phone." Today, Carroll's legacy as a comedy writer is semidefined by yet another project, the development hell of which transcended into urban legend. Carroll's adapted screenplay *Atuk*—about an Eskimo so in love with New York media and culture that he travels there (spoiler alert: celebrity and a loss of innocence ensues)—was passed around in the 80s and again in the 90s like the proverbial monkey's paw. Shortly before their deaths, John Belushi, Sam Kinison, John Candy, Chris Farley, and Phil Hartman all agreed to star in various incarnations of the film. In the DVD special features of *Anchorman*, writer-director Adam McKay jestingly pesters Will Ferrell to star in it.

17. *Deadwood* creator David Milch has long praised Altman's *McCabe and Mrs. Miller*, citing the film as a chief influence on his HBO western series. Given Mann's grudge with Altman and with much of his filmography, I thought this semi-ironic. Mann's thoughts: "Milch couldn't have tolerated Altman for more than ten minutes."

18. As he did with Daniel Jenkins, Robert Altman kept in touch with Neill Barry, post-*O.C. and Stiggs*, casting him way against type as the head drugged-out villain in what was to be a new noir film. Grittier and seedier than *The Long Goodbye* and set on the outskirts of Las Vegas, *Heat* was scripted by industry heavyweight William Goldman (*All the President's Men*, *The Princess Bride*), adapted from Goldman's novel of the same name, and had Burt Reynolds set as the lead. Due to a visa issue that would have kept his cinematographer off the film, Altman left the production. Reynolds and Barry asked for Altman's blessing to stay aboard. *Heat* would go on to be plagued with behind-the-scenes drama. Reynolds allegedly punched Altman's replacement in the face, and the movie itself was awful, especially in the scenes that feature Reynolds doing Steven Seagal-like kung-faux. Jason Statham is currently attached to the remake.

TED MANN: Kinky Friedman[19] and I watched a private screening hosted by Altman shortly after he completed postproduction. After it was over, Altman fled my presence at the elevator, apparently choosing to walk down 30 flights of stairs rather than endure the silence. I haven't seen the film since. There are many people [today] who want to make the "lost script." Michael Barnes, the lawyer who made the deal for the *South Park* guys,[20] has been trying to buy the rights for five years from MGM, to remake a film that was never made.

PETER NEWMAN: In the summer of 1984, Ted Mann and I were at party for the special-effects people on *Ghostbusters*, which had just come out. We had flown to LA for a meeting with MGM. The studio wanted to see if we had ideas for additional scenes and reshoots. We did not. A producer who worked on *Ghostbusters* walked up to us at the party and said, "What did you do?" I said, "Oh, I did *O.C. and Stiggs*." And this guy, he says, "I heard that's an unreleasable movie," and walks away.

DANIEL JENKINS: I think the delay was harder on Neill. He went out to LA and started hitting it pretty hard. I mean, I was disappointed the film didn't even get a chance to be slammed.

Even as it sat on the shelf, the film wasn't totally off the radar. In *Spin*, a positive 1985 notice for King Sunny Adé anticipated that the film was "finally" coming out that year. Unfortunately, MGM's shaky financial situation was deteriorating faster by the day. In 1986, Ted Turner purchased the entire studio only to dump it 70 days later, foreshadowing years of now-infamous instability. Frustrated, the producers teamed with a distribution company (Cinecom) and attempted, without success, to negotiate with MGM to build awareness and test the film in hip markets. An in-house marketing memo uncovered

when researching this article reads, rather amusingly, "We would suggest both print and ad campaigns that are as anarchistic as the film. For instance an ad that indicates that the film is just one more practical joke that O.C. and Stiggs have pulled off this time at the expense of Hollywood." The insightful memo says that the film works "better as an off-the-wall Altman film," the last-ditch goal being to "call in a favor" at MTV and reposition the release as a cult "success on the level of *Repo Man*, with that film's audience, our target group."

When *O.C. and Stiggs* finally premiered in Manhattan, it was five years old. For one week only, March 18–24, 1988, the film screened at Film Forum; adding insult to injury, its premiere there was as a caboose on a Dennis Hopper retrospective entitled "Out of the Sixties." The one-sheet poster for the film was printed in shades of gray, as producer Newman recalls, "because it was cheaper," save for raining pink confetti in the shape of lobsters. The poster showed the main characters, frozen in vague party mode, as if taken the moment they shouted "Cheese!"

The great squall of 80s teen movies had already crested. George H.W. Bush was preparing to take the baton from Ronald Reagan. Peaking with 1986's *Ferris Bueller's Day Off*, John Hughes would soon enter his shameless *Home Alone* and *Beethoven* period. Of the few critics who bothered reviewing *O.C. and Stiggs*, most took its whimper of a release as reason enough to unload. A 1988 *Chicago Tribune* review typifies critical reception: "For reasons that become gratingly obvious, it never was released theatrically... it takes the standard teen comedy formula to terrifying new lows of grubbiness, sadism and sheer loathability. *O.C. and Stiggs* gradually acquires the dimensions of a major human disaster. The Chernobyl of comedy, it's a film that should be rented only in

19. Texan musician, politician, and satirist.
20. For *Bigger Longer & Uncut*, the 1999 *South Park* movie musical.

O.C. and Stiggs pop into view as the title appears.

Mild, ambiguous homoeroticism during the opening credits.

Dennis Hopper as Sponson, a bitingly satirical take on his character in Apocalypse Now.

Cynthia Nixon as Michelle, an object of affection.

Neill Barry
as Stiggs
with Melvin
Van Peebles
as Wino
Bob, the boys'
dumpster-
living vagrant
mentor.

Martin
Mull as
lifestyle guru
Pat Coletti.

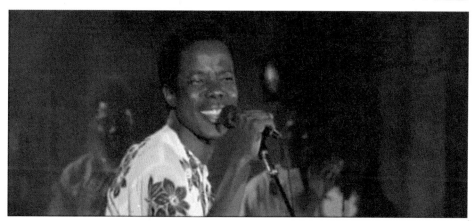

King Sunny
Adé as
himself.

The Gila
in action.

Barry, Cynthia Nixon, and Jenkins.

a lead-lined case." A 1987 pan in ever-square *Variety* read, "Unlike most [teen] comedies, [the film] fails not from too little ambition, but too much."

ALLAN NICHOLLS: There was zero promotion. I can't recall Bob doing any press for it in '87 or '88. MGM didn't know what to do with it. The lack of nudity probably confused [them]. Bob could only fight this fight in particular for so long. I remember even in preproduction, the morning we presented the budget, there were all these MGM suits, and about 36 minutes into the meeting, three of six accountants were asleep. When Bob delivered the [final] film to MGM, the entire company was in bad shape.

But Bob genuinely loved the film he'd made. I love it too. It's almost as if we took the *Lampoon* out of the film and made Altman's *Mind-Roasting Summer*. The film is exactly what Bob wanted to do. [Once it was finished] the studio just didn't get it.

ROBERT ALTMAN: Yeah, most people didn't like [*O.C. and Stiggs*]. Although there are lots of people that really think that's a funny picture. I can sit and watch that picture any time with an audience. Any time![21]

PETER NEWMAN: Ted and Tod's short story and screenplay was a really nihilistic view of two teenagers. You have to remember, these were the type of kids who were just starting to bubble up under the surface in America. To this day, [it is] the funniest screenplay I have ever read. [But] other than those of us who were there making it, to this day very few people are aware [the film] *O.C. and Stiggs* even exists. Of those who have seen it, especially in the industry, most think it's the worst thing ever made, or they think it's easily Altman's worst. But some of the smartest people I know, who didn't see it when it came out, mostly guys who are 25 or 30 years old, now say, "This film is a masterpiece."

I'll tell you, watching the film every five or ten years, I have a much different feeling now. I absolutely think the film has aged very well. And any problems I had about it, well, I don't want to say "personal," but it had a lot to do with how close I was to the film and how different it is to the magazine piece. I mean, the production design; the department heads on this film were A-list people. Bob had his finest technical and creative people working on this movie, the very top, and in that aspect, it shows. Real artists in every capacity.

PAUL DOOLEY: I've been in several of Altman's pictures.[22] I've seen this happen. When *McCabe & Mrs. Miller* came out, it tanked. But five years later, it was considered one of Altman's best. I think the same could happen to *O.C. and Stiggs*. I do. But only if more people see it. I was always happy with it. Matter of fact, my wife and I actually have a picture of me as Randall Schwab framed in our bathroom at home. It's of me sitting in a bathtub, holding a rubber duckie.

At the end of the 80s, the fate of the *National Lampoon* was sealed by a hostile corporate takeover—the same Reagan-era tactics the editors once liked to rip on. The brand never recovered. Today, it's on life support—its name having been traded, exploited, and slapped onto a litany of direct-to-video dreck. Fully turned out and then some. For younger generations, the *Lampoon* is synonymous with soft-porn banality, as exemplified by a trailer for *National Lampoon's Pledge This!*, starring Paris Hilton, which, somewhat infuriatingly, is included on the *O.C. and Stiggs* DVD.

By '88, Altman's career was faring better. That year saw the release of *Tanner '88*, a prescient, episodic collaboration for HBO made with *Doonesbury* cartoonist Garry Trudeau. Starring *O.C. and Stiggs'* Daniel Jenkins and Cynthia Nixon in key

21. From *Innerviews: Filmmakers in Conversation* by David Breskin (Faber and Faber, 1992).

22. Paul Dooley acted in Robert Altman's *Popeye*, *HealtH*, *A Wedding*, *O.C. and Stiggs*, and *A Perfect Couple*.

roles, *Tanner* follows a fictional presidential candidate stumping on the actual '88 campaign trail, Altman was once again commenting on the modern blur between American life and American media. Released on DVD by the Criterion Collection, *Tanner '88* predates by four years HBO's similarly inventive *The Larry Sanders Show*, and by several more the rise of reality television and viral videos. In a winking concession to Altman's stint among the teens, his candidate dismisses an assistant's love of 80s teen stars, until she tells him Molly Ringwald and Tom Cruise donated big to his campaign (and make a shitload more money than he does).

DANIEL JENKINS: I live on the Upper West Side, and there was a really excellent old VHS-rental place [here] in the early 90s called the Movie Place, on 105th and Broadway. The guys that worked there were incredibly knowledgeable. Dude, I walked in there, and three of them froze and said, "Oh my God, you're O.C.! We recommend your movie all the time." I think that in New York City, the VHS was passed around by film snobs. That's one of the few times I was ever recognized for it. And it doesn't get any cooler than people finally appreciating it.

The much-delayed VHS release.

NEILL BARRY: To me, the film is the punk-rock version of those 80s teen movies. It will always be that. That's why it's aged so well. It works even better now. The characters were crazier than most in the 80s, but they were three-dimensional. They weren't stereotypically insecure teens. It wasn't about, "Oh, I can't get the girl! What about prom? What am I going to do? Everyone at school hates me!" I put the film in the same class as *Less Than Zero* [1987], which was another huge bomb. That movie tanked Andrew McCarthy's career. MGM wanted a movie for 12-year-olds, but they got a real "Fuck you" anti-John Hughes picture in return.

An easy narrative for lazy critics writing about Altman's career goes as follows: His 80s period was but a shadow of his 70s hot streak, his 90s were a return to form, and his 00s were sanctified by the stately Oscar bait of *Gosford Park* (as well as the passionate championing of him by Paul Thomas Anderson, who dedicated *There Will Be Blood* to him). Only in the past few years has the film he made after *O.C. and Stiggs*—*Secret Honor*, a fiery one-man portrait of Richard Nixon cursing Bohemian Grove—begun to receive its due as a masterpiece, thanks to a Criterion release.

Among the many books and articles on Altman's filmography, a body comprising well over 30 features and countless hours of television, *O.C. and Stiggs* is rarely mentioned.

ROBERT ALTMAN: The greatest films are the ones that leave you not able to explain, but you know that you have experienced something special. I've always had this feeling that the perfect response to a film or a piece of work of mine would be if someone got up and said, "I don't know what it is, but it's right." That's the feeling you want—"That's right"—and it comes from four or five layers down; it comes from the inside rather than from the outside. 🌺

Robert Altman in 1983.
Photograph: Getty Images.

Fine visual books out now from PictureBox:

Everything Together: Collected Stories
Funny and emotive comics; opulent interiors

Negron
Luscious drawings and a couple of trip comics

Blow Your Head Vol. 1
Snapped by Shane McCauley
Photos and daggering

Sammy Harkham

Jonny Negron

Diplo

picturebox

www.pictureboxinc.com
pictureboxinc.tumblr.com
@pictureboxbooks

consciousness.
community.
craft.

Keep®
keepcompany.com

"GREAT JOB!" →

TIM & ERIC

INTERVIEW BY JESSE PEARSON

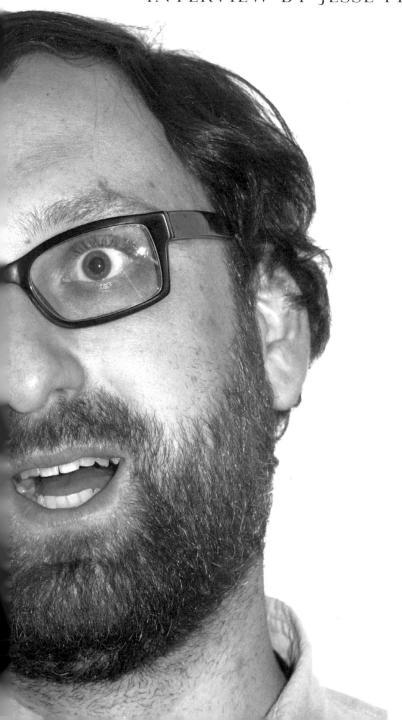

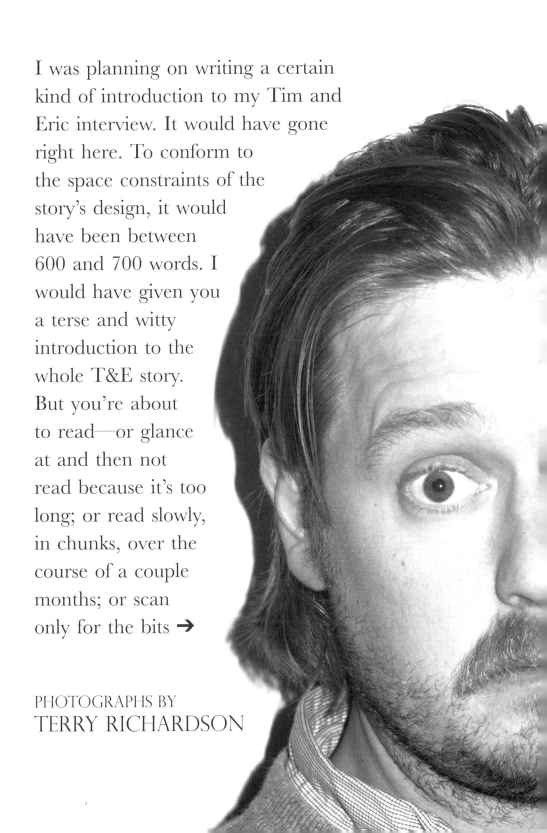

I was planning on writing a certain kind of introduction to my Tim and Eric interview. It would have gone right here. To conform to the space constraints of the story's design, it would have been between 600 and 700 words. I would have given you a terse and witty introduction to the whole T&E story. But you're about to read—or glance at and then not read because it's too long; or read slowly, in chunks, over the course of a couple months; or scan only for the bits →

PHOTOGRAPHS BY
TERRY RICHARDSON

you care about; or just look at the pictures in—a 20,102-word interview with Tim and Eric. All of the life-story things get covered therein. All of the motivational things do as well. Anything I could say here would be redundant, but it would be preemptively redundant. Which really means that it would make parts of the interview itself redundant. Why would I want to do that? What I'm realizing here, now, is that introductions are sometimes stupid.

So let's make this really simple. If you don't know who Tim and Eric are, they are two deeply inventive writers, directors, and performers who make work that is funny, gross, scary, and smart. It's satirical in ways that go so far and so hard that you might not even realize it's satire. It's challenging, but it's worth it. It's sophisticated and simplistic at the same time. Tim and Eric represent a huge jump in the evolution of comedy. Sounds grandiose, but it's true.

And if you do know who Tim and Eric are, then you know exactly why you should read this interview—because they're really interesting. Either way, I'm going to stop now. I'll just leave the extra space on this page blank. It looks good that way.

—JESSE PEARSON

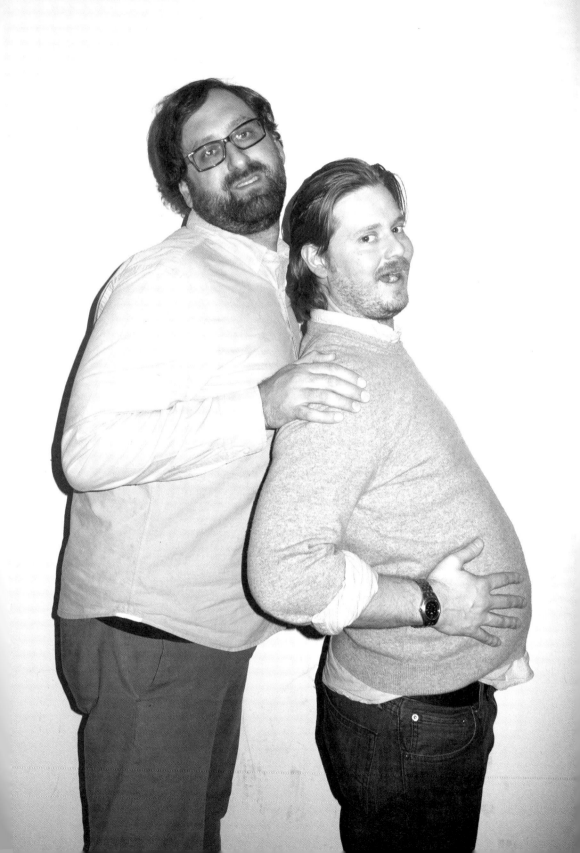

I'm curious to hear about what kind of a neighborhood and household you grew up in.

I grew up in the suburbs of Allentown, Pennsylvania, which is about an hour outside of Philadelphia. It's a medium-size town. We lived in a small three-bedroom house. My father ran a Ford dealership with his brother and his father. He worked a lot when I was young—six days a week—and I remember him coming home for dinner and then going back to work. The dealership was open until 10 p.m. My mom was a stay-at-home mom and we had, for the most part, a very close, good family unit with my parents, my younger sister, and me. We had a lot of extended family around too—aunts and uncles, cousins, and grandparents. It was pretty much suburban-dream stuff.

Car dealers are kind of a big comedy trope. They come up a lot.

Yeah. I spent a lot of time after school at the dealership, in lieu of babysitters. I was very familiar and friendly with the other car dealers. That's a whole subworld of characters and caricatures—a lot of big personalities. And historically, the late 70s and early 80s were terrible times to be selling American cars. I think it was very hard for my family to be in that business at that time. They got through it, but they worked really hard and probably endured a lot of years of stress. Then, in the late 80s or early 90s, a new highway was planned and it was going to go right through the entrance to the dealership. So they got out of the Ford business and opened a body shop, and that became a much better business.

Was there a shared sense of humor in your family?

Absolutely. I've thought about this a lot. On the one side of my family, my mom and her mom were very musical and silly and a bit self-deprecating. My mom would write little songs, and my grandma played the piano by ear. And then on my dad's side of the family, it's very sarcastic and facetious. Very skeptical and kind of "The whole world is going crazy." That can be really funny. When I was a young kid, my dad and I would watch the crazy televangelists on the Christian channel, and that would be entertainment to both of us. My dad is very smart and educated, and there was a little bit of that *National Lampoon*-style cynicism to his worldview.

Maybe you were learning how to respond to mass culture with parody even then.

There was that "Oh my, this is ridiculous" attitude about politics and the world in general, and a slight distrust of what was being presented to us. But then, on the other side, I had my mom's influence, which was more about silliness and music—being a little naive in a way that can be funny.

Did you play an instrument from an early age?

I started playing piano pretty early, and then I got into playing

ERIC WAREHEIM

Where did you grow up?
Audubon, Pennsylvania. Thirty miles outside of Philadelphia. It's
a really shitty town.

Shitty in what way?
It's a very suburban place. There's nothing there. The mall was
our centerpiece, which I think influenced a lot of my and Tim's
humor because we do so much stuff about mall stores and bad
products. I had a group of friends in high school and we were
the outsiders. I was sort of on the line though—since I'm tall I
played basketball. But I was also in this metal band and I was in
the A/V Club, and we made weird videos.

What kind of stuff?
We made videos for Dead Milkmen songs.[1] We were obsessed
with the Dead Milkmen. I think that my high school friends,
even before I met Tim in college, those dudes informed my
comedy. It was very juvenile shit, but also very anti the rest of
the school.

I'd love to see some of those high school videos.
We had to do real interviews, but then we'd also make up a band
and be really serious about it and do a fake documentary with me
and my friends talking about why this band is so important, just
making fun of it all. Also, my dad always had a video camera.
He had a Super 8 camera too, and he taught me how to do stop-
motion animation. I did a lot of that stuff early on.

What was the sense of humor in your household like?
My parents were into *Saturday Night Live* and Monty Python. My
dad would always do these Monty Python bits that I didn't get.
I didn't understand them. They also took me to see Bill Cosby
live. But I've got to say, my parents were not jokers. It wasn't like
a totally serious tone in the house, but it wasn't a constant giggle
fest either. If anything, it was more me and my sister screwing
around to make our parents laugh.

**You and I are about the same age, and when we were
kids, I think, it was kind of hip for our parents to be
into comedy. Like George Carlin and people like him.
It was kind of a countercultural thing for the generation
before us.**
Yeah. And I saw a little bit of that in my parents—very small
amounts that hinted at their past. They were way more silly
when they were kids. But when I was growing up, my dad was a
molecular biologist. He was kind of a serious guy. Really warm,
but very get-shit-done. He was working at like, SmithKline
Beecham. One thing I got from him—definitely more than
comedy—was a work ethic. That dude worked every single
day of his life, and every weekend he worked on the yard. He
instilled that in me. I think Tim shares that as well. That's why
we bonded when we were in college. We just knew we had to
work our asses off nonstop.

1. Historical
Philadelphia goof-
punk band. To
us Philadelphian
weirdos, they are
heroes. The rest
of you probably at
least know them
for their 1988
alterna-hit "Punk
Rock Girl."

guitar. I took some lessons, but I really just figured out a shorthand way of playing that doesn't involve a lot of theory.

What kind of a teenager were you?

I did a lot of community theater and I played a lot of music. I had a couple of really close friends, and we hung out and started bands. I was into my father's generation's music—the Beatles. My hobby was reading all the books about them and collecting all their music. There's that book called *The Complete Beatles Recording Sessions,* and it's literally a diary of every day they spent in the studio. And of course, the more you read the more they come back down to earth. My opinion of John Lennon has kind of shifted to where I see him more as a little bit of an oaf and asshole. But still, to this day… I just read another Beatles book a couple of months ago.

They were a primer for a lot of smart kids to get deeper into music.

It became a gateway to so many great things. I'd read something about how George Harrison learned to play the 12-string from David Crosby, and it would lead me down these crazy roads of great music.

Is it safe to say that you were less of a punk or alternative teenager than Eric was?

Yeah. In my senior year I got into Pavement, which was the first current band where I thought, "Oh, this is a connection to the 60s music that I like, but it's really its own thing as well." And that led to Guided by Voices and that side of alternative music that I really liked. But in high school I had long hair and drank beer whenever I could find it, and smoked pot and dropped acid. I went to Lollapalooza and everything.

And all the while you were doing local theater work?

That was like a different part of my life, a different group of people that were a little older. A lot of gay people, and a lot of people who lived in New York and were super-cool and adult. And they treated me like an adult—like a cool guy. It felt like I was living beyond my years. Like there was this guy William Sanders, who was the director-in-residence. He had the long hair and the horn-rimmed glasses and he only wore black. He was really intense, funny, modern, and sophisticated—and he could also be totally scary because he was a director. He had a temper when he was under a lot of pressure. I was like, "This guy is my hero. I want to be like this guy."

What were your early tastes in comedy like?

It was something I was interested in from an early age, but only as a recreational activity. *Saturday Night Live* and *SCTV* were huge. In high school, on Sunday mornings, my family would go out for breakfast at this diner, and I would do sketches from *SNL* the night before. They were annoying to hear because they're never as funny being retold.

Eric Wareheim, cont'd

Comedians are some of the hardest-working entertainers there are.
Another story about my dad, which was maybe the most important thing that has ever happened to me in my life, was we were at the mall on my birthday once, and I could get one piece of clothing. We went to Macy's and... Do you remember Z. Cavaricci Jeans?

Ugh. Those things fucking ruled my high school at one point.
Yeah. [*laughs*] And they were $70. My dad was like, "I'll say no for two reasons: A) Jeans cost $10. I can't afford these. And B) look at these things." And he opened them up and showed me how silly they were. It took me ten years to realize that, my God, my dad was right. He was saving me.

I can't believe you wanted Z. Cavariccis for even a second!
This was junior high school, right before my crossover. It was Z. Cavaricci and then: combat boots. I feel like that's the age when you don't know what you're doing. I also feel like I always wanted cool clothes, like a couple of rich kids in my middle school. Another thing I remember, early in elementary school, was when my parents got me imitation Chuck Taylors.

That's not good.
Yeah, with no logo. I remember all the kids being like, "Wow, that is fucking bad."

I had a really shitty, sad, cheap imitation Michael Jackson jacket in fourth grade. The memory still makes me wince.
Oh, that's great. [*laughs*]

When you were a teenager, what was funny to you?
I remember really starting to understand comedy when I watched Christopher Guest movies like *This Is Spinal Tap* and *Waiting for Guffman*—although I think that one might have come out when I was in college.

Actually, let's jump back for a second. So the Dead Milkmen were formative for your sense of humor?
Oh my God. Absolutely, dude. That might be the exact answer to your question about what was funny to me as a teenager. When I hear those songs, I know every lyric. I went to see their first reunion show at the Fun Fun Fun Fest in Austin. We were actually playing there—Tim and I. And I talked to Rodney[2] afterward. I was like, "I know you get this a lot, but seriously, your cassette tapes were the impetus to my comedy." And he was like, "Oh shit, I love your guys' stuff too," and he started rattling off all these bits of ours. It was such a mind-blowing moment to hear him doing that, especially with that thick Philly accent of his.

He's got one of the Philliest accents of all time.
Yeah. So in high school, it was stuff like that mixed in with

2. Rodney Anonymous, vocalist and Philly raconteur.

1. Two legends of local Philadelphia television. Alberts, a 60s lounge singer gone to seed, hosted a weekly showcase of local children singing (usually with Cheez-Whiz-thick Philly accents) ancient standards like "A Bushel and a Peck" and "Tie a Yellow Ribbon." Ferrari, an organist, had a half-hour show that aired every Sunday morning on the local ABC affiliate. It consisted of him playing schmaltzy arrangements of musical chestnuts. Please seriously consider searching both of these names on YouTube.

2. Which featured adult actors' heads (Patton Oswalt, Rainn Wilson) superimposed on children's bodies while they sang vaguely prurient songs.

3. A spinoff from *Tim and Eric Awesome Show, Great Job!* featuring John C. Reilly (*Boogie Nights, Gangs of New York*) as mentally challenged local newscaster Steve Brule. This character, created as much by Reilly as by Tim and Eric, is one of the most important comedic creations of the past decade.

So you weren't considering becoming a comic at that point?

It just seemed so out of reach. But I was acting, and I thought for a while that that was what I was going to try to do. In the middle of high school, I auditioned to be in this summer program—the Governor's School—that had this very prestigious reputation. Everyone around me was like, "You'll definitely get in." People were very encouraging about it. So I auditioned, and I didn't even get into the first round. It was this big, harsh rejection, and it soured my opinion of going to a drama school, of doing it through a conservatory method. And at the same time I started getting into film, like Woody Allen's movies and *The Graduate*. I think *Reservoir Dogs* came out during my senior year of high school. And these movies made me love movies. So that became my plan: I can go to film school and be Woody Allen or the Coen brothers. I'll make my own shit and be in it. I remember having these reasonable, logical conversations with my friends and parents and saying, "If I went to school for acting I'd just be an actor and I'd have no skills. I'd be lost."

I'm from the Philly suburbs too. When we were growing up, the local TV programming was really rich and weird, with things like Al Alberts and Larry Ferrari.[1] Were they influential on you?

Definitely. I don't think Eric watched that stuff as much as I did. But low production values are universally understood to be funny. We directly spoofed Al Alberts on *Awesome Show* with those "Child Showcase"[2] things.

Like the one with Patton Oswalt.

That was a direct inspiration. We were pitching ideas and it was like, "Do you guys remember Al Alberts?" But what was even more significant for me was that Allentown had its own channel run by the cable company. It was called Service Electric. I totally forgot this until recently, but on some Saturday nights they'd broadcast these one-camera shows of local people waltzing around in circles to polka music.

I could watch that for hours.

We would. There'd be so many characters there, and so many layers of funny. They also had their own local news there—channel 69—and the programming was always fucked-up. Then there'd be the local commercials, which were totally hilarious to my sister and me. You know, just local furniture stuff. In Allentown a lot of the humor was connected to the Pennsylvania Dutch. It felt like everything was being made for people who were 65 and older. So there was that strange disconnect from the youth.

All of this sounds a lot like the universe of *Check It Out*.[3]

The beginning of that show, with the announcements—if I show

David Lynch. *Twin Peaks*. I had an AP English class in ninth grade, and the teacher was so cool. We would have a *Twin Peaks* discussion. We had ten minutes at the beginning of class for it. I remember not even fully understanding the show but being so into it, and feeling like it was so mysterious. Those discussions got me into David Lynch's other things, like his short films, and then I branched out even further. I was mostly into art films, video art, and punk-rock music. I would still watch big, mainstream comedies with my friends, like *Cannonball Run* or something, but that would just be a thing to do.

Like a bonding experience.

Yeah, because all my friends were quoting that stuff and I felt like I wanted to stay involved with them. We'd have competitions to see how many times we could watch *Cannonball Run*, actually.

Have you ever heard any of David Lynch's quotes about Philadelphia? You know he went to the University of the Arts.

Yeah.

He once said, "Philadelphia more than any filmmaker influenced me. It's the sickest, most corrupt, fear-ridden city imaginable."

Wow.

Did being in Philly inform your aesthetic at all?

Definitely. When we were going to Temple, it was the worst neighborhood. There were like 300 murders a year happening in North Philly. It sort of hardened us quickly—really got our street smarts together. It was like Tim and I were fighting the world. That was our attitude: We're on our own here. The city is not giving anything back to us. So we made short films like *Humpers*, where we were humping Philly. It was a "Fuck you" to the city, but also "We love this city." Almost like a hate fuck. But then a little later, living in South Philly, we befriended a lot of weird old men.

Like South Philly Italian guys?

Yeah, exactly. There was this guy called Speaker Pete. We made a documentary about him that we never aired. It was kind of borderline abusive because he was so fucked-up. He would go to OfficeMax and Staples and would set up a DJ booth outside—without telling the store—and he'd play music and sing along to it. He played things like Billy Joel and Dolly Parton. He called himself the open-air DJ. He was just out there, doing it for free. And of course, Tim and I were like, "Wow, we're obsessed. This is the weirdest thing we've ever seen." We gravitated toward people like that, and those kinds of guys are in all of our work now. This idea of people struggling to get ahead, to have something on their own—that's the core of what we do, which is us, these two idiots, thinking that we're better than we really are.

Well, wait. Let's just jump ahead to *Awesome Show*

Tim Heidecker, cont'd

that to anybody of our age, they're like, "Oh, that reminds me of
school closings."

**Right, when you'd watch local cable in the morning and
wait for the announcement that you had a snow day.**

I'm sure that every town in the United States had a similar
thing. I don't think it was specific to our area.

**After high school did you go straight to Temple
University?**

Yeah, and I lived in the same dorm—on the same floor—as Eric.
It was me and him and a couple of other guys. Eric and his crew
were hardcore straightedge dudes.

**Like with the tight black jeans and the dyed Caesar
cuts?**

Yeah, the uniform.

**What do you remember about becoming friends with
him?**

It started with notes being passed back and forth in class
between me and Eric and a couple other kids. We were fucking
clowns—probably all class clowns in our various high schools.
We were always cracking each other up. This one time we were
writing down band names and passing them around. Eric always
remembers this one that I wrote that made him laugh the most,
which was "TGIF."

It's a good one.

It's exactly the sense of humor that you either think is really
funny or you don't think is funny at all. But that killed him,
and it was in this big 200-person lecture hall. We were called

*Tim and Eric in the
2008 "Innernette"
episode of* Awesome
Show, Great Job!

for a minute. When you guys are standing in front of the camera talking as Tim and Eric, are those actually more like characters that happen to be named Tim and Eric? Is that what you're talking about when you say, "these two idiots"?

Yeah. The core of the characters of Tim and Eric are not the real Tim and Eric. A lot of the time, Tim will play the bossy dick guy and I'll be a little bit more submissive. I think a lot of that has to do with our size—it's just funnier to be a big man and be the weaker one. That's why I play women a lot and he plays the asshole dudes.

And those Tim and Eric characters, are they guys who want to break into showbiz?

Or break into anything. Like in our movie, how our characters think they can make a movie, and they run a PR company, and they're really just two dumbasses. When you move to LA, there are tons of people like that.

For real. That's something about LA that terrifies me.

Out here, if you call yourself a producer, then you're a producer.

But getting back to Philly, can you talk to me about the local cable there? How did it influence you?

Al Alberts was definitely an influence. But even early in college, we had a network of people who would send us tapes from not only Philly, but from everywhere, of all those kinds of local TV personalities. Do you know this guy named Joe Burns in Philly who does bootleg show videos?

No.

He's a good friend. His business was sneaking into, like, a U2 concert and shooting it at pretty high quality and then selling it. He would also document everything that we would do, like Tim's band called the Tim Heidecker Masterpiece. And every time he gave us a tape, at the end of it was the craziest shit—like Chuck Berry peeing on a girl.

That whole mid-to-late-90s era of weird VHS-tape trading was probably a big inspiration to you guys.

Oh my God, totally. We'd have little screenings at our house. We'd get drunk on 40s and watch these tapes over and over again. We wouldn't even watch movies.

With YouTube being a big depository for things like that today, there's a sort of mystery that's gone. It used to be like handing off contraband, getting those early videos of things like Jan Terri or Winnebago Man.[3]

It doesn't feel special anymore.

Do you remember the first time you met Tim?

Yes. It was at Temple University. We knew of each other because we lived on the same dorm floor. It was mostly basketball players, and then a handful of white kids, and there happened to be a couple of dudes who were very like-minded living there. Not

3. We'll strive to keep the mystery slightly alive and not describe these things here.

out by the professor to stay after class, and that was such an emasculating experience in college. Then we were in some other smaller classes, where I think we saw in each other that we were more ambitious than most of the other kids. We had ideas and we wanted to do stuff. It was slim pickings in terms of cool people there, as I remember. Eric and I did a couple projects together, and that kind of rolled into a closer friendship. We were housemates for our second year of college. The combination of not really having any money and not having a course load that required much work gave us plenty of fuck-around, goof-around time. We would sit around and drink and listen to music. Through that, I think we developed the sensibility that became our own shorthand language.

One of your and Eric's film school projects is on YouTube. It's funny, and you can see the roots of your future work in it. It also feels very dismissive of the assignment.

We were in a yearlong thesis class. The first semester was spent developing a script, and the second semester was spent filming and editing it. But I guess the professors realized they needed something they could use to determine a grade for us besides just the thesis film itself. So they said, "Everybody has to do a report on some aspect of filmmaking—art direction or location management or something. You'll work with a partner, and you have to give a presentation to the class." Eric and I—maybe a little unfairly—felt like that was bullshit—a waste of our time. We should have just been making our movies. So we did it very quickly—probably in a day or two. We cut it on the shitty tape-editing machines they had there. We thought it was hilarious. Then we showed it to the class and they were looking at us like, "You fucking assholes." I think by that point we were already considered assholes by the rest of the class anyway. A lot of people didn't think it was funny. They thought we were being disrespectful.

Because they wanted to be artists.

Yeah. But at the same time Eric and I were also making our serious movies. Mine's a piece of shit. You go through the film school mill and you get the seriousness of filmmaking—having a message and a perspective and a social conscience—drilled into you. It's pretty explicitly like, "Comedy is something that should not be taken seriously. You shouldn't be making comedy."

So what was your college thesis film like?

My original idea was to do a musical. But I was told that that wouldn't be considered appropriate, so—this was my Jim Jarmusch period—I made this thing about racism. It was in black-and-white. It was very serious. I was kind of into it, I guess, but it wasn't very good. It wasn't worth doing. It was like a math assignment or something.

only Tim and I but a couple of other guys too. And then Tim
and I were in a Media 101 class together. We were sitting next
to each other and we started writing dumb band names back and
forth. Tim wrote "TGIF," and I lost it. I thought it was so funny.
This was in a big lecture hall, and our professor was like, "Guys,
this isn't high school." I remember feeling so embarrassed, like,
"I'm in college, I can't do this anymore." But Tim and I became
friends after that. There were a bunch of video projects in that
class—like make a TV show, make a short film, do a lighting
exercise—and we would team up and make shit together, and
our friends would be like, "Holy shit, that's funny."

How lucky that you guys lived on the same floor.
And the next year of school, we lived together again. We got
an apartment in South Philly, at 6th and Bainbridge. We lived
there for three years. We did shows at our house—screenings and
parties—and we shot there all the time.

**At the start, did you have a certain specialty you
brought to the partnership?**
I had a pretty extensive technical background. Not only from
knowing how to shoot but also editing. I edited in my A/V Club.
I always loved Video Toaster[4] and graphics programs. And then
in college we had this really bad VHS-editing equipment. It
made everything look fucked-up. I remember the moment when
Tim was like, "Let's keep that. That's what we're going to do.
We obviously don't have the money to get good equipment, so
let's just work with what we have."

**And then that lo-fi feel became one of the hallmarks of
your work together.**
I was also way into music and recording my own band. I had
this knowledge of the do-it-yourself punk-rock world. We would
go to Sears and buy a video camera that had a 60-day return
policy. We'd return it on the 59th day and get the money back
on my dad's credit card. I was also screening my own t-shirts. I
knew about all that kind of punk self-promotion. I'd been doing
it for years. And I think I brought that to my and Tim's world.
Once we knew we'd made some good videos, we kind of reached
out that way.

Using that sort of punk, DIY mentality.
Yeah. But then Tim also brought a level of almost
professionalism. He was a little bit more focused on the fact that
all this stuff could become a career.

Wow, even back then?
He has a theater background, so I think performing was always
a possibility for him. But I was always like, "I'm going to be a
director—be behind the camera. I'm going to make art films and
photography." Tim was the one who said, "Let's get in front of
the camera. We're going to be funnier than any fucking idiot in
our film school."

4. An early con-
sumer-grade video
editing hardware/
software combo.
Look at one of
their old demos
on YouTube, and
you will see the
DNA of much of
Tim and Eric's
aesthetic.

Why do you think comedy was so ghettoized there?
I don't know. Comedy had a really bad reputation then. We
didn't really know about something like *Mr. Show*. If you said
"Comedy" with a capital C back then, it was like *Catch a Rising
Star* or Richard Jeni or *Seinfeld*.

**The whole blazer-with-the-sleeves-pushed-up, standing-
against-a-brick-wall, *Evening at the Improv* deal.**
Yeah. There was absolutely nothing cool or artistic about it. It
didn't seem like it was for us. It could be entertaining at times,
but it wasn't to be taken seriously.

**Did you and Eric know that you would want to continue
to work together after college?**
I don't remember that being something we talked about. After
graduation, there wasn't really a lot of focus about a career
except for just trying to make money doing whatever was
available. I was just post-college, floundering and hanging out
and trying to live. There wasn't a plan or anything. I got a job
as a prop master on a film, and I was a waiter too.

What was the prop-master job?
At first I did it for a really shitty movie, but then I got hired to
do the same thing for *Jesus' Son*. Remember that movie? Within
three weeks, I got fired. I was so out of my element—just fucking
up. It was a period piece and a drug movie—all these things that
I didn't know how to handle, especially without the internet or a
cell phone, the things that make life so much easier nowadays.

**Was this around the time when you moved to New York
for a while?**
Yeah. It seemed like maybe I should go there and try to do this
acting thing again, and try to write. I had ambitions to write
comedy. Plus I just didn't know if I could be in Philly anymore.
My opportunities there seemed limited. So I moved to New
York and immediately—I think the next day—I had to get a job.
I started temping and that led to full-time employment doing
fucking shit work. It completely took up all my time.

**But you were also going back to Philly to make videos
with Eric?**
There was a period of between two and three years where Eric
would come up and visit or I'd go down there. We'd also chat
on IM, just to check in. But we weren't really working with each
other. I was in a serious relationship, living with a girl, and I was
playing in a band that I had started called the Tim Heidecker
Masterpiece. For a couple years we were playing around New
York and doing these rock operas. I put a lot of my energy into
trying to make that band succeed, but at some point it ran its
course. I was the only one holding it together. We even made a
record. But it just never went to that next place.

Were you doing any video work at that point?
I was making these little videos with my girlfriend. I would shoot

Would you guys give each other pep talks about how great you were?

No. It was a weird thing. Tim is really like… I wouldn't say cold, but he's like, "You know what you've got."

Matter-of-fact?

At first it was hard working with him because I was used to being in bands where we'd all sit down and listen to our stuff and go, "Dude, this is great, man." Tim and I didn't really have that. We were both like, "This is really funny." But we were kind of serious about it. We were more, "On to the next thing, let's make it better, let's not dwell on any one thing."

So how soon after starting to work together did you know that you wanted to take it out into the real world as a duo?

Right after college, we made our first DVD of all of the stuff we'd done. We sent it to all of our friends, and somehow it got into the Philadelphia International Film Festival. That's the point where we got a little bit of press and people came to the screening and were laughing at it. We were like, "Oh shit, this could actually be something." Then Tim moved to New York and I stayed in Philly. I was a bar and bat mitzvah photographer and videographer.

That must have been really trippy.

It was insane. But I had a lot of gear that I had bought for that, so Tim would come to Philly on the weekends and we'd shoot things like *Humpers*. Then I'd go to New York, and we'd shoot things in Brooklyn. Every weekend we'd do that stuff. I compiled another DVD, and we were like, "Let's send this out to some people." Tim had a shitty office job so he had a lot of time, and he looked up people's addresses and sent it to Conan O'Brien, Robert Smigel,[5] Christopher Guest, and Bob Odenkirk. We didn't know shit. We were like, "Let's give this a try. Who knows?"

And it worked!

With Odenkirk, since Tim had already sent him an earlier package, we wanted to make the second one special. So we put our silly headshot in there and we included a bill for everything. Even for the shipping. We charged Bob Odenkirk $85 for this unsolicited package! When he first got it, that's what he saw. He called Tim and said, "That's really funny. Who the fuck are you guys?"

I'm surprised he was opening his own mail.

So were we. At that point, *Mr. Show* was really big and he was getting tons of packages. He could have just thrown ours out, but maybe it helped that we made it look a little bit appetizing. I was like, "What would I like to get in the mail?" We were pretty serious about it. We printed DVD covers, made it look professional, made it look like you'd want to experience this

5. Primarily known as the voice of Triumph the Insult Comedy Dog, Smigel is also the man behind the underrated *TV Funhouse* skits on *SNL* and the short-lived series of the same name on Comedy Central.

Tim and Eric as Casey and his brother (left) and as Jan and Wayne Skylar (right).

Rainn Wilson (top) and Patton Oswalt (below) appear in "Children's Showcase" segments on Awesome Show.

This is what
Tom Goes to
the Mayor
looked like.

*Will Ferrell as Donald
Mahanahan, an*
Awesome Show
*character who makes
and sells child clowns
by mating with women
who "are clean and
have real clown traits."*

The recurring Awe-
some Show *phe-
nomenon known as
the Chippy.*

us playing with our cat, and then I'd share those with Eric. He was kind of doing similar things—making these art-piece videos with his girlfriend. He was doing bat mitzvah and wedding video work too, so he had equipment. Then my girlfriend moved to LA. We kind of broke up. I was in this lost place. My life was changing. And over IM, Eric and I started talking about doing a cat-film festival. We shot a little video for it, and our first instinct was to make it purposefully bad—to make it weird. After that I started going down to Philly and spending the weekend there—which was fun anyway, to see some old friends—and we'd put a couple hours of work in. We made the first *Tom Goes to the Mayor*[4] short that way.

Is this the era when you made the *Humpers* video, where you and Eric run around Philly in hot pants humping benches and trees?

Yeah. That would be a pretty early one, along with some prank phone calls that I did and Eric animated. We started thinking, "These are kind of good." So we made a little compilation of them and starting sending it out to friends.

And one of these went to Bob Odenkirk?[5]

Yes. I called Dakota Films, the production company that made *Mr. Show*, and they gave me his office address. I'd actually sent Bob a Tim Heidecker Masterpiece CD before that, but I didn't hear back. Then I sent him another one and also included the Tim and Eric compilation in the package. Maybe he recognized the name or something, but he paid attention to that second mailing.

And he became sort of the patron saint who shepherded you and Eric through the beginning of your careers.

I got a call on my cell phone from a 323 number while I was sitting at work. I answered and he said, "Hey, it's Bob Odenkirk calling for Tim Heidecker." I was like, "Who is this, really? Who's fucking with me?" He said, "I'm watching your stuff and it's really funny. Who are you guys, and what scene are you in?" Unbeknownst to me, there was a whole New York comedy scene with people like Jon Benjamin, David Cross, Demetri Martin, Eugene Mirman, and so on. He just figured I must be with those guys. But Eric and I were completely on our own. We had no connections. Nobody else was in our world. Anyway, from that point on, Bob and I kept in touch through email. That inspired me and Eric to make another round of videos in an attempt to put something cohesive together. We wanted to create a lot of little sketches and one big piece. We put that out as a DVD. I think we still sell it, actually.[6]

Just going back for a second, I know that before all of this happened, you'd tried doing stand-up. What was your act like?

It was kind of just me being weird. I did this one bit that was

4. Tim and Eric's first television series, which premiered on Adult Swim (the Cartoon Network's night-time raft of more mature programming) in 2004. It starred Heidecker as the titular Tom, an earnest wanna-be do-gooder, and Eric as the Mayor with whom he would launch schemes and have adventures. It employed crude animation and basic Photoshop filters for a very distinctive—and divisive—look.

5. Most people know him best as Saul, the crooked lawyer on *Breaking Bad*, or as one half of the cult HBO comedy series *Mr. Show*. As you will come to see, we effectively have him to thank for bringing Tim and Eric to us.

6. They do. It's called *Tim and Eric Ultimate DVD Collection* and it costs $14.99 at timanderic.com.

thing. And that got him to watch that DVD. And then he literally just called Tim on the phone and was like, "Who are you? What scene are you in?" Tim was like, "Uh, we don't know anybody. We don't do comedy. We just make these films." Bob said, "Come to LA. Let's talk." He was like, "I'll help you get an agent. I'll help you get meetings. I just want to help this show, *Tom Goes to the Mayor*, get on the air." At that point he was branching out and trying to work with new people. He hadn't seen anything like our stuff before, and he liked that we weren't part of a troupe or anything.

Do you remember when Tim called you and told you that Odenkirk had responded?

We were thinking it had to be a friend pranking us. Tim was like, "But it was an LA number.' We didn't really believe it until we actually flew to LA. We were so nervous meeting him. At that point, *Mr. Show* was our biggest influence. So it was really fucking crazy.

How did you two settle on *Tom Goes to the Mayor* being the first series you'd do?

It was one of the shorts on the DVD. Bob said, "You should get celebrities to do voices. It would make people pay attention." And he was so right. He got David Cross to do a voice character, and I edited that episode, and then we had a reel— two episodes. At that point we had meetings with Comedy Central and some other people, but finally we got the DVD to Mike Lazzo at Adult Swim. He loves Bob Odenkirk and so he was like, "All right. I'll take a chance on this." And also, when Bob is pitching something he's passionate about, it's the most amazing thing ever. So he won everyone over with this new idea. Tim and I took the money and packed up our shit and moved to LA together.

Just like that.

We rolled the dice. Like, we might have failed and had to move back in with our parents.

Was it a culture shock moving to LA?

It was crazy. I moved to Echo Park, and when I would walk down the street and people would say hi to me I was like, "Fuck you."

A true Philadelphian.

Yeah. I was like, "Don't talk to me." But it was pretty wild—we got here and Bob introduced us to everybody and got us an agent right away, and the pilot turned into a series within months.

Did getting to know Los Angeles add something to your sense of humor?

Oh, totally. Our art director on *Tom* was like, "You've got to come to where I grew up in Simi Valley. It's just buffet restaurants and strip malls and shit holes." We drove up there and started taking photographs of everything. We used all of

216

kind of my go-to bit, and it's embarrassing but I had this Russian fur hat and I wore it with this fur jacket and I sang songs. Like I would sing "Blowin' in the Wind" by Bob Dylan, but I did it a capella while I was listening to it on my headphones, the way you would sing it on the subway or something. And I wouldn't know all the words, so you'd just hear something like, "How many… turn… before… duh duh, yeah." I was also really naive in that I thought that every time I did stand-up, I had to do something completely different. That created a lot of pressure. I couldn't keep generating these weird ideas. I didn't realize that you should probably just come up with an act and do it for like two years. I went down the wrong path there.

I like how Odenkirk assumed you guys would be in one scene or another. It's so true that comedy is divided up into cliques and factions.

New York magazine recently put out this giant diagram of the world of comedy and it has all these sects, like the *SNL* group and Will Ferrell, and how they all interconnect. We're on there.

Do you agree with where they placed you?

The weird thing is that Odenkirk is on the other side with *Mr. Show* and there's no connection between us. But it would be impossible to do it really thoroughly and accurately. It's cool just to be in it.

Tim and Eric with Bob Odenkirk.

that in the show. It could have been any town, but LA was particularly disgusting—and beautiful too. We didn't put that in the show, but moving from the East Coast to California… it just changed us. It changed me specifically. I had been a very angry man. I couldn't stand the summers, couldn't stand the winters. But out here the weather is fucking amazing.

And you'd also just experienced this quick and sudden dose of success.

It was awesome. Like, "Oh yeah, I'm paying rent with money from a TV show that's fully ours." Bob would always tell us, "You've got to value this experience because this does not happen. No one has this creative freedom." Adult Swim was new at the time, and they were allowing us to do anything. It's a very rare occurrence to be able to make TV like that. It's almost art in a way. It was very personal. Tim and I were just left alone.

It sounds like Odenkirk was almost a life coach to you guys.

He was our godfather. He introduced us to Jack Black, Jeff Goldblum,[6] all these guys who he basically forced to do the show. Like, Jack Black came to my house and recorded a voice for the show. I had to put my blankets up on all the windows to block out the street sounds. It was just crazy. And then Bob also taught us the business. Like, don't be dicks, don't let this shit go to your head, be thankful for what's happening.

It's amazing how generous he was to you and Tim.

He really took us under his wing—and without ever wanting money or recognition. He did it out of love for what we were making.

Was *Tom Goes to the Mayor* canceled?

It was sort of canceled. Mike Lazzo called us and said, "You guys made 33 of these, and they're not getting good ratings. But we love you. Do you have any other ideas?" We were kind of bummed, but we always had this idea of the *Awesome Show*, a sketch show with all the different kinds of things Tim and I do—not just animation. Lazzo was like, "We don't do live action. But fuck it, let's try it." His whole philosophy was to make some shit for not a lot of money, throw it up on the wall, and see if it sticks. That's really how he did business.

I wonder whether he still works that way or whether it was a symptom of them being in their early stages.

I think things have changed now because they've gotten so popular. He needs more hits, so a lot of Adult Swim material is parody now. It's not as truly unique and innovative as it was maybe five years ago or something.

I kind of got the sense that at some point Ted Turner finally realized he owned it.

Yeah, I think that happened too. I mean, Adult Swim was getting huge ratings. It destroyed everything in its time slot—*Letterman,*

6. Goldblum went on to play small but memorable roles on *Awesome Show* and in the *Billion Dollar Movie.*

Tim Heidecker, cont'd

Let's talk about getting *Tom Goes to the Mayor* started as a series on Adult Swim.

Through Bob, we met the guys who did *Aqua Teen Hunger Force*[7] at an Adult Swim party in Philly. Eric went up to them and said, "Hey, we're working with Bob Odenkirk on this thing." They loved Bob, so they took the DVD that Eric gave them of *Tom Goes to the Mayor*. They gave it to this woman, Khaki Jones, who was in development at Cartoon Network. She flipped in the same way Bob had flipped. She loved it. She started writing me, and we developed a little friendship. She kept putting it in front of Lazzo,[8] saying, "You've got to watch this." And eventually she said to us, "Why don't you guys write up ten ideas that would be interstitials[9] that we could send to Mike, and I'll make sure he takes them seriously." So we did that, and Mike called me and said, "We don't really do interstitials, but I think that *Tom Goes to the Mayor* could be a TV show and I would like to see you guys write it. There's $14,000 for the development deal."

Did you freak out?

I was like, "Holy shit! We just got a TV show!" I was jumping up and down, running along 2nd Avenue and calling Eric: "You're not going to believe this!" And then I was like, "I hope I got the number right. I hope he didn't say $1,400." Because $14,000 seemed like the most money ever. It was absurd. The next step was having a long series of conversations with Bob about how he would be producing it. We had gone out to LA a few times to meet with him and Dan Harmon[10] and Rob Schrab. They were doing their own thing in LA, showing videos, and they had shown some of our stuff. The idea of moving out to LA seemed very appealing to both me and Eric, and having that very small but significant amount of money was just enough propellant to get us out there. All we had was a development deal, which basically was guaranteeing that we would be writing the script. So we were going out to LA with nothing—just the money that moved us there.

A lot of people have moved to LA with a lot less.

Yeah. And we felt confident because we'd kind of gotten the message that Adult Swim didn't do a lot of development deals. They weren't giving those out left and right. They were really going to try to make this into a show. And they did. We wrote the pilot and they read it and said, "Why don't you guys just make 13 of these?"

Were you both able to live off *Tom Goes to the Mayor* right away?

No. I borrowed a little money from my parents just to bridge the gap, and I had some money saved up. Then there was another infusion when the series was greenlit. It fell into place very quickly.

7. One of Adult Swim's definitive animated series. It told the story of an anthropomorphic meatball, milkshake, and container of french fries who lived in South Jersey.

8. Mike Lazzo, mysterious head honcho of Adult Swim.

9. Super-short little bits and riffs that run between regular TV programming. Kind of like station IDs.

10. The unfairly-deposed creator of *Community* but, more importantly, the creator of 1999 cult unaired TV pilot *Heat Vision and Jack*, which Heidecker has called "the greatest thing I have ever seen." It's on YouTube and he's right. It's great.

MTV. And then the big boss was like, "Oh, this is actually doing better than the kids' side of Cartoon Network."

Adult Swim was probably perfect for your show to start on because a lot of college-age stoners watch it, and things can kind of radiate out from that group to people who aren't kids and who aren't stoned.

Since the beginning, we've been trying to figure out who's watching our shows. A lot of the true cartoon people—the animation fans—hate us. In fact, we still don't know who's watching it and why and how. It's like a mystery.

When *Awesome Show* was ready to start up, did you have to write a pitch?

It was pretty much a verbal thing. But we handed something in, just to have it on paper. It was like, here's what five sketches would be. And one thing Bob forced us to do—and it was the best advice—was when he said, "You two have to come out sometimes and say, 'Hi, we're Tim and Eric,' and then you can go into the insanity. If you just had the insanity, there's nothing to hook it."

How did the writing process for *Awesome Show* work?

It was like *Tom Goes to the Mayor* in that Tim and I would come up with a million ideas and then we would bring in a core group of people—John Krisel, Doug Lussenhop, our producer Jon Mugar—and they would each bring a couple of ideas. But it was mostly about them hearing my and Tim's ideas and finding out what they thought was funny. Every season we had maybe one meeting that was two hours long, and then the rest of the time it was Tim and I taking those thoughts and reorganizing them into scripts, even though a lot of the time the scripts ended up being more like outlines.

How do you even write a script for something like "Where's My Chippy?"[7]

We'd have to submit something to Adult Swim so they could sign off on it. But it would just be something like, "There's a weird mustache baby, and we're looking for something in a meadow, and…" Lazzo would just kind of trust us that we would mold it into a bit.

There seemed to be two sorts of sketches on *Awesome Show*: Things that had actual narratives, and then things that were more like mood pieces—the weirder art-video stuff.

And sometimes it would only be the more concrete narrative ideas that were in the script. The mood pieces weren't always written down. We'd just come up with some kind of graphical interlude that would become the Chippy. Or we had these things called "Morning Meditations,"[8] which were kind of throwbacks to cable access. Just people doing weird shit.

7. A recurring sketch in which Eric, in voice-over, implores his "Chippy" to show itself and when it finally does, it's a horrific, shrieking, unibrowed baby.

8. Another repeat-bit that comprised Felliniesque extras writhing around on a bland local-TV set. These bits are terrifying.

Tim Heidecker, cont'd

You and Eric wrote *Tom Goes to the Mayor* at home, right?

Yeah. It was just me and Eric at his house in Echo Park. Bob was our sounding board. We'd bring him outlines, and he was really helpful. We had never written anything like that before, and we didn't know much about structure or the fundamentals of writing. He schooled us, even about such simple things. Like we had an original draft of the first script—and I think everyone makes this mistake—that had this huge origin story about why Tom moved to town and his and the Mayor's first meeting. Wisely, Bob was like, "Just drop us into their world. People will figure it out." So the show developed through making it, and the characters came. I think it's easier to make a second season of a show because in the first season you're building characters, building a world. But then when the world's built and the characters exist, you can just use them. They become rich.

The visual style of the show looked so simple, but I always wondered if that was deceptive.

Strangely, there was a lot of very subtle animation and camera work going on despite the very lo-fi aura of the show. For every episode, we'd have to take a hundred pictures. Each of those had to be processed. Eric became very anal, a very tough taskmaster, when it came to the quality of the way it looked. You couldn't get away with very much. He'd be watching something, and he'd be like, "Look, there's a little speck"—which I never really gave a shit about. People worked really long, hard hours on that show.

What do you remember about the initial public reception of it?

I remember there being a very small, core fan base that loved it—and a lot of people that hated it. They couldn't understand what was supposed to be funny about it. There were people on message boards just destroying us, like, "Fuck those nerds, I hope they die of AIDS, those gay queers"… these nasty things that I'd never experienced before. But Lazzo knew it was coming and he prepared us for it. He said that Adult Swim liked it, that people weren't ready for it, and that it would be considered great in five years.

Right from the start, you and Eric were able to work with some great, established comics.

The Bob Odenkirk card played in that way. He had called people and asked them to be on the show, and we ended up working with some of them a lot. Zach[11] was on *Tom Goes to the Mayor* early and John C. Reilly was too—all these comics and actors who are now the best in the business.

Why did *Tom Goes to the Mayor* end?

The network kind of cancelled it. When we were making the second season, there were a couple of episodes where the network was not on the same page as us. And, admittedly, the show got kind of silly for a bit—maybe a little too anything-can-

11. As in Galifianakis, longtime Tim and Eric collaborator.

**I always thought those were what it would be like if
Bob from *Twin Peaks* did an exercise show.**
That one guy we used looked a lot like Bob. We would have
a big casting and we'd work with these guys in a weird,
experimental fashion. Like, "Okay, now you're a tiger." In the
later seasons we had this black box that Tim and I would be
in with the monitors, and we had a microphone. So the actors
didn't know who was talking to them. We wanted it to be this
weird world where people would get really uncomfortable.
After they would do their stuff, then we'd come out and be like,
"Hi, we're the directors." Most of the time they were cool with
it. Even the camera guys wouldn't know what was going on.
But I think that's how we got a lot of those really, really good
performances.

**Would the actors ever resist what you wanted them
to do?**
Almost never. One thing we learned about LA is that everyone
wants to be on TV. And people like David Liebe Hart and James
Quall, we made them stars. They loved it. At first they were like,
"You're making me look silly." But then they were like, "Wow,
I have 5,000 Facebook friends now." So we've never had one
complaint from an actor coming back and saying, "You fucked
with me."

**With those performers, I feel like you guys were
tapping an unutilized natural resource of Los Angeles.**
That's so true. Early on we made the decision that we didn't
want any pretty faces in the show.

**But on the flip side, you got all these well-known actors
and comedians to come and do the strangest stuff
they've ever done. Actors like Paul Rudd, Alan Thicke,
and Ted Danson, and comics like Zach Galifianakis,
Patton Oswalt, Will Ferrell, and Will Forte. With those
comedians, was there much improvising?**
It was mostly written beforehand. But once they get there, they
all know that in our environment they're free to try things out,
to go way off script. Will Forte would do that in particular. He
really goes for it.

He was crazy on *Awesome Show*. Amazing.
He's such a good actor. He could really get to that place of
lunacy and sort of blend in with the *Awesome Show* world. Some
of the guys we worked with a lot, like Will Forte, John C. Reilly,
and Will Ferrell, they really get into those characters. They live
on this thin line of sanity, almost. Will Forte calls it therapy.
Because, really, a lot of shit comes out. He was like, crying on
set. It was awesome.

**When there was so much improv involved, how would
you know when you'd gotten all you could from a bit?**
Tim and I would come on set and be like, "Let's try this... let's

*Stills from the 2009 Awesome Show
sketch "I Live with My Dad."*

try this… oh! There's the joke. Let's redo it to focus around that." For the movie we had big sets, lots of actors, and a huge union crew, and so we could only do things twice. We really had to rely on the script. I feel like that was a little creatively stifling. For our next movie, we're doing things totally differently to allow for that time of improvising and finding what's really funny. Because sometimes what's funny is not in the script—it's in the way someone says something. And you're only going to find that when you're working it out and improvising.

Billion Dollar Movie had a straight-through narrative, as opposed to the piecemeal nature of *Awesome Show*. Did that feel confining when you were writing it?
It was cool, actually. It was refreshing. The reason we ended *Awesome Show* was because we wanted to try something new. We wanted to challenge ourselves. We felt like we'd really nailed that series. So we made a couple short films for HBO—*The Terrys*[9] and *Father and Son*[10]—and we became turned on by the idea of doing a little story where you cared about the characters. We were like, "That's the next level. Let's write it." So the writing was fun. But the *Billion Dollar Movie* was a little stifling in terms of the performances. It was really fucking hard. Tim and I were in 95 percent of it, and it's tough to direct and be on camera so often. That really killed us. Usually with *Awesome Show*, we'd take breaks and let other people pick up the slack. In the end, though, doing the movie was a cool learning experience.

Is your next movie going to be another single narrative piece?
Yeah. We just outlined the *Trillion Dollar Movie*. We don't know if anyone's going to want to continue that brand, but it's sort of a sequel.

It's the same Tim and Eric characters as the *Billion Dollar Movie*?
Same two guys. We're in prison for killing all those people at the end of the last one, and we're trying not to get electrocuted. I think we're going to use what we learned, which is that what's important about us is the comedy and having the time to fuck around. What's less important are big sets. We're definitely not going to shoot in an abandoned mall again! One of our ideas for the next movie is that the whole film is sponsored by this Subway kind of company called Wingers. It's a circular sandwich.

[*laughs*] That's good!
And the whole thing's going to be branded with it. It's like fake product placement, where we'll constantly be talking about something. It might not end up being Wingers. It might be something else. But we're still trying to find ways to fuck with the idea of watching a movie.

Based on a lot of what can be seen on the internet, being interviewed on the press junket for the movie

9. A short film that takes the Trailer Park Grotesque genre to truly guttural depths.

10. Another short film, which stars Tim as the pizza-deliveryman-stepfather to Eric's damaged manchild (whose mother died after she was "bit by a bird"). Though it's full of laughs both grim and light, the real strength of the film is its unexpected poignancy.

happen. The network was like, "It's just kind of not funny to us, and the ratings aren't great. We think it's running its course. So why don't you just finish making x amount so that you get to 30 episodes total?" But then on the same phone call, Lazzo was like, "I love you guys and I want you to do another show. We want to make whatever you want to make."

There are still some hardcore *Tom Goes to the Mayor* purists out there.

People write us to this day asking if we're going to make any more episodes of it. But I think we did everything we could do with that show. And once we realized the end was coming, the last six episodes were the best we'd done. They're very dark and uncompromising.

The *Thelma and Louise* climax of the series is incredible. So this leads us to *Tim & Eric Awesome Show, Great Job!* Did it stem directly from the non-animation parts of *Tom Goes to the Mayor*?

That was a precedent. And we had also made a video podcast during some downtime. We made six episodes of that. They were very primordial *Awesome Show* style. It was Eric and me in front of the camera saying, "Hi! We're Tim and Eric and this is our show," and then we played short films. We made this "LA Guyz"[12] thing, and that was a reference for the kind of series that we wanted to make. We went to Lazzo with it, and there wasn't that much to be discussed. They knew our sensibilities so well, and I think they were hoping to get a couple of live-action shows on Adult Swim at that point.

Was there a written component to the pitch for *Awesome Show*?

We brought in a one-page pitch. The original title of the series, which will tell you exactly what the mood was at the time, was *Let's Have Fun Again*. That was coming out of how dark *Tom Goes to the Mayor* became, with his son dying and Tom going into a depression. While that was creatively satisfying, there was also this sense that we wanted to go out and dance and jump around and do silly stuff. But yeah, there was a terrible one-page proposal—the kind of shit that you have to laboriously write, you know? "*Let's Have Fun Again* is an 11-minute-per-episode-live-action spontaneous series that delves into the absurd minds…" and so on. We knew it was only going to be read by Lazzo. But I don't think we really had any idea of what the show was going to be, except that we would kind of host it and it would be composed of sketches.

Did you write all of season one before filming started?

We wrote out a lot of sketches and some frameworks for episodes, but we were writing along the way as well. I feel like we were never ahead of the game. None of us had ever done

12. A short that featured Tim and Eric overperforming all of the most brutal stereotypes of the frosted-tips, orange-tan, banana-hammock LA douchebag set.

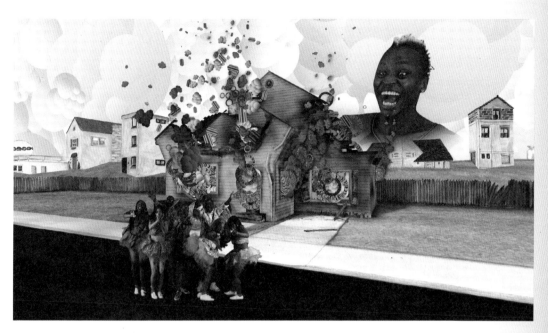

Music videos made by Eric for Major Lazer's "Pon De Floor" (top) and Health's "We are Water" (bottom).

13. Subsequently the cocreator, along with Fred Armisen and Carrie Brownstein, of the IFC series *Portlandia.*

14. One of Tim's trademark *Awesome Show* characters. Jan is a portly, shorthaired female TV anchor who, with her husband, Wayne (played by Eric), is part of the world's "only married news team."

15. Another of Tim's trademark characters. Spagett is a tiny, balding, ponytailed man who leaps from corners and dumpsters to "spook" people on his hidden-camera show.

16. One more of Tim's ™ characters. Casey is a truly disturbing manchild with an oily face who sings songs about time travel and horse-and-buggy rides.

17. Two nonverbal club-going monster men who exist solely on a diet of shrimp and white wine.

that kind of show before, so it was all figuring it out as we went—and with very little money. It wasn't a union show, so we would just be shooting things with whoever could operate the camera best. There was not a real crew. Jon Krisel[13] would be shooting stuff even though he was the editor. The first couple of episodes totally came together in the editing.

It sounds stressful. Like you *weren't* having fun again.
It was fun, but the schedule was intimidating. We were coming in on the weekends, and the editors were working really long hours. That kind of editing just physically takes a long time. And there were a lot of special effects.

***Awesome Show* ushered in a whole new level of performing for both of you, playing such a wide range of characters and types.**
That was always the last thing we thought about—who the character's going to be and how we're going to play it. There was very little time ever spent on that. But I think there's this general sense through all of our work where Eric is always kind of Eric. I can morph into different kinds of people, so I would always play more of a character. That was always a joke, that Eric was just Eric—even in a dress.

When you were playing a character like Jan Skylar,[14] I know you weren't doing the Stanislavski method or anything. But what sort of preparation did go into that character?
I would kind of be her for a few hours before we shot. I'd get into the costume and I would walk around and do little bits with people in the office, mostly because it was fun. It would be a kind of little warm-up, but it was playtime.

Jan and Wayne Skylar—along with Steve Brule—are good examples of the recurring characters on *Awesome Show*. It was really cool to see depth and life added to them as the series went on.
The more the audience knows about the character, the more you can give them to do and the more you can shade them in. And also, one misconception about us is that we're an idea factory. We actually don't have a big writing staff at all. We have three or four guys who come in on a temp basis. And we're also precious about ideas—we don't want to just do anything. We want them to be really good and for there to be a reason for it. So when we have characters like the Married News Team or Spagett[15] or any of the things we'd go back to occasionally, it's because that made our lives a little easier. We need a canvas to paint on, and we don't have an unlimited supply. [*laughs*] And these characters are good! But then there might come a point where we'd be like, "I'm bored of this character," and we'd kill them off.

Like Casey?[16]
Yeah, or the Beaver Boys,[17] where it was like, "People love this

was torturous for you guys. You probably got asked the same five questions by everybody.

When we were promoting the movie, anytime we were on camera, it was not going to be a real interview. There was going to be some sort of joke or experiment. But we also appreciate real interviews. The common man does not know our story, so we don't mind talking about it.

When you guys do those interviews where you're pretending to be on mushrooms, or when you did the whole Rango[11] deal, do you plan or even write those ideas beforehand as if they were bits?

Tim had the Rango idea right before we got to Sundance. We knew we were going to do tons of press, and I was on board for it. But we don't really talk about it. Part of the fun of doing those days of press is that one of us will start the joke and then the other person will think, 'Oh shit, we're going in that direction,' and then you've got to jump in.

Some of the interviewers seemed uptight about it, but they were really basically getting a free Tim and Eric improv bit.

And if you have a straight face about anything, people will just let you go. We compiled all the press that we did for the movie, and I think it came out to three and a half hours' worth of interviews.

That's amazing.

And none of them make any sense. All of them are on a different subject. When we were on the press tour for the movie, the Magnolia people were with us and they were seeing us do things like rip apart a hotel room for a college-TV interview, and they were like, "Oh my God, could you just say the release date?" But it's way more worthwhile to have a video that's a comedy piece than informational bullshit.

It's like doing viral marketing without having to say the disgusting phrase "viral marketing." And in fact, some of my favorite things by you guys are totally ancillary. Like the online commercial you did for the Chrimbus[12] special. That never fails to kill me, but it's just a little throwaway for you guys, right?

Yeah. We've loved making fun of commercials from the beginning, and I think we like making our own commercials since it's making fun of ourselves. Like, "Since we have to do this bullshit, we might as well have fun with it." At the core of our shit, it's pretty much just Tim and I being on camera, riffing. I think sometimes that's the best stuff. It's just a green screen and one of our editors who knows how to process it properly. Sometimes that's way better than a really polished bit. But you never know how it'll turn out. Some of them are awesome, some are just stink bombs.

11. Tim and Eric, in multiple interviews to promote the *Billion Dollar Movie*, claimed that the film had been "Rango'd" by the studio at the last minute, meaning that footage from the already-forgotten, Johnny-Depp-as-animated-lizard movie, *Rango*, had been arbitrarily inserted into Tim and Eric's film to boost its appeal.

12. For an Adult Swim holiday special, Tim and Eric invented a holiday, Chrimbus, and a series of unpleasant traditions to go along with it. They also went on tour around the same time, and the online commercial for all of this stuff is one of their masterpieces, spawning the immortal Heidecker line, "I showed it to my dad and he thought it was a very funny goof and a spoof." Again, YouTube this.

Tim Heidecker, cont'd

but there's no dimension to these characters. They're totally disposable."

Did you ever worry about being pigeonholed for something like the Beaver Boys? They were the sorts of characters that *SNL* would pound into the ground.

There's nothing exciting about getting pictures of shrimp and white wine sent to me over the internet by fans. It's like, "I'm happy you guys enjoy the Beaver Boys, and I'm happy we made you laugh." But that's just one joke from the show. It's not the whole show, and it's not us. For whatever reason it resonates with some people, but there were plenty of jokes we did that to me were funnier or more valuable.

I'm curious about the difference between writing a bit that's more dialogue-heavy and writing a sketch like "Ooh Mama," which consisted only of you and Eric screaming in a basement, yet was somehow totally compelling.

"Ooh Mama" was born in the editing room. It was basically a failed sketch that we had filmed. Like some of our bits, it was

Above: The Beaver Boys. Below: Tim, as Spagett, with Eric.

Something really great about *Awesome Show* was how dark it could get. Like with "Cinco Boy" and "Druwing on Drawing."

[*laughs*] Oh my god, that was so fucked. We've always been drawn to the darkness and showing it in a new way. Like casting Peter Stormare for "Cinco Boy." He gave such a frightening performance in *Fargo*, and that's something we want people to think of when they see that sketch. Tim and I have always liked the idea of that boundary. It's like, we're talking about a replacement boy for a son that died. That's horrible. But that's sort of what we got from David Lynch and Stanley Kubrick—like in *A Clockwork Orange*, when he's raping a woman and it's kind of funny in a way. You sort of have to laugh about it because it's so fucking horrible.

You guys have also made some of the most unpleasant, hilarious, and right-on riffs on the father-son relationship ever. Because dads are weird.

Dads are so weird, man. When you find out your dad is a real person and not just a dad, your dynamic totally changes. It's just awkward. I remember when my dad flipped off this guy who cut him off—reached across me and gave him the finger, and I was like, "Oh my God, my dad just did that." And then I remember when my dad was feuding with his neighbors and I was like,

Eric and Tim in their short film Father and Son.

Tim Heidecker, cont'd

written like, "I don't know where this is going to go, but let's set up the conditions where we can improvise and possibly get into some kind of groove, and we'll try to make the stakes low enough so that if it doesn't work—so what?" But we didn't really know what to do with "Ooh Mama," so we gave it to Doug Lussenhop[18] to edit, and he found a loop that worked. He played with it and then showed us a little sample, and we were like, "This is the best thing we've ever seen." Half of *Awesome Show*—maybe not half, but a good portion of *Awesome Show*—was some variation of improvisation and freethinking and just kind of creating a mood.

18. Longtime Tim and Eric friend and collaborator. Also known as "DJ Douggpound."

When you guys would get a really good improv going, how would you know when to stop filming?

It was generally a time-and-money thing, because there was never a lot of either. And our producers were always behind the camera giving us positive or negative feedback. By the third season, we'd developed a real confidence in knowing if something was usable or not. We knew what was going to work, so there was less experimenting.

19. Two linked sketches that represent Tim and Eric's absolute darkest work. One is about a manne-quin replacement for a dead child and the other is about a man who makes horrific portraits of corpses in caskets.

Awesome Show **could sometimes get very dark, with sketches like "Cinco Boy" and "Druwing on Drawing,"[19] or even with the music cues and the casting choices—like using Ray Wise, who was Leland Palmer on** *Twin Peaks***, or Peter Stormare, who was so scary in** *Fargo***. Can you talk about the darkness-comedy connection?**

Let's take the example of "Druwing on Drawing." There's something absurd and completely disturbing about somebody photographing funerals and corpses. But as an idea, it isn't funny. It's in the context of the way we're dealing with it that it becomes funny—to me at least. And also, sometimes our things just aren't made to be funny. They're made more to make you feel weird or uncomfortable. There's a sadistic side to it. Now, that's not really our ultimate goal—to fuck with people or upset people just for the sake of upsetting them...

But you can have more than one goal with comedy, too.

Right. I was thinking about this the other day. Remember the sketch "I Live with My Dad"?

Sure—the fake karaoke video where a dad and his middle-aged son sing about living together in a one-bedroom apartment because their lives have fallen apart.

I just watched it recently because we're putting together another album of songs from the show. If you dissect it, there are a couple different jokes there. The first joke is that this man lives with his son and they're both adults and single and this older dad is hanging out with this younger guy's friends in their bedroom. That's a fairly traditional premise. I could see the *Kids in the Hall*

"Oh my God, my dad's being a dick, he's doing all this shit to this dude." That kind of feeling was horrible when you were growing up—you were embarrassed by your dad. So we tried to take that kind of energy and put it out there as comedy. Tim and I share an obsession with the father-son thing.

Dads are just men, and men are fucked-up.
Yeah, he's just a man.

What does your dad think about your comedy?
He likes it, but he doesn't love the extreme stuff. He just doesn't comment on, like, "Cinco Boy." I don't think he likes that. And the sexual stuff, he's always been a little weird about that. Even growing up, we'd watch a lot of 80s movies together, and whenever there would be a lovemaking scene, even a making-out scene, he would turn and talk to me about something else. He was so embarrassed. Sex was kind of a taboo subject around the house. I was also busted for porn mags twice. Like hardcore porn mags. And my dad was forced to have a talk with me about it, like, "Masturbation's okay, but you can't look at women this way." It was a really heavy moment with my dad that I know he didn't want to have.

I rewatched *Father and Son* recently. It's funny, of course, but there's also a sadness to it. When you and Tim are writing, do you guys discuss motivations and themes?
I think we do that in the very beginning. Like for *Father and Son*, we talked about the concept of living with a stepparent and what that relationship is like. Then we get into the funny stuff, like what would be the worst thing my character could do as revenge at a certain point in the film? Well, I could kill that other character.[13] Tim and I don't pay attention to pop culture at all for our writing, but other things—like news stories about weird murders where kids kill their dad? That kind of stuff can be an inspiration to our comedy. Because if you do it in a funny way, it's crazy and horrible and people are gasping, but they're also laughing. That's our zone. We really love that.

13. Don't worry. This is not a spoiler.

I wouldn't guess that you guys worry too much about the audience's reaction when you're writing.
Ninety-nine percent of the time, we do not care what the audience is going to think about it. At first it's just, like, what's going to make Tim and me laugh? But when we reread a script, we look at each page and say, "All right. There aren't enough jokes in this part. How can we make this funnier?" That's when we might insert something silly where you know you'll get physical laughs—really deep laughs you're going to laugh about again the next day. We're really interested in that experience where people remember the bit later and are like, "What happened there?" The best stuff—the stuff that I love—is really dense, multilayered kinds of things that you can rewatch and

or *Saturday Night Live* doing it as a sketch. But the direction we went with, it was a music video.

Which does somehow make it more disturbing.

It's just the way we execute things. It's a different execution.

It brought a whole different kind of pathos to the joke. It's also cringe-y and awkward, like when the father and son are going to bed together and they kiss. You and Eric really return to dads a lot as a subject for jokes.

The relationship between a father and son is an interesting one because the son eventually grows up and becomes a man and can see his father from the perspective of another man. The father that was once a god or an all-powerful person is kind of brought down to earth as being just a guy. And then there's also that absurdity of a man getting older and losing touch with what is current and young. The dads of our age group are specifically very funny to me in that way because they came out of the first generation of people where "cool" was something that they probably were for a while. So they don't just go from being young to being a grandfather, with the slacks and the sweater. With our dads' generation, there's that weird, awkward transitional period.

Yeah. All of our dads were either cool or wanted to be cool at one point, but then they have to get old.

And some men are perfectly capable of managing that transition. But there are a lot of men who don't handle it well.

***Awesome Show* really explored every side of the weirdness of men.**

We don't do a lot of pop-culture stuff, and we don't do a lot of politics. It's more about personal stuff—family and relationships between people. That's really where the core of our work comes from, so naturally dads get caught in the crossfire. There are also those weird heterosexual male relationships where it's like, "We've got to maintain our masculinity, but I also need to show you that I love you." That's just naturally awkward.

What does your dad think of your work?

We've never talked about the dad humor specifically, but he's loved everything we've done. He's always telling me when he meets people who are fans of the show.

Eric told me that his dad is a little more ambivalent about the whole thing.

I think they're a little less connected to it. And I don't know, maybe my dad is bullshitting me. I can't tell. But it's been consistent. And there's some stuff where he'll be like, "I don't know what that was, but it was really fricking weird."

You built a stable of great, eccentric character actors for *Awesome Show*. People like David Liebe Hart, James Quall, and Richard Dunn.[20] It seems to me like

20. Three strange, touching, and wonderful Los Angeles-area performers / weirdos whom Tim and Eric plucked from obscurity and made essential parts of *Awesome Show.*

maybe understand on a totally different level the second time.

One of the signature moves on *Awesome Show* was letting a moment of awkwardness go on for far too long. Were those written into the scripts?

Those mostly happened as improv. Sometimes we'll just decide that, say, we're going to hug for way too long. We wrote something where Tim literally hugs this boy for four minutes. Like, no joke. So I guess sometimes those length-jokes will be in the script, but most of the time we'll improvise something and in our minds we'll be like: The editors can take that and extend it. We really do try to give our editors the whole gamut of emotions for almost every scene. Like we're crying, we're laughing, we're squirming. Because you never know what will really hit. Sometimes the opposite of what's going on is where it's really at.

As an extension of the whole dads thing, you guys also do a lot of bits about men and masculinity in general. One thing that comes to mind is the "Puberty" episode.[14] What's funny about manhood to you?

It's similar to the dads thing in that there's nothing funnier than dudes trying to be cool. [*laughs*]

You've always cast really, really unique-looking men.

When we did our Chrimbus special, the audience was all men.

Yeah, that was really disturbing.

And they were all convicts. Really. They'd all just gotten out of prison and were in this weird casting program. Somehow Tim and I didn't know this until they got there. I mean, we can't afford shit so we went to the lowest casting director, and they

14. In which Eric, as evidenced by a massive forest of pubes, goes through puberty before Tim does.

Tim and Eric in the 2009 "Brothers Cinco" episode of Awesome Show.

236

you come from a really kindhearted place with these people, but you've also been criticized for making fun of them somehow.

There are going to be elements of truth to that. In the heat of battle, in trying to make the funniest show possible, there are probably times where we cross the line. And there is a little bit of the audience laughing *at* somebody. I'm not going to deny that that's happening. But all those guys love being on the show. They are constantly calling and wondering when we're doing something else. That's because, first of all, we're the only people who pay them. There's money being exchanged, which is very desirable.

And there was a moral compass at work. I think a viewer can sense that.

There were always things that Eric and I knew we wouldn't do with them, things that wouldn't have been fair, that weren't funny, that weren't what the show was about. And I think, ultimately, it was all pretty harmless. There were no hidden cameras, nobody was getting physically hurt, and everyone was compensated for their work. But sure, I feel there are some casualties in the war of making you laugh, and those people are being exploited to some degree. But I kind of think that it's worth it. It provides them with some sort of satisfaction. They've gotten on television and if there's been a kind of exploitation, then it's okay. It's not the end of the world. And none of them has ever come to me and said, "I can't believe you used that take," or, "Why would you present me that way?" No one's ever complained to us or to anybody else about it.

The simple fact that they kept coming back season after season demonstrated that they knew what the bargain was.

David Liebe Hart—out of all those people, I would say—is truly from another planet. Something's wrong with his brain. He's just not wired the way we're wired. He's a complete character, a complete eccentric, a total lunatic. And he loves being on television. So where's the harm, right? I think the only thing that we might manipulate is we try to get him to burp sometimes. That's who he is, and we're presenting him on the same level as Zach Galifianakis and us and everyone who's doing the show. We're not off in the corner snickering and throwing pies in his face. We're also presenting ourselves as being strange and weird.

You two get more ugly and awkward than anyone else on the show. Has there ever been an instance where an actor balked at something you wanted them to do?

The only person that I remember doing that was Rainn Wilson. We had written this song for him to do when he was on the "Children's Showcase" sketch. It was the "tits" song[21] that Patton Oswalt ended up doing. I think what happened was that we'd

21. "Oh it's been a long time / since I had my favorite drink / And I lick my lips / every time I start to think / Maybe it's not the taste / or the shape that drives me to bits / Cause all I wanna do is stick my face / right between your tits."

Eric Wareheim, cont'd

were like, "We can get 300 guys." And we wanted them all middle-aged and kind of rough. We saw these guys and we were like, "Holy shit, look at them. They're all kind of scary."

It really worked.

With all the man stuff, it's more about living in the Tim and Eric universe than it is about representing a real situation in society. A lot of our fake-product sketches are for guys. Like when we made those thong socks—the sexy male socks. And then there's a lot of shit and diarrhea jokes.

Which all men love, whether they admit it or not.

And, really, the shit stuff is a personal thing. Tim and I tour a lot, and we're always getting diarrhea on the road.

What are some things from outside of the comedy world that influenced or informed *Awesome Show*?

The best compliment that I got about our movie was when a friend said that it was kind of like a Paul McCarthy[15] exhibit. That's the nicest thing anyone's ever said, because I am a huge Paul McCarthy fan and I would go to all his shit in New York and be so thoroughly disgusted, but still into it. I'd be turned on and fascinated by the way he played with grotesqueness and silliness. And then a lot of music has been influential too, like we already talked about the Dead Milkmen. Talking Heads was a huge inspiration to us—their music, but also their idea of the suburbs, like in their movie *True Stories*. Tim actually turned me on to a lot of this stuff, like David Byrne and Laurie Anderson.

I never would have pegged Talking Heads as an influence on Tim and Eric. But now that you say it— especially that movie—it makes a lot of sense.

15. Los Angeles-based performance artist and sculptor whose work, it's true, shares sensibilities with T&E.

Eric grows a huge bush and Tim is jealous in the 2010 episode "Puberty."

Tim Heidecker, cont'd

found out we could say the word "tit" on television and I took it to be my challenge to write a song that used it. Rainn Wilson was like, "I just really don't want to say the word 'tit.'" So then I wrote a new song for him: "Do You Really Have to Pee in a Girl's Mouth?"

"Do you really have to pee in a girl's mouth / to make babies?" It's way worse than the tit song. So have there been times where you felt very strongly about a bit but Eric wasn't so into it, or vice versa?

I would say that 70 percent of our individual ideas, the other person is like, "I love that, that's great, let's do it." There's 20 percent where one of us might not be that crazy about it but won't really care, and then there'll be like 10 percent where one of us is like, "That's not something I want to get into." So that would be very rare. Ideas are just the beginning, and then it becomes about how we execute them.

All the way through performing and editing, little decisions get made that alter and enhance the idea. How did you guys make the decision to stop doing *Awesome Show***?**

We were starting to feel the reserves of our fuel burning out. We felt a sense that some of the beats and tropes of the show were getting a little old. We also felt that we had done a lot of what we wanted to do with the show. All the sketch shows that we love were, for the most part, short runs.

Your next big project was the *Billion Dollar Movie***. Eric gave me the impression that it was at times a frustrating experience in terms of working within the constraints of a traditional movie crew.**

I remember it being fairly fun. Though there were certain moments where the pressure of it was like, "Oh my God, there's so much to accomplish, there are so many restrictions, there

Tim and Eric with some of the Awesome Show *regulars including David Liebe Hart (bottom left), Richard Dunn (bottom right), and James Quall (top right).*

It has this air of being a little silly, but it's commenting on things we always thought were funny: suburbs, commercialism, bad commercials, corporations, things that are ruining society. And there's a dryness and a surrealism in how seriously they took it all. If you look deep into that movie, you'll see so much that we use in our work—even the physicality, the way he was making people move in ways that were just different enough so that you're like, "What the fuck is going on?"

Outside of the Tim and Eric world, you're a respected director of music videos. That one you made for the band Health[16] is pretty much pure horror.
I'd had this dream about a girl being locked up and raped over and over again and then she gets out. It was a really scary dream, and it was weird because I wasn't even in it. It was like watching a story. But afterward, it built up for a while. I wanted to take this really scary moment and shoot it kind of beautifully, and then at the end the twist is that the girl wins. I also wanted to try a narrative in my music video work rather than the kind of freak-out I was getting known for.

Right. Perhaps your best-known music video so far is Major Lazer's "Pon de Floor,"[17] and it's pretty much total special effects and choreography insanity. It's great too. But the Health video made me wonder whether you plan to work completely outside of comedy at some point. I'd love to see you make a horror film.
It's interesting you say that. We just had a meeting with our agents and they said the same thing: "Why don't you guys do a weird horror thing with really dark comedy?" And Tim and I think that could be cool. On a personal level, even before I met Tim, I always wanted to direct movies that were dark and creepy. So that's definitely on the docket at some point. But Tim and I are really hitting the Tim and Eric shit hard right now while we have some momentum and popularity. Then we'll slowly branch off into creating things from our singular passions, because we're pretty different in that respect.

Do you ever worry about being pigeonholed for the kind of humor you did on *Awesome Show*?
One of the things that I hate the most is when people label me a comedian. I understand why—because we have a comedy show—but I consider myself more than that.

But everything you've done is funny. Even the Health video; there's a sense of humor there.
It's just that when you're out here in LA, you have comedians and then you have directors. And I'd rather have more to offer than just comedy. I'm not a stand-up comedian or anything like that. Anyway, this is just a weird little issue I have.

You and Tim have done a fair amount of commercial work too.

16. For a song called "We are Water." Features a young woman being chased through the woods at night by a massive man who is wielding a machete and wearing only bikini briefs.

17. The most hyper, vulgar, excellent, and funny choreography yet to appear in a music video.

are so many compromises." The lesson I learned—and I sort of learned it midway through and became okay with it—was that movies are a series of compromises. For the movie to work, there have to be compromises.

It's much more of a straight narrative than you were probably used to writing after all those years on *Awesome Show*.

We took our time writing and rewriting the movie script. Originally, we got together for lunches and kind of beat out the general story. Then I assigned us both scenes to write, basically splitting it in half. I made an Excel document so we could create deadlines and have benchmarks. Eric would send me scenes and I'd put in my scenes and rewrite his scenes and he'd rewrite mine. We went back and forth like that, and it worked out really well. It took maybe two months. Then it was sitting for several months while no deals were being made—no movement on the project—and we'd open it back up and rewrite. At one point we had a 130-page version of the script. Then we got our real budget and our real schedule, and we did more cuts to make it into a script that could actually be shot.

Was it tough to get the funding for it?

We started with a guy who was all set to go, but he turned out to have kind of misrepresented himself—what he was and the money he had. So that fell apart. Then Eric and I had to go around and pitch the movie. The people at Magnolia Pictures were really the ones who wanted to do it the most. They had the money and believed that since we were getting Will Ferrell and Zach Galifianakis to be in the movie, it was going to be worth them making it.

I've used all the *Awesome Show* guest stars as hooks to get some people to watch it. Especially older people. I'll say, "You like *Breaking Bad*, right? Well, the sleazy lawyer from that is on this other show!" And then they'd be able to start getting into your stuff. It was a way to ease them in. It worked on my mom and stepdad.

That's real capital, to have somebody that people recognize be in something you make. And those people are fucking talented, and they're good at what they do—so why not use them, if that's what the scene and the character call for. There's nothing more enjoyable than working with a real, professional actor who knows what he's supposed to be doing. It's really exciting to write something that then gets created by someone who's a professional at it.

Like John C. Reilly. His work with you and Eric has opened up a whole new world of what he can do as a performer. He's insanely good as Steve Brule.

I love being behind the camera and shouting out something for him to say in the Brule world, and then he says it in exactly the way I was imagining.

We started with those Absolut Vodka ads with Zach.[18] They were more like these cool short films. But then we started seeing our work everywhere in terms of people just ripping us off in their commercials—using the same editing style, the colors, the sensibility… and then commercial agents started coming up to us like, "We love this Absolut Vodka stuff, and Eric, we like your music videos. Did you ever think about doing commercials?" Tim and I were always like, "No, we don't want to." But finally we gave it a try.

Were you saying no because of classic punk-rock reasons?

Exactly. We make fun of commercials all the time. But you can make a fucking shitload of money doing them. It takes two days, and then for the rest of the year you can work on your weird movies you don't get paid much for. Eventually we were like, "All right. David Lynch and Christopher Guest have done it. They all do it." So we did some, and a couple of them were really successful. So we did a couple more, and we charged enough money where we were like, "Yeah, we're happy with this." But we still try not to be in the commercials. We've been offered a shit-ton to actually appear in the spots, but we don't want people to see Tim and Eric promoting, like, the new Jack in the Box sandwich.

Your best-known commercials are probably the insanely hyper Old Spice spots starring Terry Crews.[19] Did your agent get that for you? Did you have to pitch to them?

We barely need an agent for this stuff because these ad dudes are so obsessed with our work. I'm telling you, these guys, they use "Tim and Eric" as a shorthand term for a certain style. It's crazy. We've even befriended some of these guys, and they've said, "Listen, to be honest with you, the reason we've brought you guys in is because we're such huge fans and we just wanted to hang out with you."

So they already had Terry Crews cast?

Yeah. They just wanted to get the Tim and Eric vibe. It was already totally scripted out and storyboarded line by line. These guys have to get stuff approved for a multimillion-dollar commercial. Then when Tim and I come in, we'll tweak them. We might insert lines, have Terry improvise, and add our spin to it. But then it still has to go back to the client, Procter & Gamble, and a lot of the time it then gets trimmed down to nothing.

In a way they didn't have to come to you guys at all. It was almost like a tribute or a gesture, because they could have paid somebody way less to just imitate Tim and Eric.

But they have so much money that they're like, "Why hire

18. In which Tim, Eric, and Galifianakis play three sort-of-cross-dressing friends who sip vodka in a surreal *Golden Girls*-ish setting.

19. You know these. The ones where the former NFL linebacker screams at you about Old Spice.

Was there much room for improv on the *Billion Dollar Movie* set?

Not as much as in our TV world. As small as our movie was, it was still a lot bigger than anything we had previously done. It was a union show, and it was a slow-moving ship. We were shooting in this mall, and it required a lot of technical work. We knew it couldn't be a movie where some things looked good and some things looked like shit. There needed to be consistency. But there were some scenes, like the stuff with Will Ferrell, where the producer would say, "Let's make sure we're giving more time to that because there will be a lot of improv." We knew when we had to have room to flex, and we knew when a scene needed to just go the way we had written it.

You probably learned a lot about filmmaking during the whole process.

Definitely. One thing we learned is that there needs to be a real consideration for blocking and for the dynamics of actual composition in a way that feeds life into the film. It's tough when you're writing and you get to a point where the movie kind of slows down because it ends up being a lot of people talking to each other. And that happens in all movies at some point. Most movies *are* people talking to each other. But there are ways to do it where there's also action and movement. And I've known, ever since *Tom Goes to the Mayor*, that whatever we do generally gets better as we go on. You get better at doing something simply by doing it. So I'm really happy with the movie, and I think a lot of people loved it, but it's a compromise in a lot of ways. It was the first time we had ever done something like it, so it's not going to be this perfect thing that's a realization of all our work.

You guys used a pretty daring distribution model by putting it out digitally and on pay-per-view before it was in theaters.

My personal opinion of the industry in general is that the game is over. I don't know how the old way will ever work again, unless the internet suddenly stops working. It seems like we're in the death spiral of the 20th-century model of mass entertainment being consumed.

Your fans are so dedicated that I'm sure they're willing to try different ways of seeing your work.

Just this morning I got two pictures sent to me from fans on Twitter. One was a wedding invitation that said, "Jim and Michelle's Awesome Wedding, Great Job." The other picture was of a Beaver Boys hockey team—about 13 guys all wearing Beaver Boys shirts. That's just a random, anecdotal sampling that goes into the pot of people with tattoos or license plates that are inspired by us—this whole world of people who are really strongly connected to our work. But then when you look at the numbers, they seem very small. I mean the number of

someone who is going to replicate Tim and Eric? Why not just go for Tim and Eric?"

Was *Awesome Show* something you guys were able to live comfortably on?

It was. But it was a rent-paying thing only because our production company produced it. And we directed it, and we starred in it—so we'd get a couple different paychecks for it. We started doing commercials because we knew that making movies is a longer process. You make one every two years or something. And we knew the *Billion Dollar Movie* wasn't going to pay off right away. Maybe it will in ten years, when the DVD sells a billion. [*laughs*]

So commercial work can get you through the between-project times.

Yeah. We've talked to a couple other directors about this too—Harmony Korine and Spike Jonze—and they're like, "Yeah, we do it every once in a while and it's kind of a buffer."

The Absolut films you guys made were so out there. I can't believe a big liquor company sponsored them.

Well, Absolut couldn't officially release those on their website. We submitted them, and they were like, "You broke every single law of alcohol advertising. But these are so good." We said, "Just pay us, and we'll put them up on our YouTube channel." So they sort of live on the internet as non-official ads, but at the same time…

They're totally ads.

Yeah, it's totally an ad for them. It's great.

It's so good to hear that you both were able to live off of *Awesome Show*.

If we were with somebody else's production company, it would be different. But we've made this world of people—we hire art students and film students, and none of them have any Hollywood experience. So they're pretty much our friends. And when you're in control of the money, you know there is no fucking bullshit. There's no corruption. On *Tom Goes to the Mayor*, there was a situation where Bob's producing partner unfortunately took a lot of money from the budget. He didn't pay people what they should have been paid, so at the end of the year he had all of this money. He goes to Bob and says, "I saved $200,000 from the budget," and Bob was like, "Fuck you. These guys are working around the clock, and you should be paying them. You should be hiring another editor and helping these guys." So Bob took his half of that money and split it among all of us.

Jesus Christ, this guy. He's amazing.

Dude, he's a god. And because this other producing partner was such a cock, Tim and I were like, "We can produce *Awesome Show*." And that's when we started our production company. Right now, Tim and I are producing three shows that we have

people who are actually buying our stuff. So it's like, where is the disconnect happening? And I can only assume it's happening in the torrent world, in the sector of the audience that feels somewhat entitled to our work without needing to pay for it—to support it.

And you need that to be able to continue making stuff. It's not like people torrenting some juggernaut studio blockbuster.

A lot of our fans do support us, of course. But yeah, we're unable to compete with stuff that gets marketed to the thousandth degree and hammered down people's throats every day.

The digital-distribution model seemed smart because a movie like this might not get played everywhere, and this was a way for your fans all over the place to be sure they could see it.

We asked Magnolia, "What is the prime reasoning for this distribution idea?" And they were like, "Listen, we're not going to open this in 1,000 theaters. We're going to open it in 20 theaters. There are tons of your fans who live in towns that don't have a small theater that's going to have room for this movie. So why not get it to as many people as possible?" That made sense to me. A lot of people, especially younger kids, don't feel like they need to go see a movie in the theater anymore. They've got a nice sound system at home and a great TV—or they're very comfortable watching it on their laptop. So Magnolia was totally playing to our audience. And the fact is that our audience is small relative to the world, you know? It can seem big because once a week somebody at the coffee shop will say, "Oh, hey man, I like your work," but it's really a very small sampling. And I don't know how that ever gets bigger, because the very core of what we do is not going to be appealing to a lot of people.

But the fans who do get it are so dedicated. I remember looking at your Twitter feed the night that the *Billion Dollar Movie* was first available on Zune and iTunes and everybody was tweeting at you about viewing parties and getting dressed up in special costumes for it. It's a cult, like Deadheads or *Rocky Horror* fans.

That's right. Listen, a band like Pavement goes out and plays shows for thousands and thousands of people. But it's going to stay at that level forever. There's never going to be a special Pavement edition of *American Idol*. It's never going to cross into the mainstream in a significant way. That just seems to be the state of things.

And it's similar for you guys?

In a way, what we do seems very disconnected from the world. You look at the rest of the world and our stuff doesn't look like anything I recognize. But there are millions of people who

Opposite: John C. Reilly as Steve Brule—the role of a lifetime.

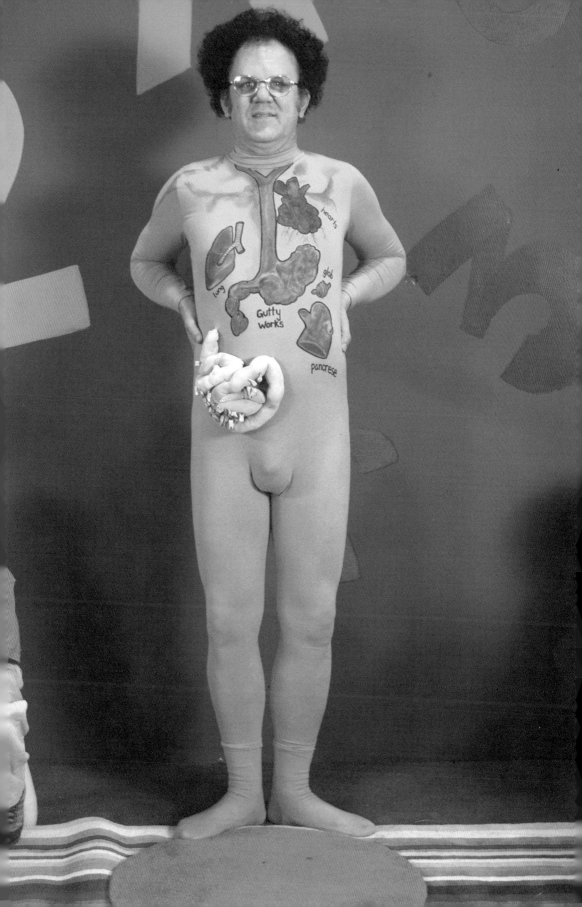

consume it and seem to be in love with it. I look at the picture of those hockey guys dressed as Beaver Boys, and they look like the most normal guys. I mean, they're fucking playing hockey. How alternative do you think they are?

Is it true that you would both like to make the *Trillion Dollar Movie* soon, but to do it a little differently?
Generally speaking, we're going to try to not spend so much time on the blocking of shots. [*laughs*] We'll try to make it a little more punk.

I'd like to talk for a minute about the stuff you do completely outside of Tim and Eric.
Finally.

You've been waiting for this. So you have these other projects, like the *On Cinema* podcast with Gregg Turkington, aka Neil Hamburger,[22] and your band Heidecker & Wood.[23]
It's weird because these side things are so not popular enough to warrant the amount of time I'm putting into them, but they're really fun and they're different from the work I do with Eric. Working with Eric is great, and I love the stuff we've done together, but there is something satisfying about doing things on my own. I think what happened with Tim and Eric is that we are both very strong personalities and we kind of signed up for this brand, we created "Tim and Eric," and then we ended up getting lost in it. I think Eric would say the same thing. Like when somebody might see him alone on the street and go, "Hey, Tim and Eric!" It's sort of like your identity gets swallowed into one blob called Tim and Eric. I think that was really bothering me for a while. Then I started doing some stuff outside of Tim and Eric and it made me feel so much better that I wasn't just trapped in this one thing. It also made me want to continue with Eric.

Something like *On Cinema* seems very easy to do.
And I'm really having fun doing it. I like to be able to sit in my little home studio that I've put together and do it all here. I don't have to ask for any help. I'm very limited in my skills, but I can edit the podcast together and I can put it up. I don't need anybody else, and I don't need to spend any money.

What about Heidecker & Wood?
I've always wanted to play music, and now I have the technology to do stuff and make it sound pretty good. I'm much more comfortable writing a song than I am sitting down and writing a comedy sketch.

That's interesting, because it feels like with the music you're putting more of yourself out there. It's a little more vulnerable than writing jokes.
When I'm writing music I'm not really thinking about what I'm saying. I'm just singing to go along with stuff, and I end up

22. Just Google "Neil Hamburger." You should know this already. I really hope you do.

23. In which Tim, along with collaborator Davin Wood, expertly apes the mellow sounds of later 1970s singer-songwriter radio hits.

no creative involvement with. We now both get a very small paycheck for running the company, but in the future that's hopefully something we can live off of while we focus on our creative projects.

So is *Awesome Show* totally done?

Once season five was wrapped and we'd killed off everyone on the show, Tim and I had a talk. We said, "We did it. We went out with a bang, we did everything we wanted to do, and we made 50 episodes." It just felt like a good number.

There were rumors that Adult Swim had canceled it.

No, they were kind of begging for more episodes. It was doing well for them. Maybe not ratings-wise like *Family Guy*, but it sort of legitimized them in a way, where the network wasn't just showing weird cartoons. We brought a lot of celebrities to our show, and we drew a lot of press because it was something a little different. And our following was pretty ravenous.

Will you miss all that?

I don't know. At this point, right now, I'm like, "Fuck, man. I could make another season. That'd be fun." But then we decided to make *Check it Out*, a spin-off series, and keep the *Awesome Show* alive in a way.

The second season of *Check It Out* is one of my favorite things you guys have done.

Thanks! When we were making it we were like, "Okay, Brule is going to be a little more fucked-up now." The first season was hard. We had to figure out this character. But making season two, we knew we had all the goods and we were able to delve a little deeper into his personality.

Does John C. Reilly have a lot to do with building that character?

Like 100 percent. He came in very early in *Awesome Show*, and you can see the Steve Brule character was not as fucked-up then. Tim and I pushed him to go further with it. We'd give him ideas like, "Your relationship with your mom is really weird." He would take that information and just spew it back out. It's really a lot of John improv-ing.

If you guys are John Cassavetes, he's your Gena Rowlands.

Yes. It's awesome.

Will you guys be making another TV series?

We're pitching a couple different shows right now. One is called *Tim and Eric's Bedtime Stories*. The idea is that Tim is my dad tucking me in as a young boy and he tells me a different story every episode.

Would it be structured like *Amazing Stories* or the *Twilight Zone*?

Totally like the *Twilight Zone*—an anthology series. We think that could be kind of cool.

248

singing things that are very therapy-driven. Then I try to rewrite so it doesn't come off as that. But yeah, initially it's very primal or something.

Heidecker & Wood is a genre exercise on one level, but the humor is really subtle. You guys know the ins and outs of that kind of soft rock music so well that it's kind of a slow burn. Someone might not even realize there's a sense of humor at its core.

That was our idea. I always thought it was funny that often you could listen to lyrics and not really pay attention to whether or not they mean anything. And I thought it would be funny to write music that upon inspection would be somewhat meaningless. Like our song "Right or Wrong." It goes, "You either can be right or wrong." It's like, what are you fucking talking about? There's no meaning.

But you do have other songs that have straight-ahead jokes embedded in them, like the one about watching your father getting dressed.

That's a case of, like, where is the line? There's very little humor in the actual words. It's kind of autobiographical in a way. What I think is the funny part is that the song exists at all—that I wrote it and that it's on something I put out and it's well done.

The very seriousness of the song is the funny part.

Right.

You also did *Cainthology*,[24] which seemed to me like you just had this spark of an idea and pounded it out really quickly.

I'm sort of a political-junkie guy. I love watching the horse race. But we always really consciously keep that stuff out of Tim and Eric. It's not our place, and it can be divisive and have a very short shelf life. But with Herman Cain I just couldn't resist. Xeni Jardin from Boing Boing sent me that one campaign video of his like, "Did you guys make this?"

The one with his chief of staff smoking and staring at the camera?

Yeah, that was it. That came out and I was having lunch with someone, I think with John C. Reilly, and we were talking about it and it was all I could think about. So I went home and just started writing that first song and then made a video for it that afternoon. I wanted to get it out as soon as possible, and then I had so many ideas for other Herman Cain songs I wanted to do. Within the course of a week I had done a whole album.

This is similar to your Bob Dylan parody, where you read that his last album would have a 14-minute song about the *Titanic* on it, so you cranked out a 14-minute Bob Dylan *Titanic* spoof and got it out before his album was released.

It's just fun to make stuff. With Tim and Eric, there are

24. Tim's maniacal album of hastily assembled musical tributes to Herman Cain.

Eric Wareheim, cont'd

Do you go straight to Adult Swim with your pitches?

We always go to Adult Swim off the bat because that's our home and they deserve to hear our ideas first. But sometimes they're like, "This is not for Adult Swim," and we might try HBO or IFC—even Netflix and Hulu are buying shows now. The other show we just wrote is called *Tim and Eric Go to the Moon*. It's set slightly in the future, and there's a colony on the moon. Tim and I get roped into going there. We think we're going to be these big scientists, but they really just need people to paint the exterior of the moon base. Tim and I are lackeys. But then we find this other civilization living up there—like this Howard Hughes kind of guy who's been living on the moon for 50 years. And then there's this weird mutant incestuous race.

This sounds promising!

It would be a dark sci-fi kind of thing. We'd try to play it as real as we could, but also funny. And then we have this other idea with Galifianakis. It's a TMZ-ish show where we follow all the people around who are in the actual TMZ show. We paparazzi them.

Tim, Eric, and Zach Galifianakis in their short film Just 3 Boyz.

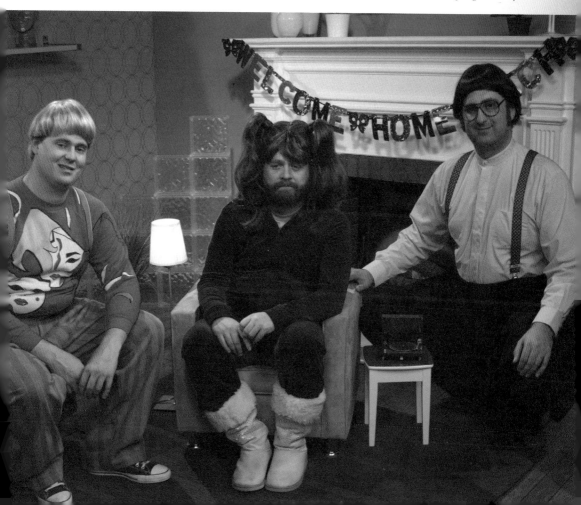

boundaries to it in a crazy way. I don't think people appreciate that.

I know what you mean. It's a very special feel and mood.

There's a trick to it, and a consistency to it. There's also our shared voice. But I'm itchy and spontaneous, so I also want to make this other stuff—and make it quickly.

You and Eric are so tightly linked. It's almost like a marriage—a really deep, long partnership. Do you worry about it dissolving one day?

I don't know. We've created a business together, a production company that produces other people's shows. And since I'm a student of the Beatles, I know how things can go bad and how egos can destroy great things. All that stuff has to be kept in check. And it's also like, right now, do we still have ideas that we want to work on together? We do. There are a lot of things we want to do, and there seems to be a demand for it. But there's going to be a point—and we always joke about this—where what we're doing won't be relevant anymore. Some younger people will start doing more interesting things. We're not always going to be trailblazers. There's going to be a kind of sunset on that.

Do you have plans to work outside of comedy at some point?

I recently acted in *The Comedy*.[25] That was working outside of comedy, even though it has connections to comedy. I'm being funny in it at times. But it's not a comedy at all. Eric's world is a little different because he's connected to music videos. He has much more of an art sensibility and a visual style that doesn't necessarily involve humor at all. I'm maybe a little more connected to comedy in a way that I don't think I could ever really separate from. There is music that I've written that isn't intended to be funny, but I don't know if I'll ever feel confident enough to put that out in any public way. I think that drama, in some ways, is a little easier than comedy. With the right director and the right manipulation going on, in editing and music and everything, an actor in a drama doesn't really need to do very much besides be themselves—if you're doing something that's naturalistic and honest. It's kind of a magic trick.

Comedy takes a different kind of guts. And I think you proved with *The Comedy* that you can step into a dramatic role and do it well.

There was a period where, for a while, as huge fans of Andy Kaufman, we hid behind the Tim and Eric persona and kept the mystery alive about who we are. We would be very strict about what kind of work we put out. But I kind of just fucking stopped caring about that. I stopped caring about how I was perceived and just started making stuff in a way that made me happy. 🐝

25. It is not a comedy, though it is brutally funny at times. This movie is an indictment of hip, entitled man-children and their intense jadedness. It's hard to watch and very good.

Like in real life?

In real life, yeah. What if we really paparazzied them and did a show on it? I feel like Adult Swim would have the balls to do that.

What you and Tim have is like a marriage. It's a really serious, deep relationship. Does the idea of branching out and doing your own things give you a twinge of sad feelings?

We've been working hardcore together for 15 years. I mean, every day we work together. He probably sees me more than he sees his wife. We know what we have is really special, and right now we both want to make more Tim and Eric shit. But Tim has his own set of interests—he does his music and he's more into political comedy. And I do my things, making artwork and music videos and films. I think that once the Tim and Eric thing really becomes a drag, we'll both agree to move on. Hopefully throughout life we'll come back and do stuff together—reunion tours or whatever. But it does make me sad, just like ending *Awesome Show* kind of made me sad. It's this thing that everyone loved and everyone quotes, and I see it all over YouTube. But we also have to stick to our guns, and we know that that's going to live on forever as this great thing.

Do you and Tim socialize?

We don't hang out as much anymore. We lived together for five years. We hung out every night, we drank every night. Over the past couple years we've really developed some other friendships. So we make it a point to have our own lives, but we're always intersecting socially. Like we play wiffleball every week.

Just before this issue went to press, Tim and Eric closed the deals with Adult Swim for both *Tim and Eric's Bedtime Stories* and *Tim and Eric Go to the Moon*. Production on *Bedtime Stories* starts early this year. 🌠

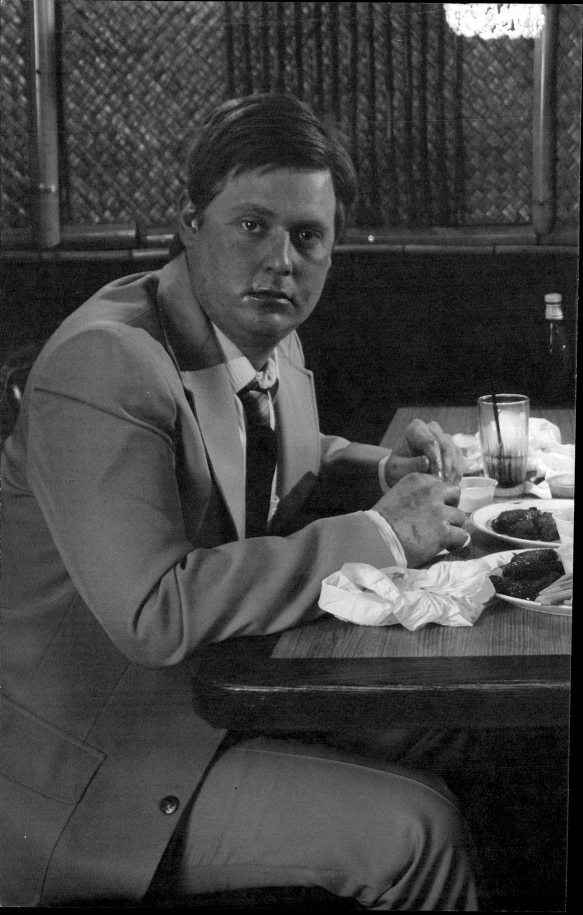